LIVING IN

Cuba

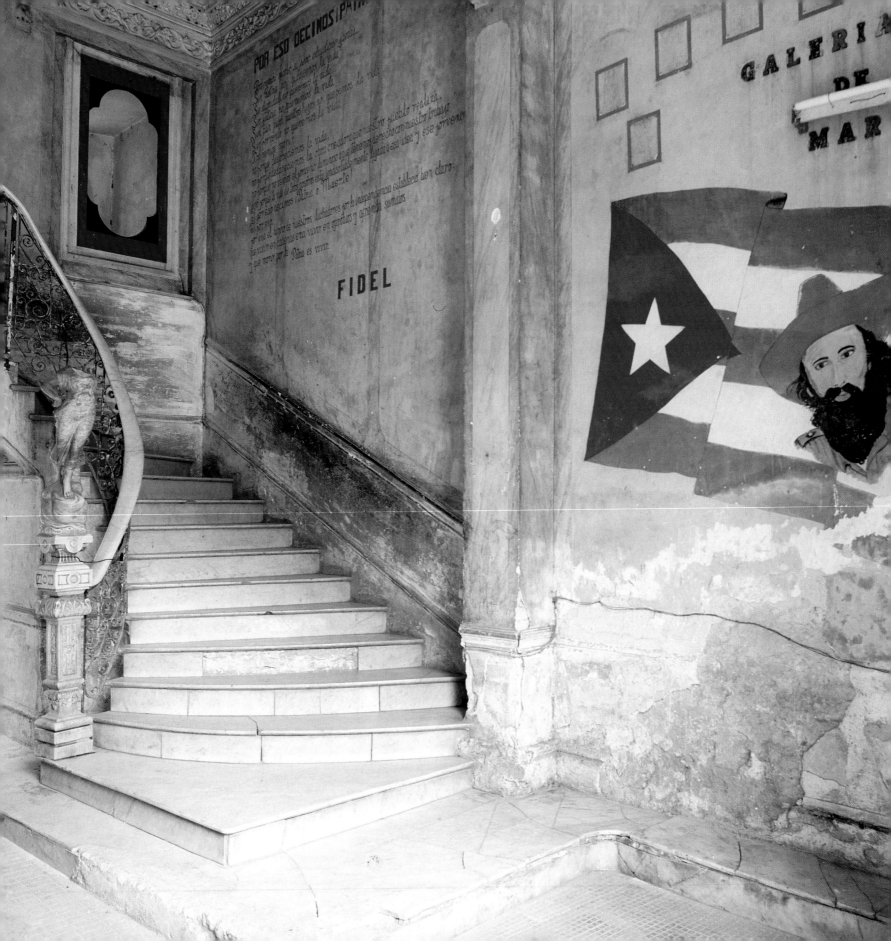

Living In
Cuba

ALEXANDRA BLACK PHOTOGRAPHY BY SIMON MCBRIDE

St. Martin's Press ☙ New York

A THOMAS DUNNE BOOK.

AN IMPRINT OF ST. MARTIN'S PRESS.

Created by Co & Bear Productions(UK) Ltd.

Copyright © 1998 Co & Bear Productions Ltd.

Photographs copyright © 1998 Simon McBride.

The text of this book was set in Palatino.

Printed and bound in Novara, Italy by Officine Grafiche de Agostini.

Colour reproduction by David Bruce Imaging.

First edition

10 9 8 7 6 5 4 3 2 1

ISBN 0-312-19727-6

Printed in Italy

Publishing Director Beatrice Vincenzini

Project Manager David Shannon

Project Coordinator Yasemin Olcay

Designers Emma Skidmore & Paul Ashby

Jacket Design David Mackintosh

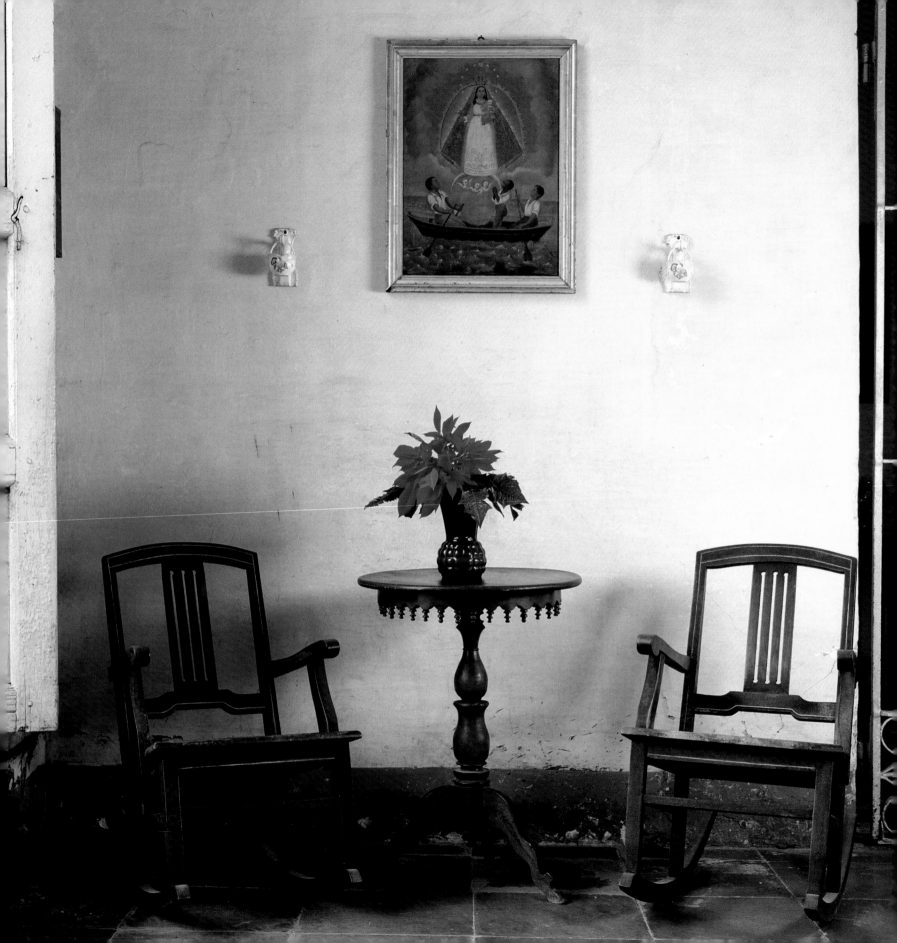

It is with great pleasure that I write these words to preface the book *Living In Cuba*, written by Alexandra Black and illuminated with such evocative photographs by Simon McBride.

Over the last few years, many volumes have been published on Cuba, in particular on the beautiful city of Havana. But in conveying an authentic view of the country, one that manages to capture even the smallest nuances, the trick is to approach the subject with searching eyes and in the spirit of love, not with a prejudged state of mind.

Cuba has attained the status of an almost mythical Caribbean island: for its luxuriant nature, and for the legendary hospitality of its people, who over the last four decades have experienced no less than a social revolution. Some view this social experiment as hopeless; others see it as a dream realised. Regardless of which view you hold, one thing is certain: no one who encounters the country, its history, and its will to remain unscathed during the next century, will return home indifferent – just like the author who travelled from one side of the country to the other recording her thoughts on paper, and the photographer who captured his impressions on film.

In my own job as historian, I rely on the goodwill of people to contribute to the rescue of Cuba's precious architectural inheritance, and to preserve the memory of every event, big or small, that has shaped the island's history. I would like therefore to express my thanks to the author and photographer of *Living In Cuba* for their contribution to this end.

The following pages mix a little magic with a candid approach to reveal a very new and distinctive truth. I invite readers to draw their own conclusions, in the certainty that, like me, they will not be deceived.

Eusebio Leal Spengler
City Historian,
Havana

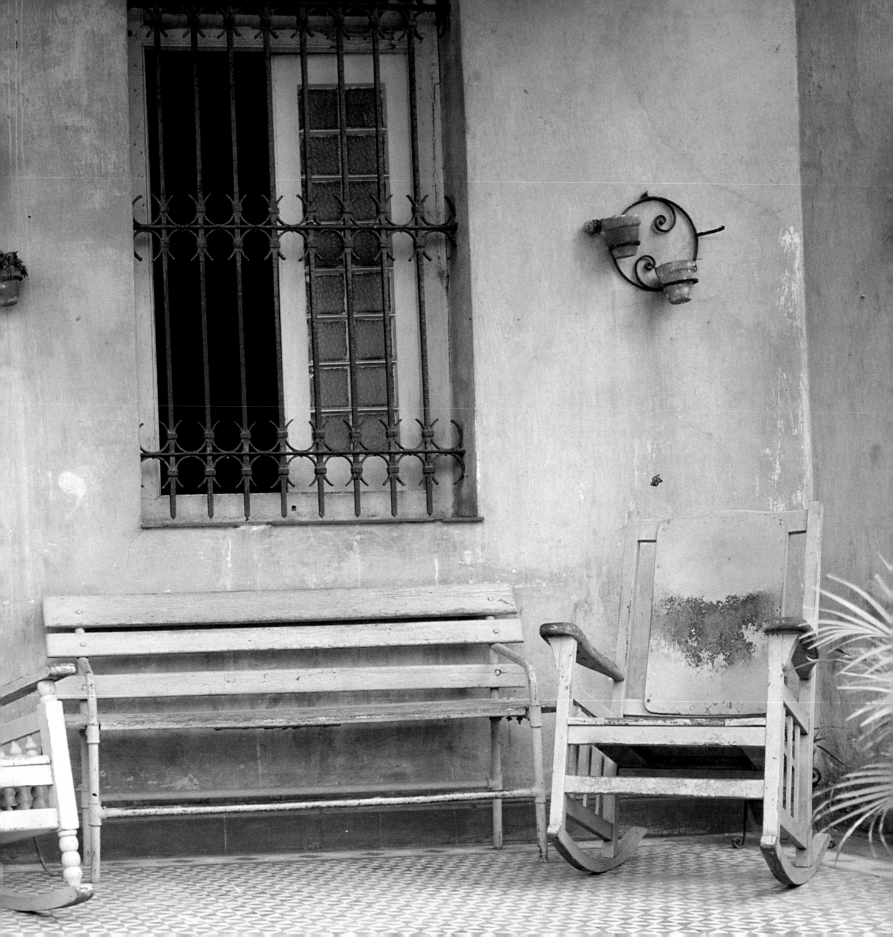

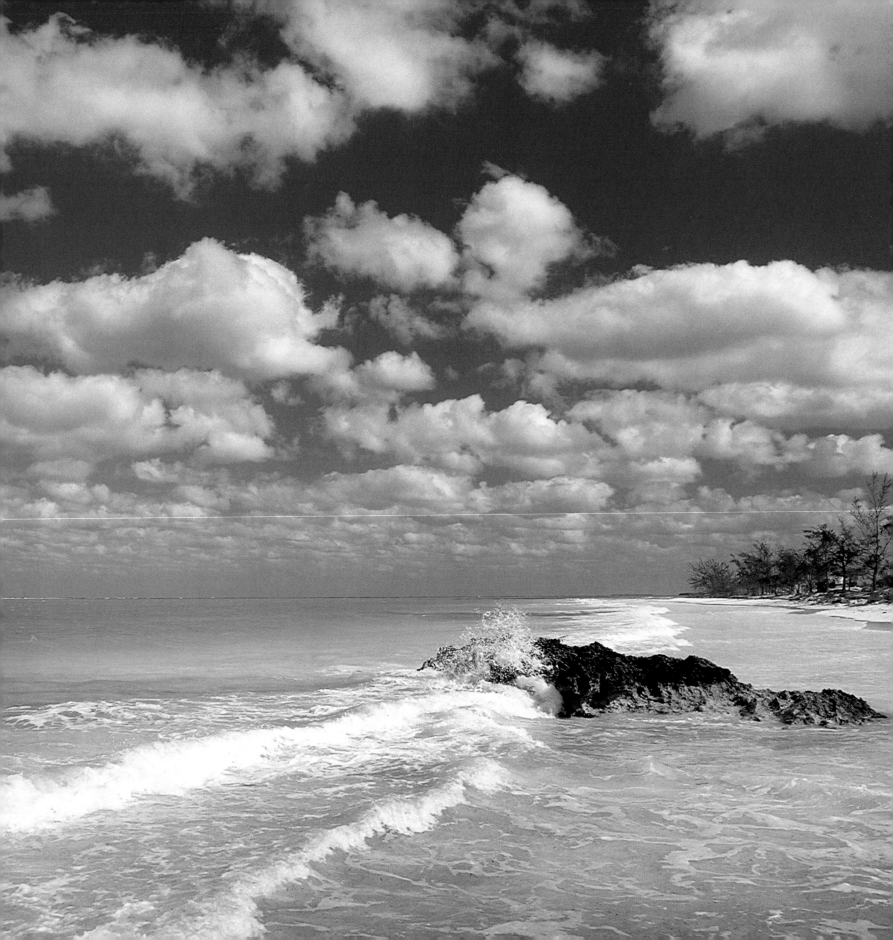

PARADISE FOUND

When Christopher Columbus caught sight of Cuba's turquoise seas and sandy shores edged with palms and tropical forests, he declared it the most beautiful land that was ever seen

ISLAND SHORES

Edged with the palm-fringed sands of the blue Atlantic to its north and the warm, turquoise waters of the Caribbean to its south, Cuba embodies the elemental allure of a tropical paradise. The largest island in the Caribbean, stretching 1,250 kilometres from east to west and 191 kilometres from north to south, it is ringed by a seemingly never-ending chain of beaches, harbours, cays, and coral atolls.

But more than the tranquil beauty of its shores, the forces of nature that bless Cuba with fine white-sand beaches and a wealth of ocean life have also shaped the island's destiny. With the Atlantic Ocean and Florida Straits to its north, the Caribbean to its south, the Gulf of Mexico to its west, and the Gulf Stream to Europe on its eastern side, Cuba's position at the gateway to the Americas made it one of the prize possessions in the New World. Ships dropped anchor in the port of Havana on their way to and from other outposts in the Americas, building what would become the richest Spanish satellite of the colonial age.

OPPOSITE *In the remote far-eastern corner of the island, the rocky Caribbean coast affords views of Jamaica, 140 kilometres south*

LEFT *The Atlantic coastline winds east from Havana past the brilliant white beaches of Varadero, then shatters into a reef of countless coral atolls and tiny offshore islands, the largest of which is Cayo Coco*

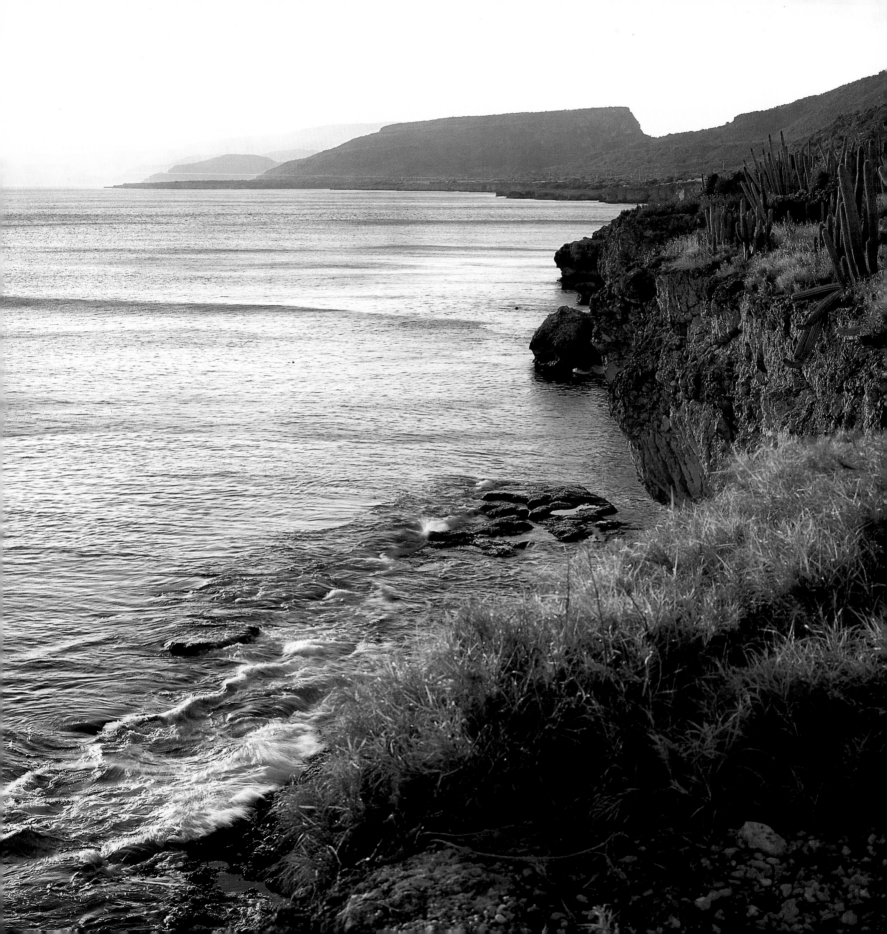

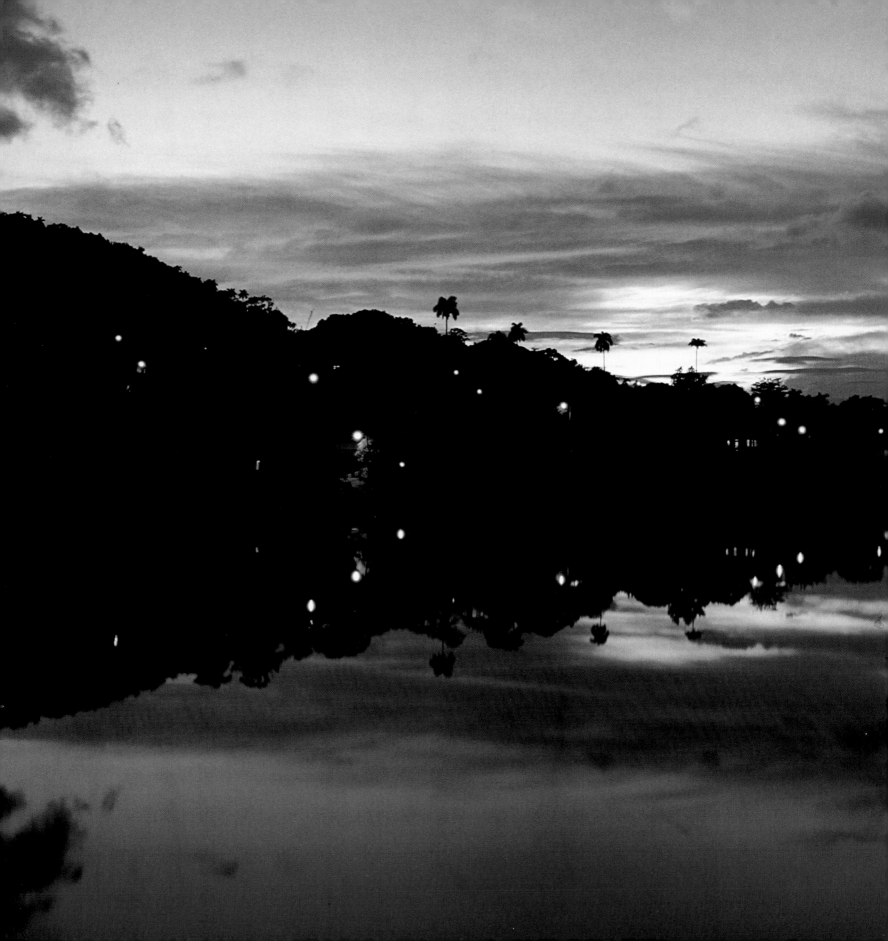

OPPOSITE *Although this palm-fringed shore appears to edge a tranquil sea, the reflective surface is in fact a lake high in the Sierra del Rosario mountain range of Pinar del Río, Cuba's most westerly province. The Sierra del Rosario, which provides a rich habitat for orchids and forest life, is one of two ranges that run parallel to the province's northern coast*

BELOW *West of Havana, the Atlantic Ocean curves around past coves and beaches on its way to the fertile valleys and lush mountain ranges of Pinar del Río. The waters here teem with fish, including scores of white, black and striped marlin, which appear each year in spring, travelling west against the current of the Gulf Stream*

OPPOSITE *Caribbean waters feed the lagoons and vast swamps of the Zapata Peninsula*

ABOVE *The Ernest Hemingway Marlin Fishing Competition is held every May near the quaint Atlantic fishing village of Santa Fe*

BELOW LEFT *Sunset over the beach of Giron, on the Caribbean coast*

BELOW RIGHT *Looking over the gentle hills on the outskirts of Trinidad, a thin sliver of Caribbean Sea is visible on the horizon*

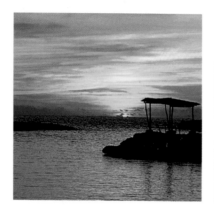

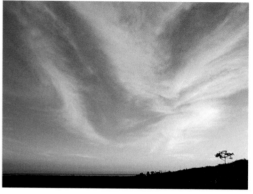

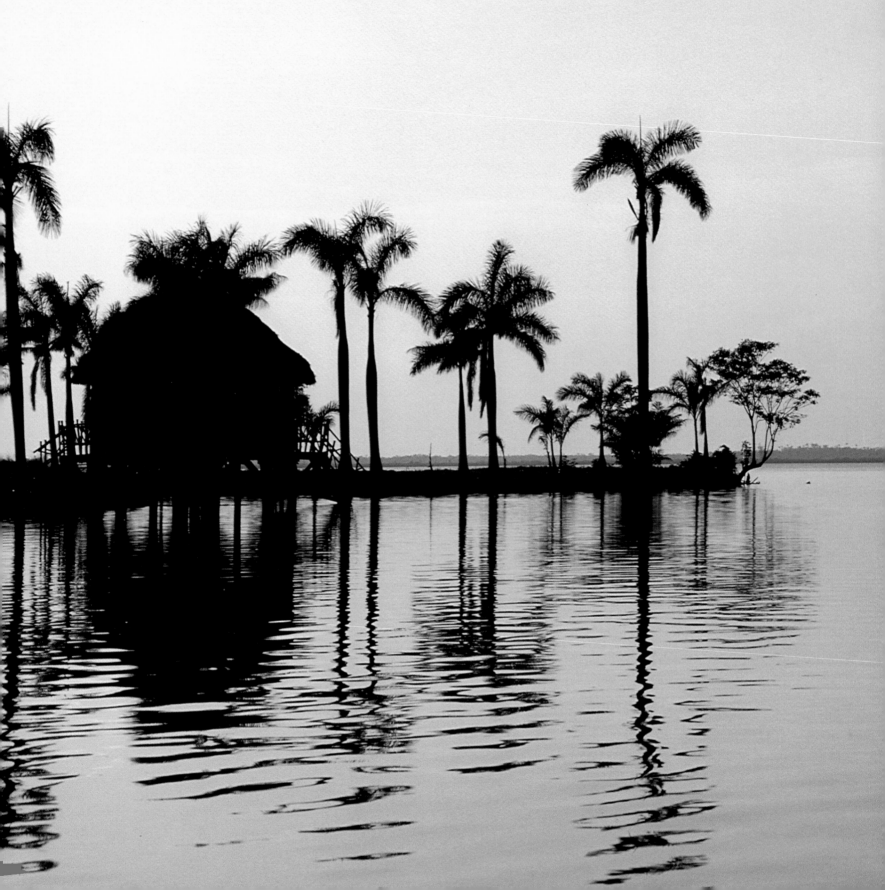

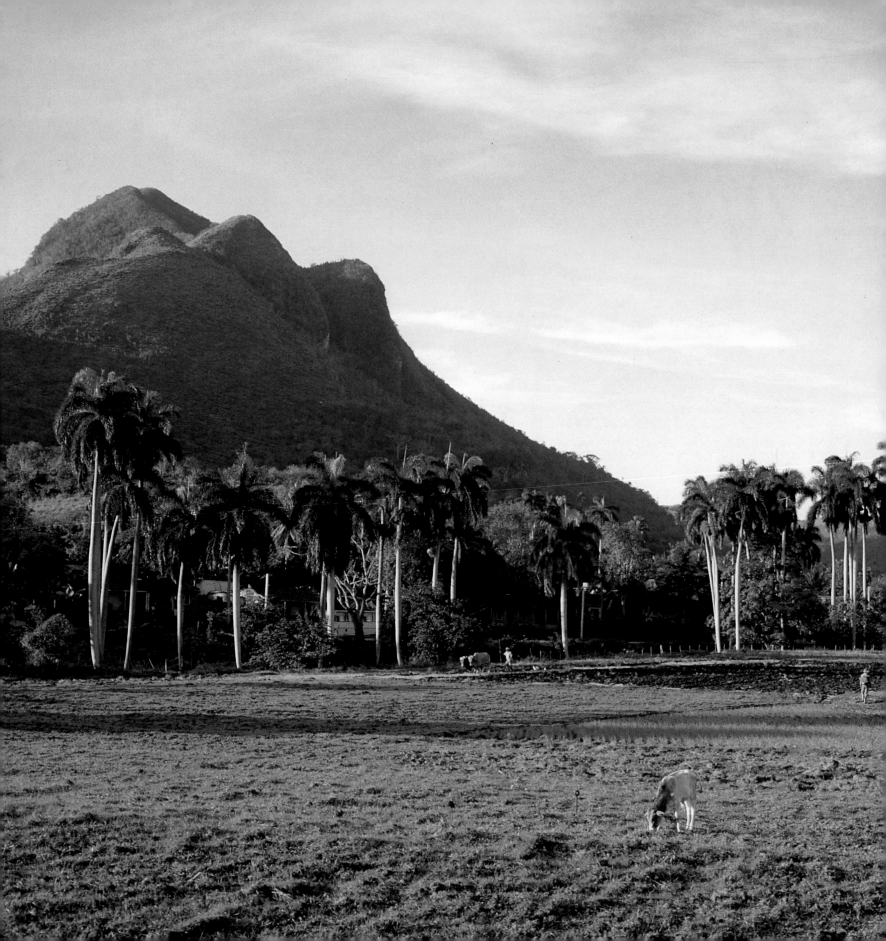

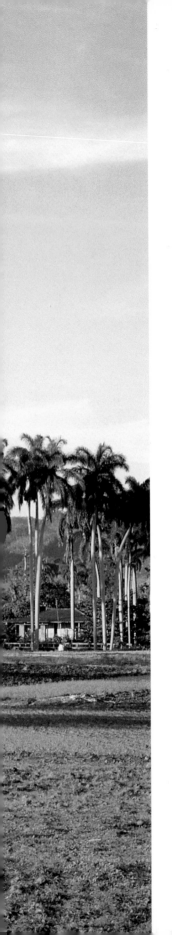

INTO THE TROPICS

When Columbus landed on Cuba's north-eastern coast in October of 1492 his journal records his initial response: 'That this land is the most beautiful that eyes have seen, full of good harbours and rivers, full of beautiful mountains; that the land has a great number of palms, and is full of trees, beautiful and green and different from ours, each one with its own kind of flowers and fruits; that the sea appears as if it must never rise because the growth on the beach reaches almost to the water.'

Today, Cuba's pristine landscapes are little changed from the days when the conquistadors first looked on in awe: the mist-shrouded Escambray Mountains with its rainforests, waterfalls and prolific wildlife; the orchid-filled forests of the Sierra del Rosario in the west; the impenetrable Sierra Maestra mountain range to the east; the tropical haven of the Oriente, a region of lush growth and natural fruit groves; and everywhere across the island, the valleys of densely clustered royal palms that first struck Columbus with their distinctive silhouette.

OPPOSITE *The Escambray mountains in the province of Sancti Spiritus*

RIGHT *Stands of royal palms flourish in the valleys of the Sierra Maestra mountains in the eastern part of Cuba. The royal palm is a national symbol and is protected under law. Its trunk and fronds have been used for centuries to build thatched houses*

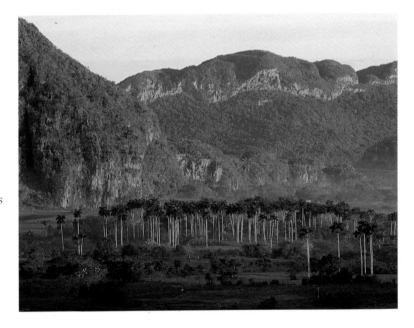

OPPOSITE *Dappled light bathes the soft hills of Cienfuegos province in the centre of Cuba, and the patchwork of fields beyond*

RIGHT *Beyond the historic city of Trinidad, on Cuba's southern coast, the countryside of green rolling hills and plains once supported a huge sugar industry, with plantations dotting the surroundings. When the soil became overworked the crops failed and much of the area returned to its natural state*

BELOW *Although the province of Pinar del Río occupies a thin finger of land, it boasts some of the island's most dramatic scenery, including the Sierra del Rosario mountain range, visible here in the hazy distance*

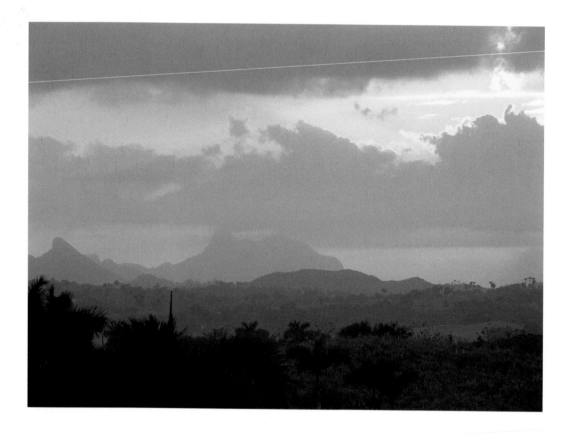

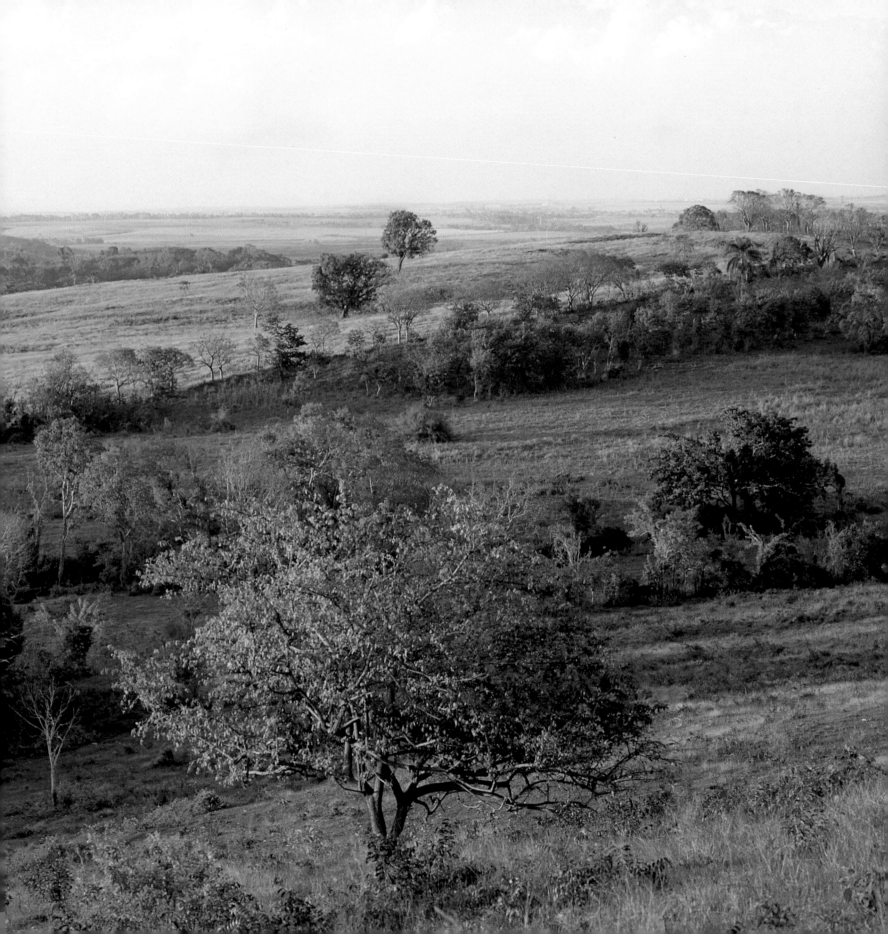

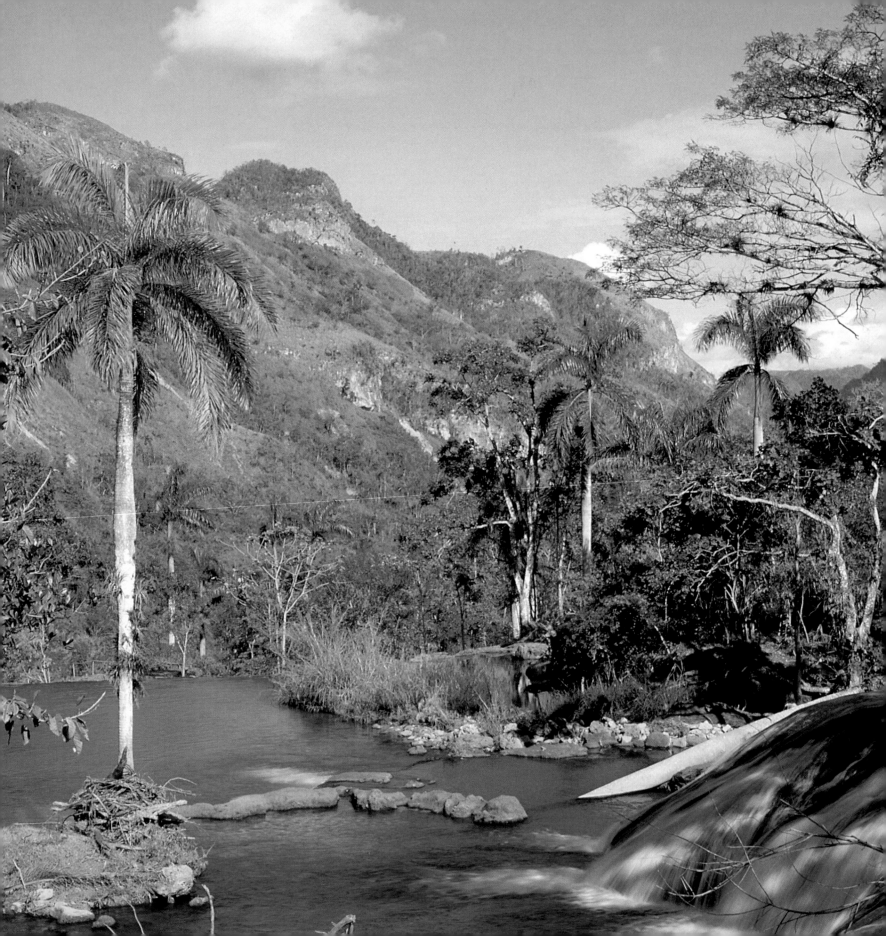

OPPOSITE *The green folds of the rugged Sierra del Escambray mountains tower behind the town of Trinidad and stretch into central Cuba. Deep in the mountains, humidity of around 80 percent year round harbours a rainforest ecosystem, home to myriad species of butterflies, birds and flowers, including the sweet-scented Mariposa, Cuba's national bloom*

BELOW *The highest rainfall of any region on the island fuels the dramatic Salto Caburni Falls in the heart of the majestic Escambray mountains. The rushing waters tumble from a height of 75 metres down a series of cliffs. The falls are at their most spectacular in the rainy season, when tropical showers drench the mountains during the summer months*

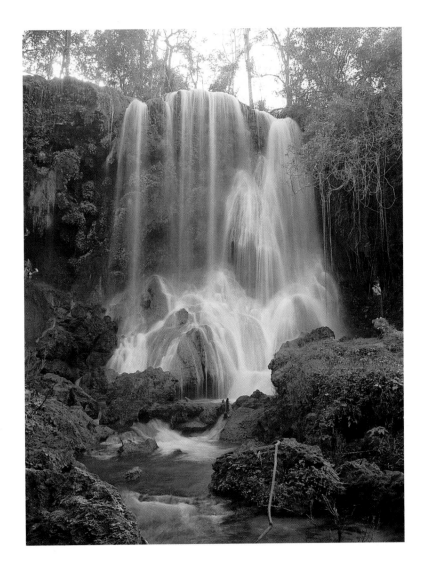

THE HEARTLAND

Columbus stayed little more than a month on his first visit to Cuba, but he was so convinced of its hidden wealth that he returned a year later to embark on a search for gold. The explorer believed that this new-found land was Cipango, part of the Empire of the Great Khan – the East Indies – a land rich in gold and other treasures as famously described by Marco Polo.

A few hundred years after Columbus sailed away empty-handed, Cuba yielded more riches for its Spanish colonizers than he could ever have imagined. But it wasn't thanks to gold, of which there was very little, but sugar and tobacco. The island is blessed with vast plains and rolling hills made fertile by warm tropical rains that sweep in on the trade winds, and by rich limestone deposits that make the island's deep red soil among the most luxuriant on earth. Tobacco and sugar cane grow better here than almost anywhere else in the Americas, creating fortunes for the Spanish crown and for plantation owners in past centuries, and still the mainstay of the modern economy.

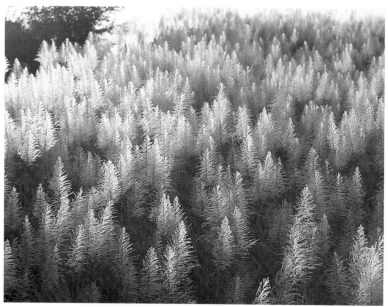

OPPOSITE *Fields of tobacco, Cuba's most enduring crop, in Pinar del Río province*

LEFT *The feathery flowers of the young sugarcane plant – worth more than gold to the Spanish during the colonial era. Columbus brought sugarcane seedlings from the Canary Islands to plant on the Caribbean islands on his second voyage*

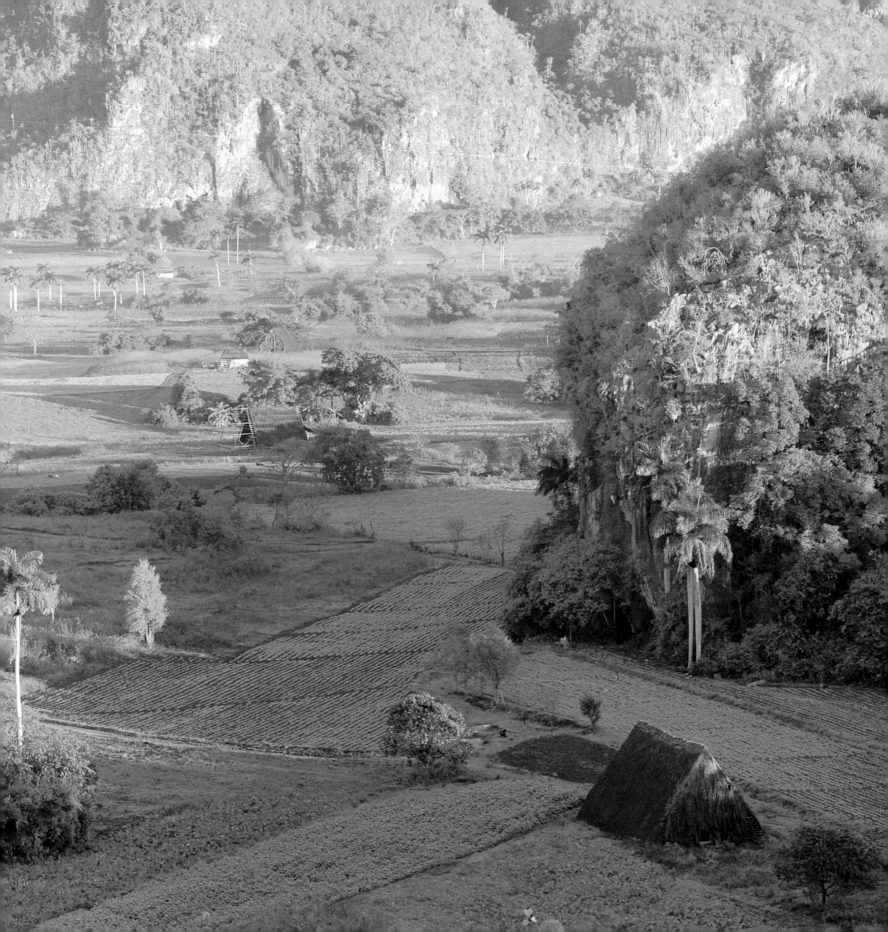

OPPOSITE *In remote Baracoa, a thick grove of coconut palms dwarfs a peasant house*

RIGHT *A row of royal palms marks the border of a sugar plantation*

BELOW *In the western province of Pinar del Río, A-frame huts fashioned from palm fronds are used to store harvested crops*

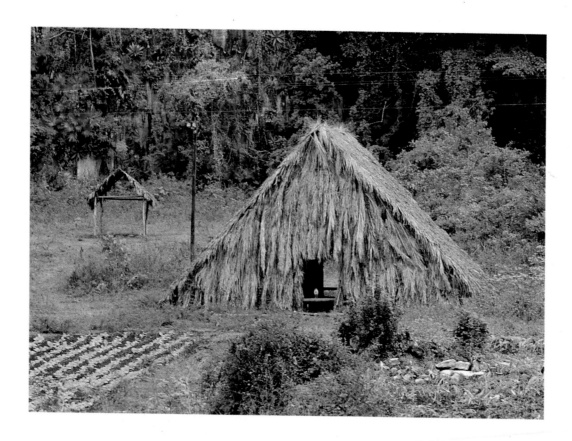

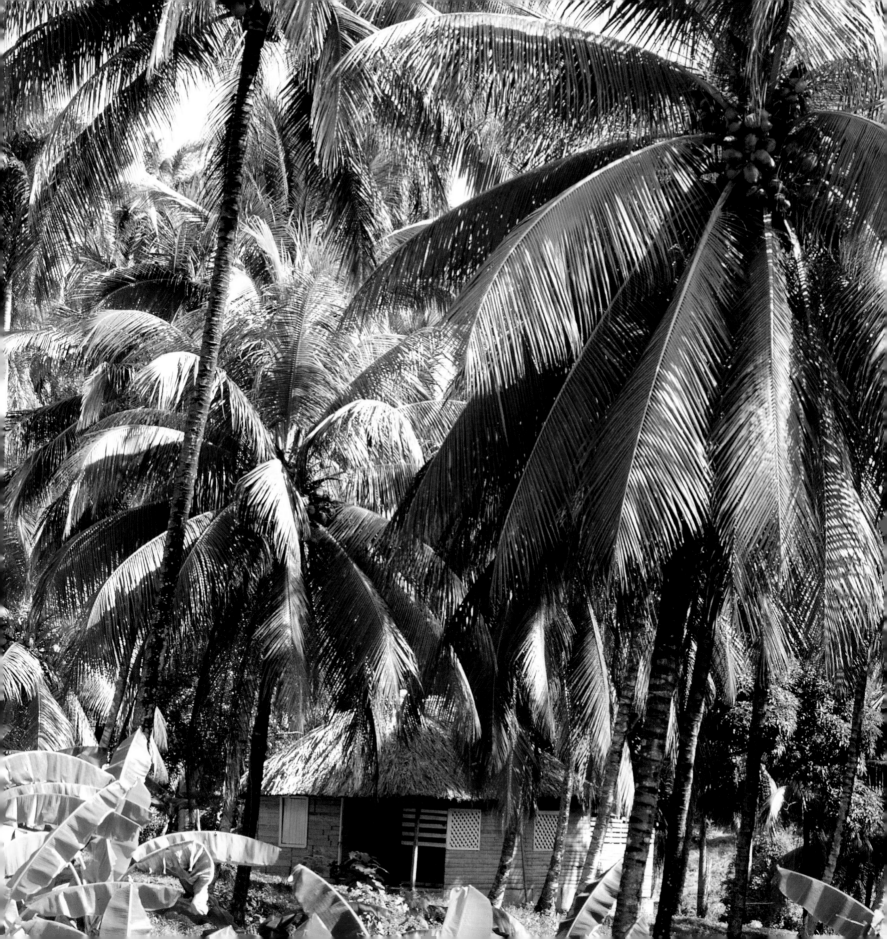

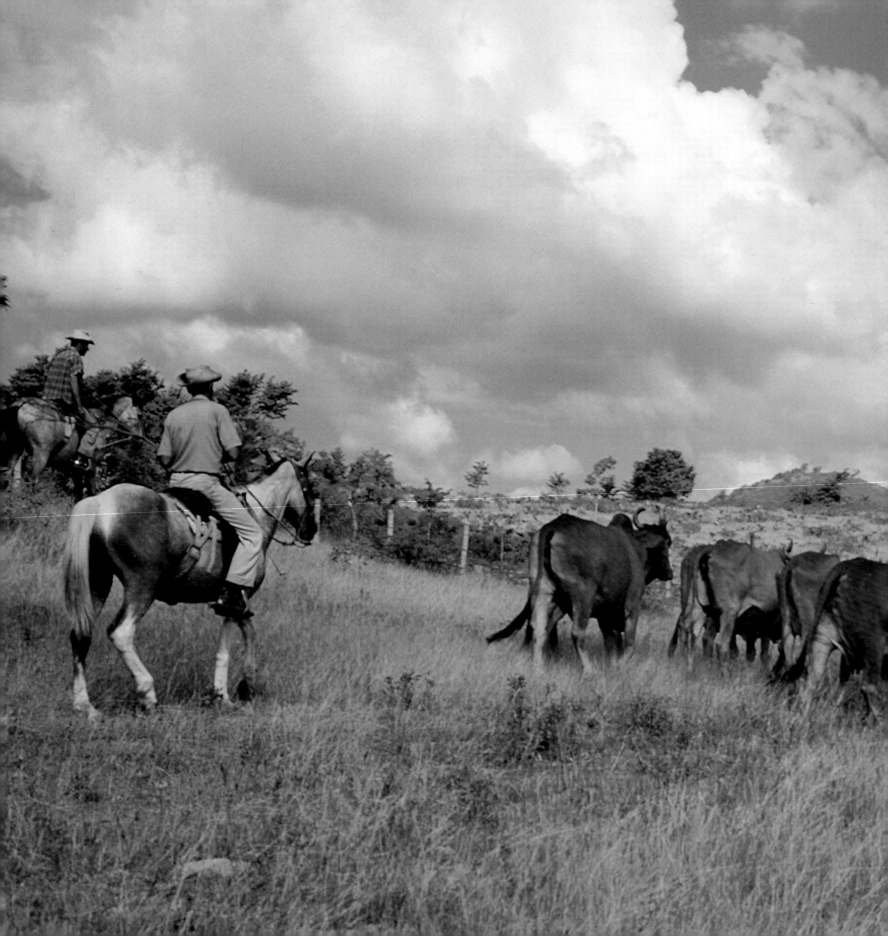

OPPOSITE *The flat plains of Camagüey province have long been used for the raising of beef cattle. The cowboys, or* vaqueros, *who work the land are known for their independent spirit*

BELOW RIGHT *In a pond coloured by the red, lime-rich soil of Pinar del Río, a lone farmer washes his horse*

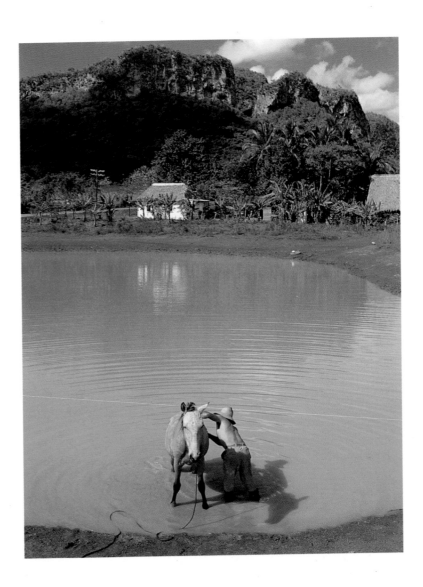

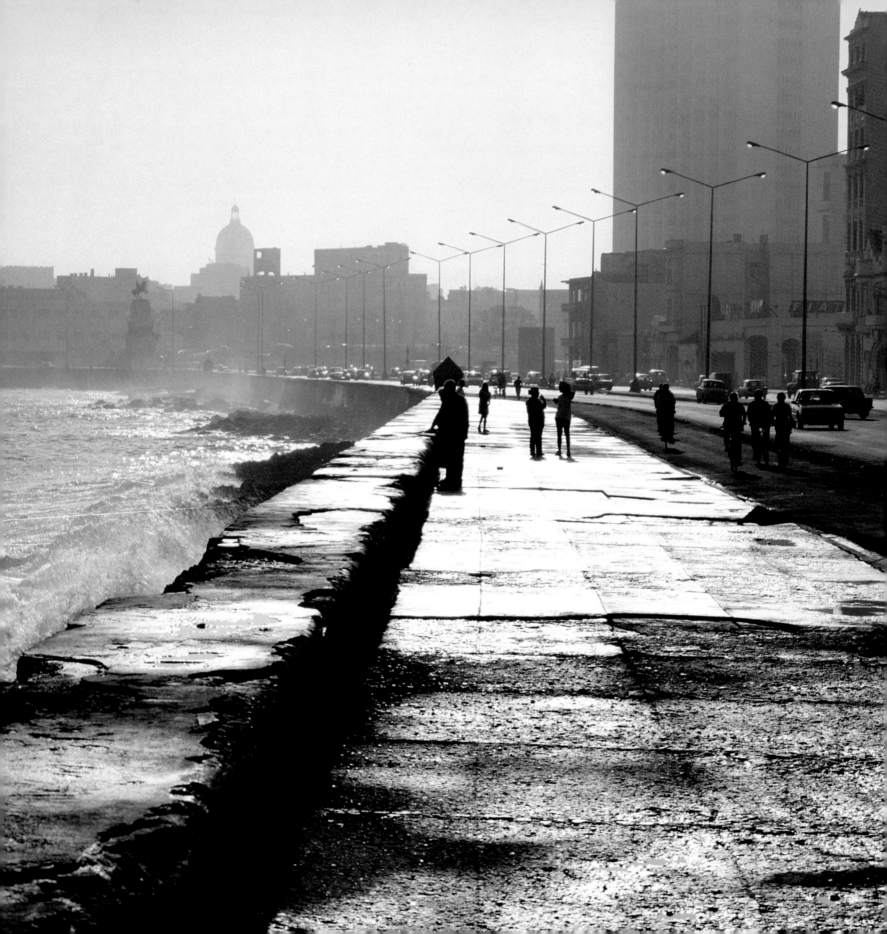

HAVANA

A city that seduces with its sparkling harbour, its vibrant street life, and a rich architectural legacy all but untouched by four centuries of life as Cuba's capital

AN AGELESS SPIRIT

Crumbling, decaying, yet with a character that defies the ageing process, Havana is Cuba's evocative capital. Unlike other Caribbean capitals which developed into little more than large provincial towns, Havana has from its very beginnings projected a sophisticated urban face, with an unrivalled architectural legacy spanning the major styles of the past five centuries, from colonial to Baroque, Neoclassical, Art Nouveau and Modern.

At the heart of the city's allure is Old Havana, from which the rest of the city developed. It became the Cuban capital in 1607, after Diego Velázquez had worked his way around the island establishing the key cities that would serve as Spanish outposts. All Spanish ships heading to the New World, or returning home with cargo-loads of treasure, stopped in the Cuban capital to rest and replenish supplies. A seamy quarter of bars and brothels developed to cater to passing crews, but gradually a wealthy class of colonials also began to make their mark, turning sections of the city into reminders of Spain.

They built grand civic structures and mansions of stone, with deep, colonnaded arcades and neat balconies. They lined their floors with terracotta tiles, and furnished them with the dark tones of mahogany. Gradually their buildings incorporated characteristically Cuban features – brilliant stained-glass panels above windows and doors,

OPPOSITE, LEFT *An air of gracious decay pervades the narrow streets of the old quarter. The colours have faded from the grand town houses and their facades are worn, but each has retained its distinguishing features, whether in the pattern of a balcony railing, or the silhouette of an iron lamp*

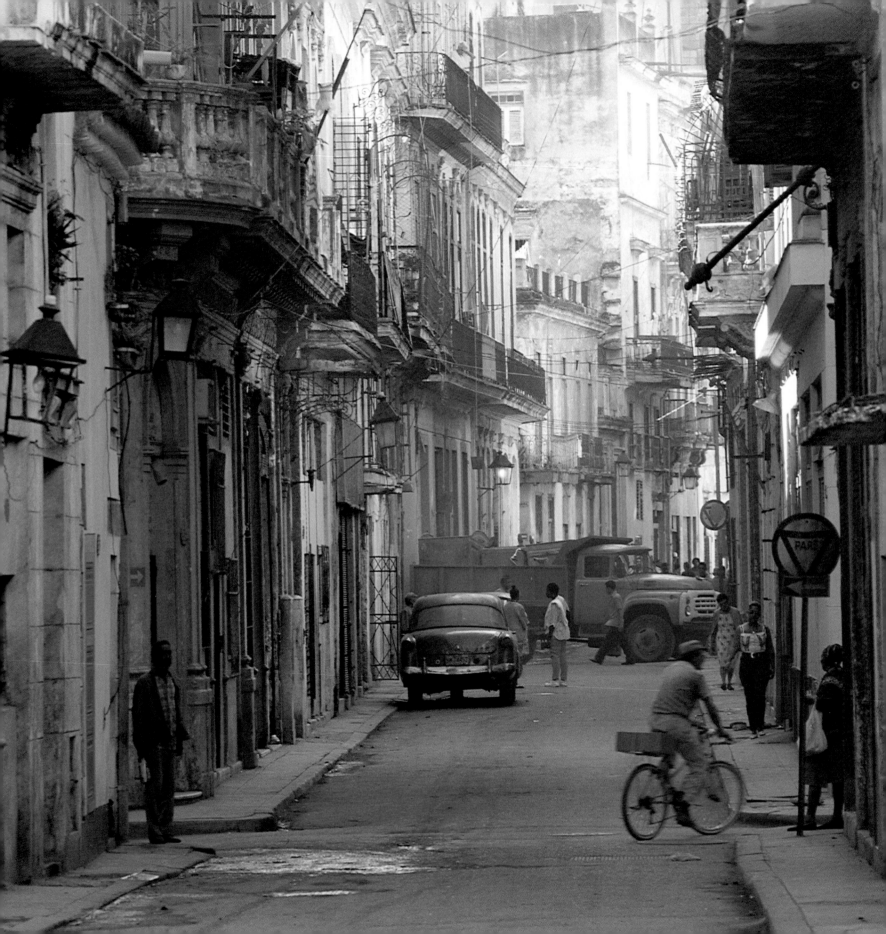

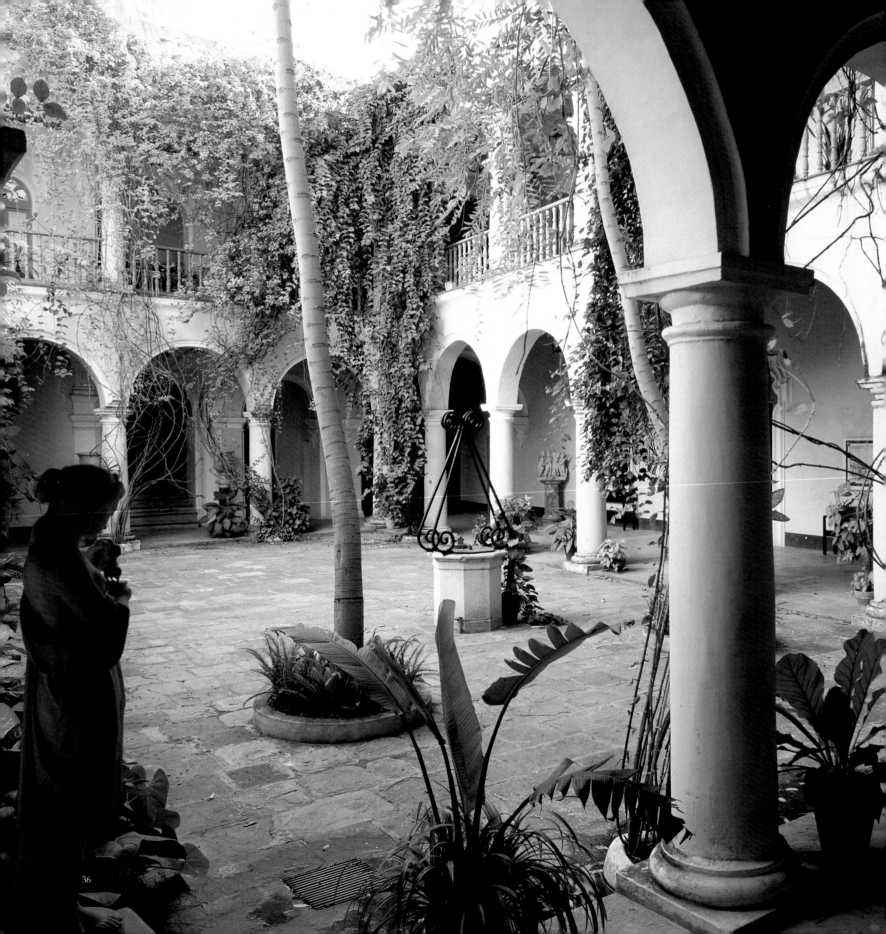

lofty beamed ceilings, known as *alfarjes*, and facades embellished with decorative ironwork. In their courtyards a profusion of tropical trees and flowering plants thrived in the moist climate.

Like all tropical cities, Havana is at the mercy of the elements – salt, storms and sun. A lack of resources due to tough times has hastened the pace of decay, with many of the older buildings dilapidated and frayed. Though corroding, much of the capital's splendour remains.

Narrow atmospheric lanes run in straight lines through the midst of Old Havana, offering up a mix of old merchants' premises, handsome faded exteriors and restored palaces. Darting off to either side for as far as the eye can see are seemingly endless lines of terraced houses washed in pastel colours, their sagging balconies overhanging the dusty cobbled streets below. Now and again, a grand seventeenth-century mansion, a magnificent church, or a leafy plaza edged with gracious town houses comes into view. With their colonnades and balconies providing shade from the sun, their red tiled roofs, lush interior courtyards and combination of Moorish and European features, they capture the essential style of colonial Havana.

OPPOSITE, ABOVE RIGHT *The Casa de la Obra Pia was, at its construction in the early 1600s, one of the most beautiful homes on the island. Built in the Spanish style, it features an arcaded gallery looking over an inner courtyard. Typically Cuban though is the jungle-like foliage which adds a distinctly tropical air*

RIGHT *After it was expanded in the late 1700s the house acquired refined period furnishings, most imported from Europe. Chairs and sofas were adapted to the heat, with cooling wicker used in place of tapestry or silk upholstery*

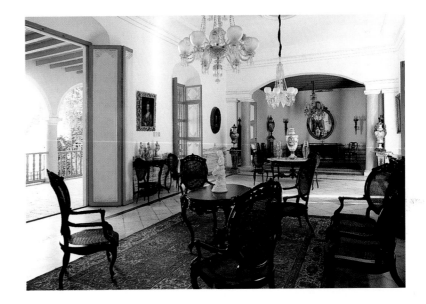

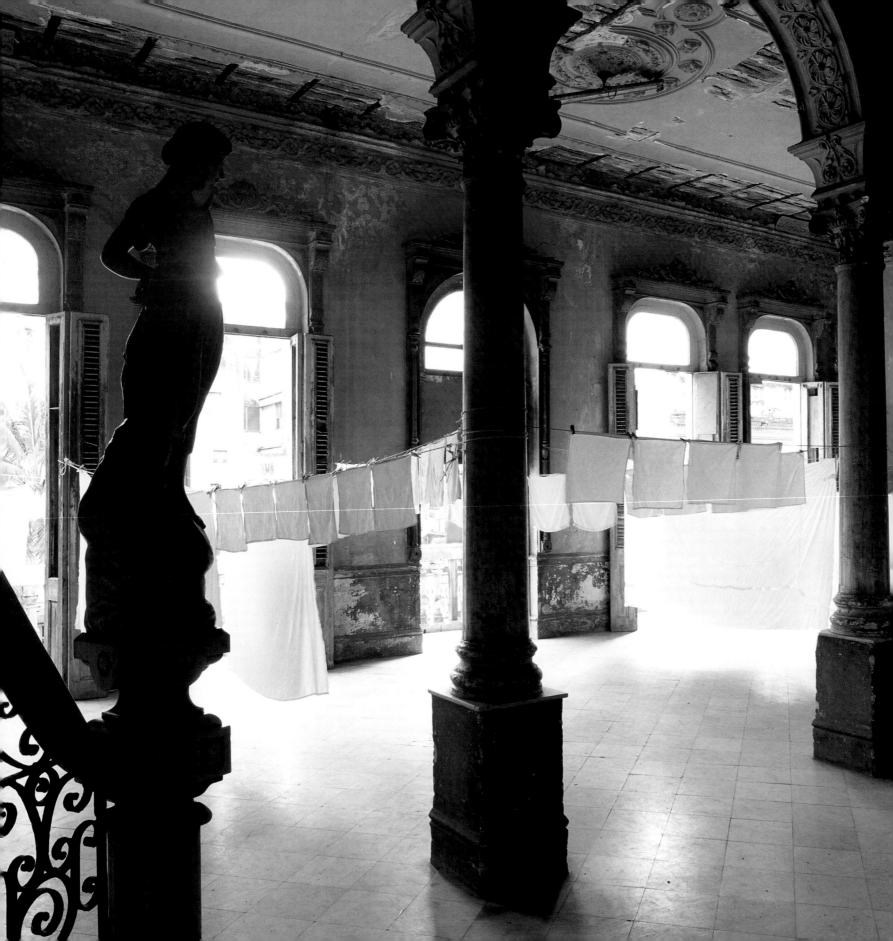

OPPOSITE, BELOW *The masonry may be chipped and the paintwork mottled, but little can detract from the atmospheric beauty of Havana's grand architecture. Although this structure dates from the turn of the century, its patina, scale and colours echo those of the now-faded colonial terraces of centuries earlier. Originally designed as a clinic, the building is now divided into apartments, a sweeping marble staircase connecting each level*

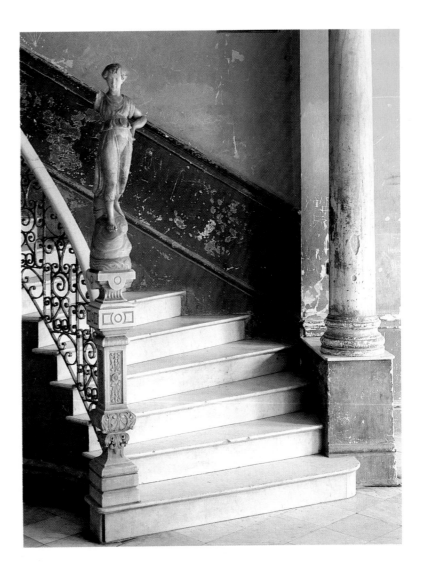

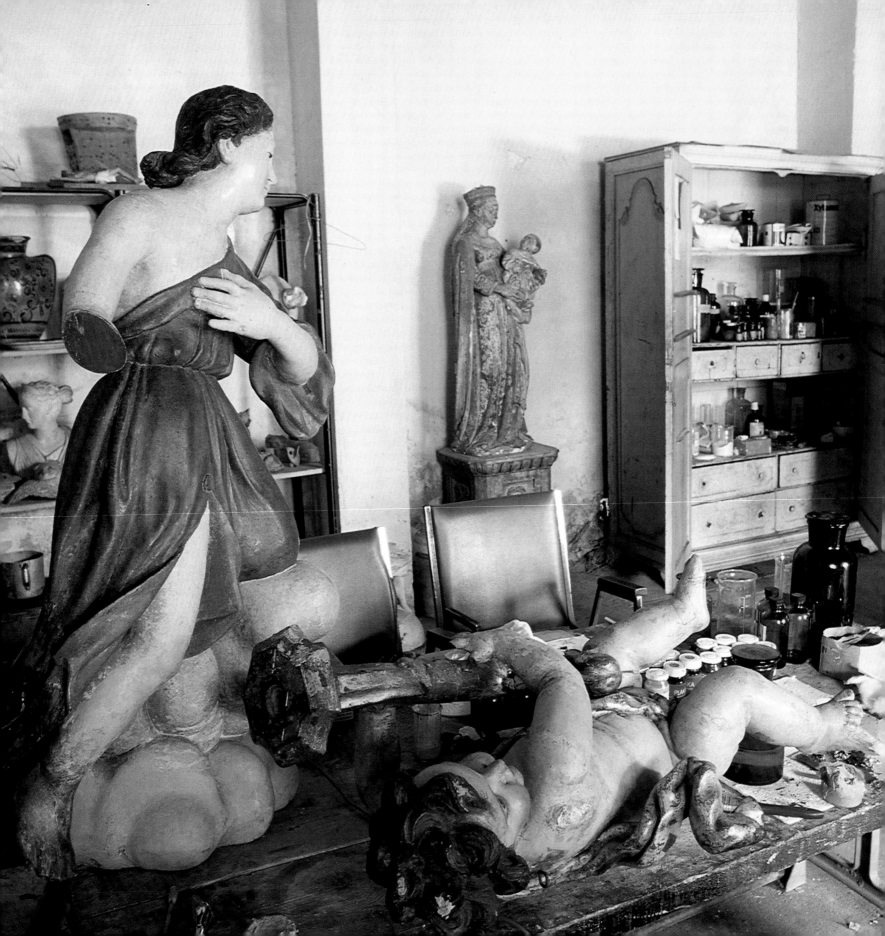

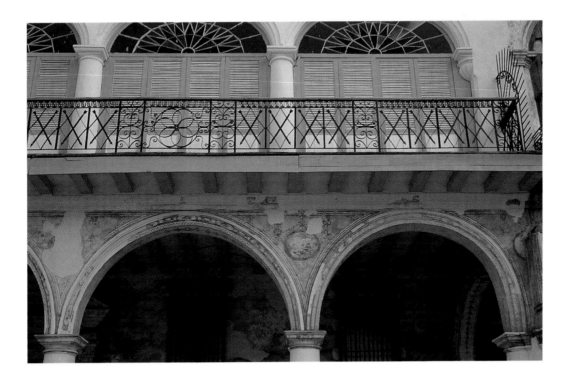

OPPOSITE *Santa Clara, Havana's oldest convent, was founded in 1638, and eventually expanded to cover four city blocks. Now the convent houses laboratories and workrooms used for much of the restoration underway in the old quarter*

ABOVE, BELOW LEFT *One of the few palaces in Cuba featuring exterior frescoes*

BELOW RIGHT *These 18th-century walls are covered with faded scenes depicting an exotic Havana, perhaps more imaginary than real*

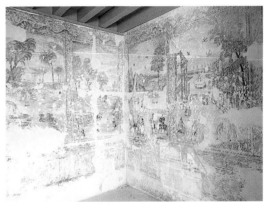

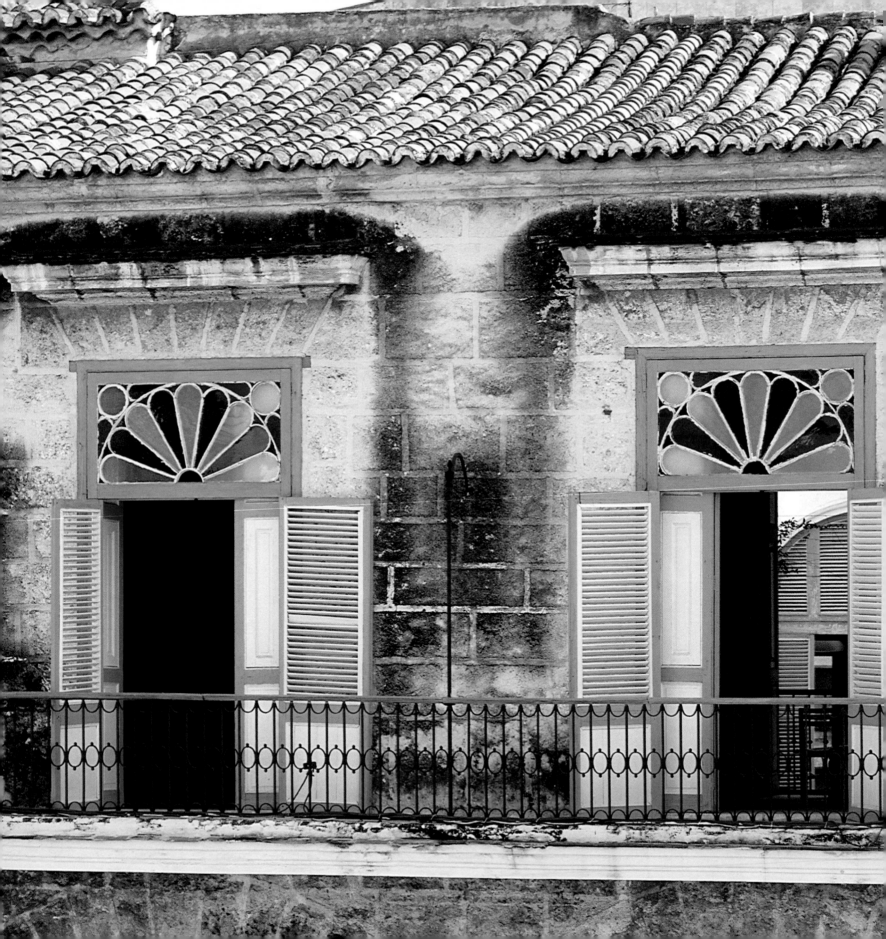

CARIBBEAN BLUE

The houses of Old Havana are washed with many shades of the Caribbean, but one hue stands out from the others – the azure blue of the ocean and the tropical sky. Interpreted in myriad ways both in interiors and facades, blue is the colour of colonial Havana, the perfect partner for exteriors in austere grey stone and smooth white plaster, or the daffodil yellow that coats so many buildings in the old city.

Blue is used to edge louvred shutters, to define balcony railings, and to frame doors and windows. It is ever-present in the vivid panels of stained glass that soften the glare of the equatorial light, casting jewel-like shadows against interior walls.

Inside too, blue decorates lofty *alfarje* ceilings, softening the bright white walls and calling to mind the tranquil Cuban sky. It highlights balustrades and timber beams in courtyards and patios, providing a cooling counterpoint to the summer heat.

OPPOSITE, RIGHT
Stylistic elements that define the buildings of Old Havana – white louvred shutters trimmed with blue, semicircular window panels inset with coloured glass, and wrought-iron railings

ABOVE RIGHT *A synthesis of colonial Cuban colour – stark white, pale yellow and brilliant blue*

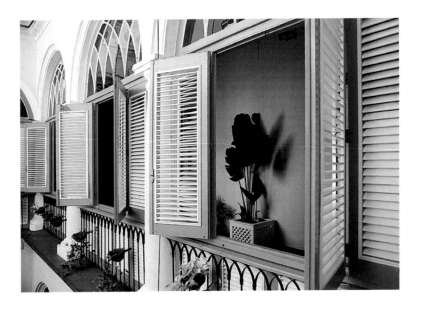

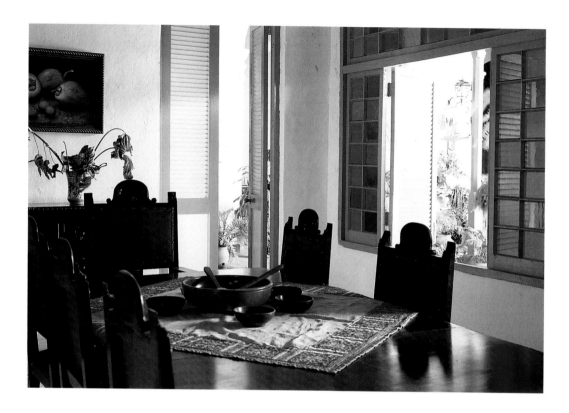

OPPOSITE, BELOW LEFT AND RIGHT *This simple residence was built in the 19th century in the colonial style. A deep veranda runs the perimeter of the courtyard, with trees and plants creating a shady oasis*

ABOVE *The blue trim applied to door and window frames, as well as to wooden surfaces outdoors, is echoed in alternating panes of glass in a deeper shade of blue paired with ruby red – a device used throughout the house*

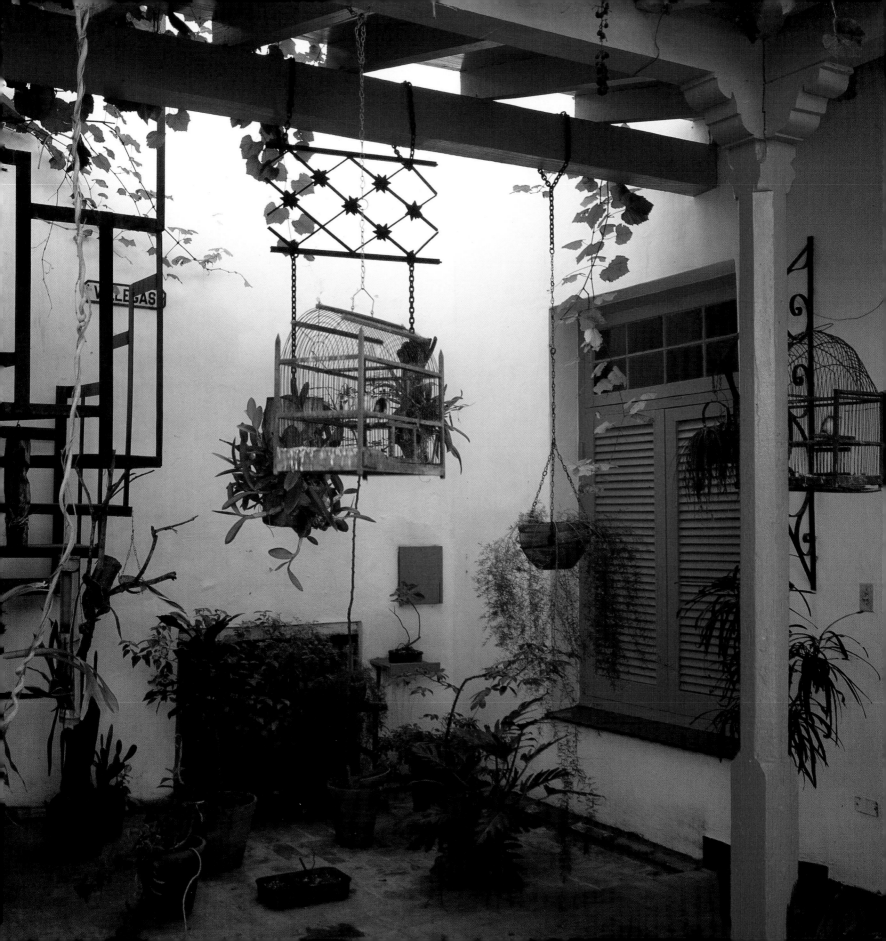

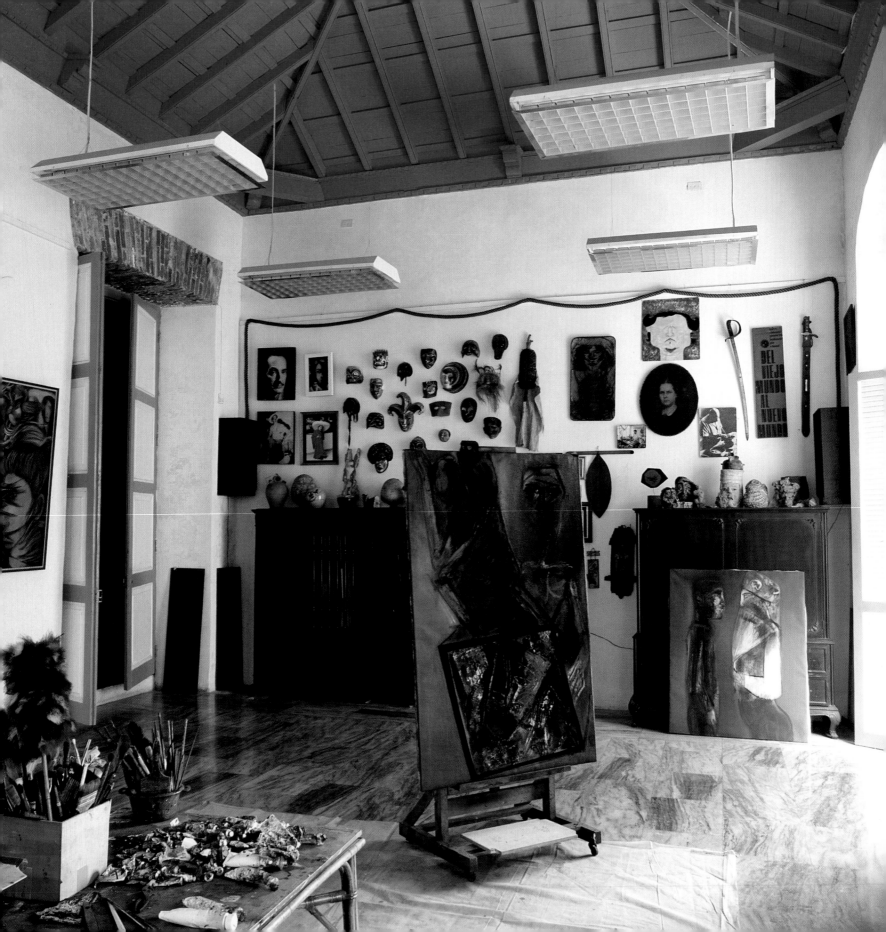

OPPOSITE *Nelson Domínguez, one of Cuba's most respected modern painters, works from a studio in an early colonial house. Louvred shutters allow the artist to adjust the light for ideal working conditions*

BELOW, ABOVE RIGHT, BELOW RIGHT *Saved from demolition in the 1970s, this house dates from the 1600s. Typically, the pitched ceilings, tiled floors and shuttered balconies are designed to keep the house cool*

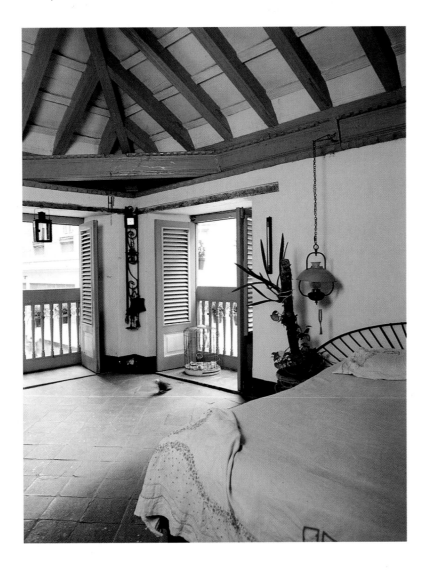

DIVINE INSPIRATION

Like the other capitals of Spain's colonial possessions in the Americas, Havana became a centre for the Catholic religion – a role that was to be reflected particularly in architecture. The beginnings of the city's Christian experience are enshrined in the Iglesia del Espíritu Santo, Havana's oldest church, constructed in 1638. Also begun the same year was the convent and church of Santa Clara, both in the Spanish style, but with cloisters filled with the tropical greenery of the Caribbean.

It was not until construction of the Cathedral of Havana that a distinctive Cuban look came to the architecture of religion. Building was begun by the Jesuits in 1748 but completed thirty years later after the order was expelled from Cuba.

A fine example of the local Baroque style, the Cathedral is worn, but much of its swirling facade is still intact. Its ornate exterior is more than matched by the elaborate interior of the Iglesia de la Merced, dating from the same period.

This new penchant for ornamentation and exuberant decoration is echoed over a century later in the marble mausoleums of the beautiful Columbus Cemetery.

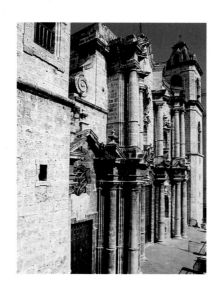

OPPOSITE *The Columbus Cemetery is designed according to medieval tenets as a series of crosses, dividing the dead by their social position and wealth. Completed in the 1870s after the city catacombs became full, its lavish tombs, chapels and statuary reflect the eclectic architectural mix of Havana itself*

LEFT *In Cuba's Early Baroque style, the imposing Havana Cathedral boasts an exuberant scrolled facade and twin belltower. The cathedral is said to have housed the bones of Christopher Columbus until the time of Cuba's independence from Spain*

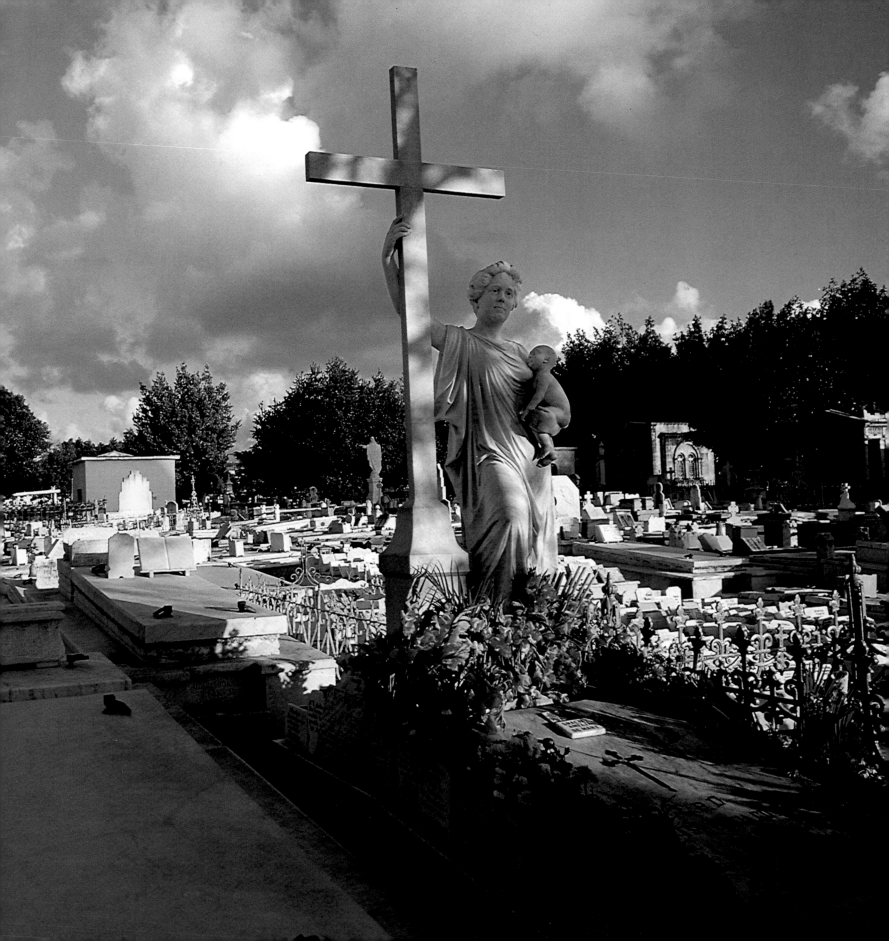

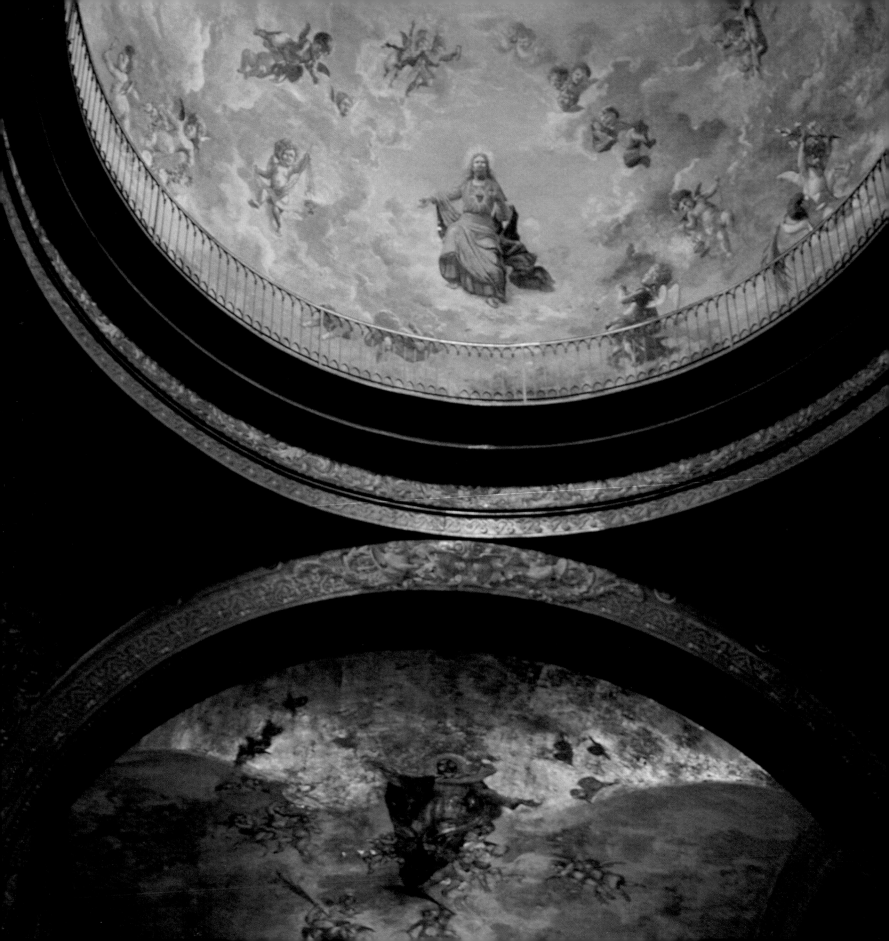

OPPOSITE, BELOW *One of the church's finest features, a high vaulted ceiling covered with magnificent tromp l'oeil murals*

RIGHT *The cloisters adjoining the Iglesia de la Merced offer a quiet place for contemplation*

BELOW RIGHT *The church is dedicated to the Virgin of Merced, a Catholic incarnation of the African god Obatalá, attracting followers of Santeria, the Afro-Cuban religion*

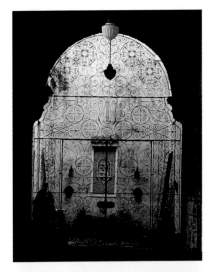

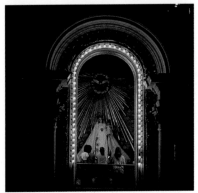

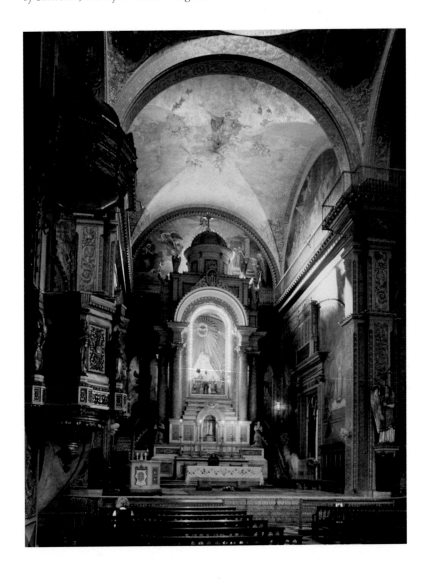

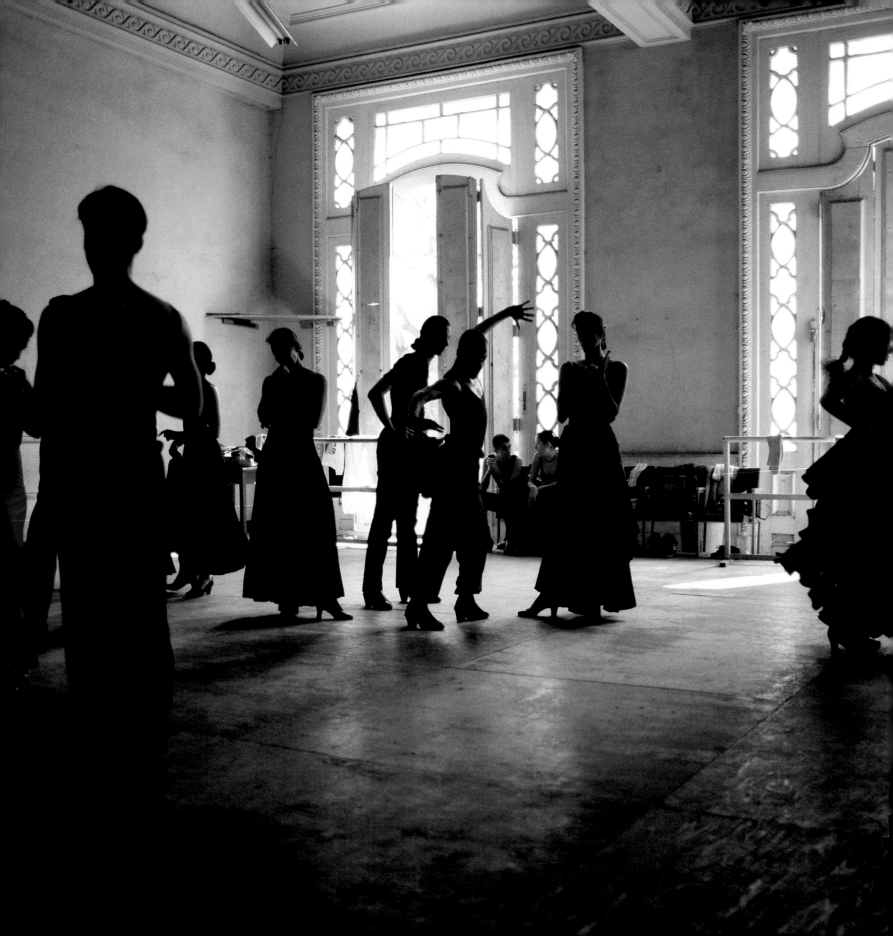

THEATRICAL GRANDEUR

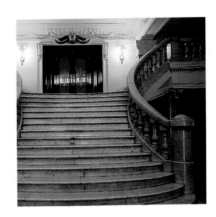

With its angel-topped turrets recalling the minarets of the Arabic world and its ornately scrolled facade, the Gran Teatro is a Neo-Baroque fantasy for the performing arts. First commissioned in 1837 as the Teatro Tacon, the original building was bought by the Spanish Galician community in the early 1900s and transformed into both a theatre and cultural institute within a single extravagant structure, a mix of Baroque, Art Nouveau and Neoclassical features. Today the theatre is the home of Alicia Alonso's Ballet Nacional de Cuba.

The Gran Teatro is one of the crowning architectural achievements of Havana's age of luxury, the years of the nineteenth and early twentieth centuries when the city was considered the most exotic in the Americas. Unlike the Early Baroque style that blossomed in Old Havana more than a century earlier with its solid proportions, the expressive style of the theatre represents a new strain of self-confident Cuban architecture.

OPPOSITE *Cuban dancers practise flamenco steps in the rehearsal rooms of the Gran Teatro*

RIGHT, ABOVE RIGHT *The ornate style of the theatre's facade continues inside, with a foyer dominated by the sweeping organic curves of the Art Nouveau movement*

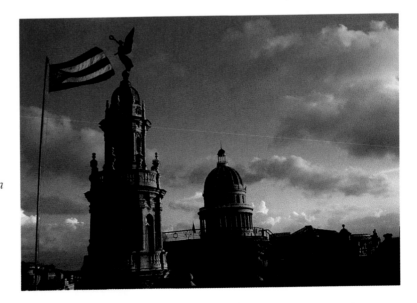

RIGHT *At the time of its construction at the turn of the century, the Gran Teatro was the showpiece of the Prado, the elegant tree-lined boulevard that runs west of Old Havana, marking a new phase in the city's development. Although later overshadowed by the towering Neoclassical Capitolio constructed in the 1920s, the theatre still holds its own – its lithe, graceful lines emphasized by the disciplined mass of its neighbour*

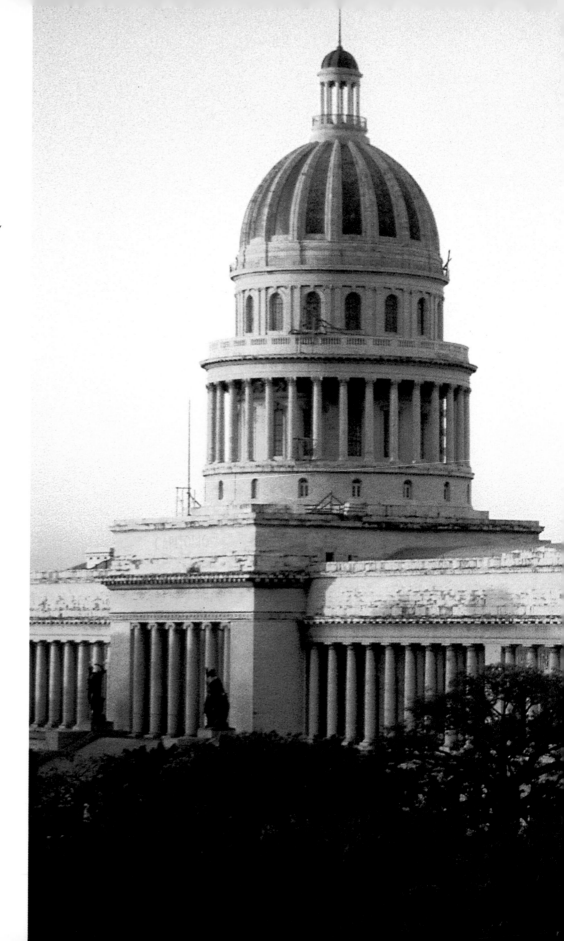

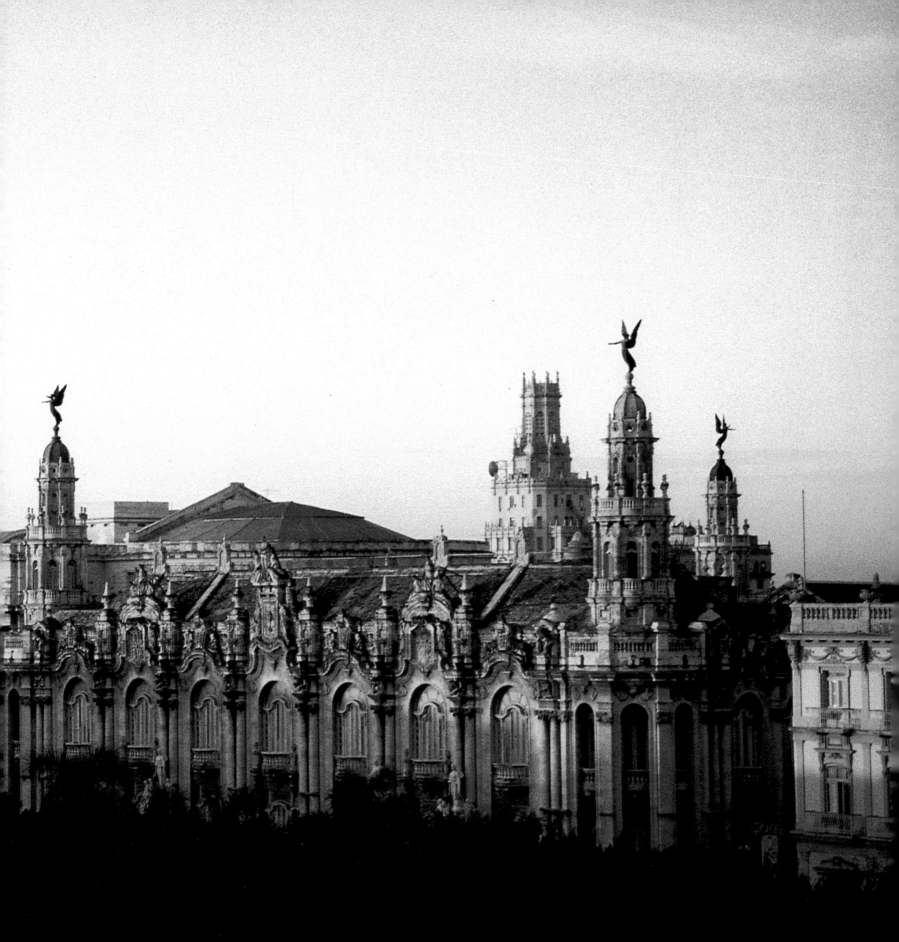

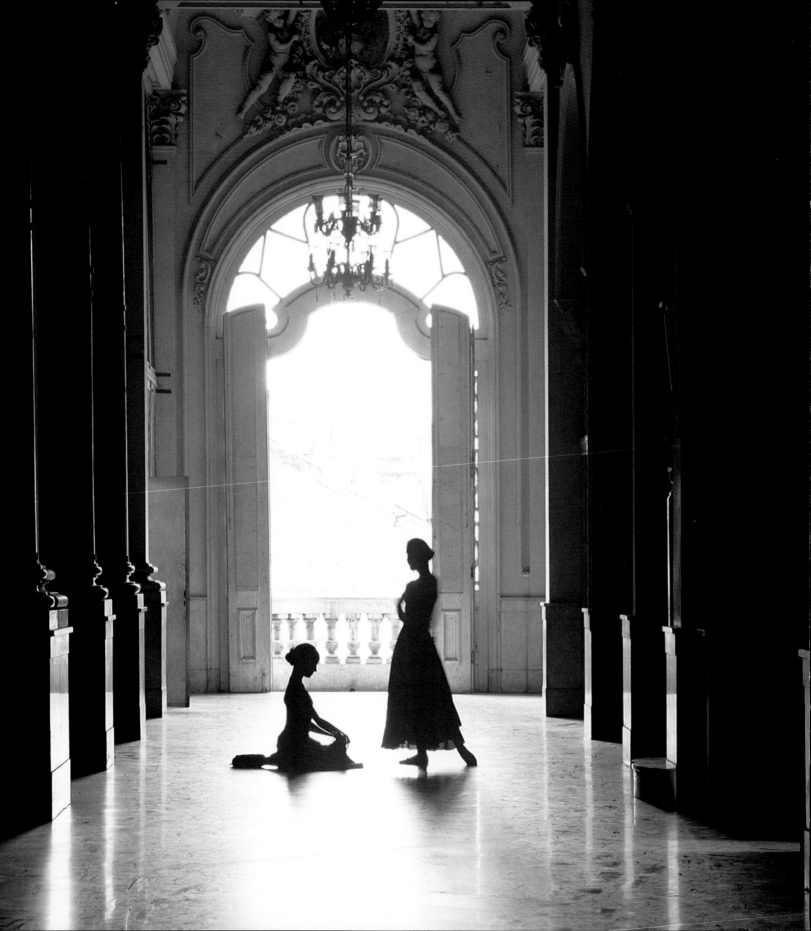

OPPOSITE *The light, delicate style of the Art Nouveau is expressed in details throughout the theatre. Here that style is interpreted in flowing forms above a doorway onto a balcony overlooking the Prado, the perfect backdrop for ballerinas in rehearsal, and for the imposing corridor of Neoclassical marble columns*

BELOW, RIGHT *Art Nouveau and Baroque meet in the theatre's sumptuous foyer to create a look that would be equally at home in the palaces of Austria. Rising high above a hexagonal-shaped gallery are twin columns of purple threaded marble, supporting a parapet of ornate statuary. The pastel tones imbue the dramatic interior structure with a deliberate daintiness*

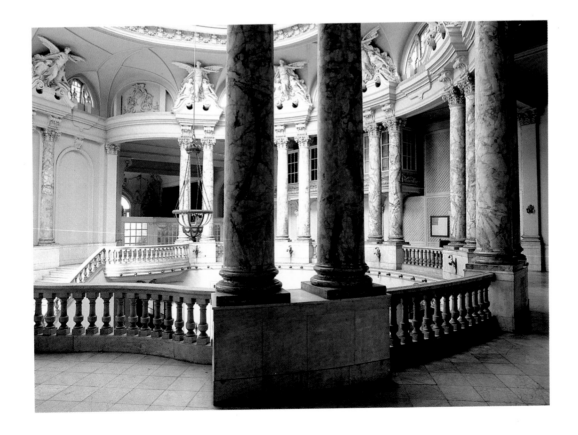

THE AGE OF ELEGANCE

Sometime in the late eighteenth century, Old Havana burst the city walls that had defined it for two hundred years. Economic gains through the sugar trade had made the capital so prosperous that it inevitably attracted new inhabitants and commercial interests. What developed beyond the colonial walls was not merely an extension of the intimate warren of streets that characterized the old centre, but something new altogether.

It was not just the scale of the new city centre that was different; the architecture was also new, taking its cue from Europe but adapting to local tastes. The vogue for Neoclassical that had touched Europe made its presence felt here, as did the lavish spectacle of the Baroque. Unlike the early Baroque style that had blossomed in Old Havana with its solid proportions, the new strain of architecture boasted finer lines and more ornate decoration. From the turn of the century it was the organic forms of Art Nouveau that infused the city's style.

The focus of the new Havana was a single sweeping boulevard, the Paseo del Prado. Modelled on its namesake in Madrid, it was part of then-Governor Tacon's vision for a city that would

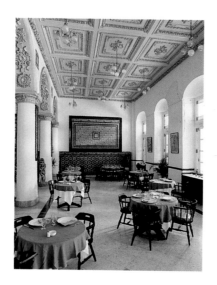

OPPOSITE *The late 19th-century Inglaterra Hotel was built in the Neoclassical style, but its interior is flavoured with the radiant colours and Moorish style of Andalusia. The hotel café and bar is decorated with tiny glazed mosaic tiles and features the bronze cast of a flamenco dancer*

LEFT *The dining room with its panelled ceiling, ornate arches and mosaics was considered the height of Havanan chic, as was the hotel itself. Diva Sarah Bernhardt stayed there in 1887, conducting an infamous affair with Spanish bullfighter Mazzantini*

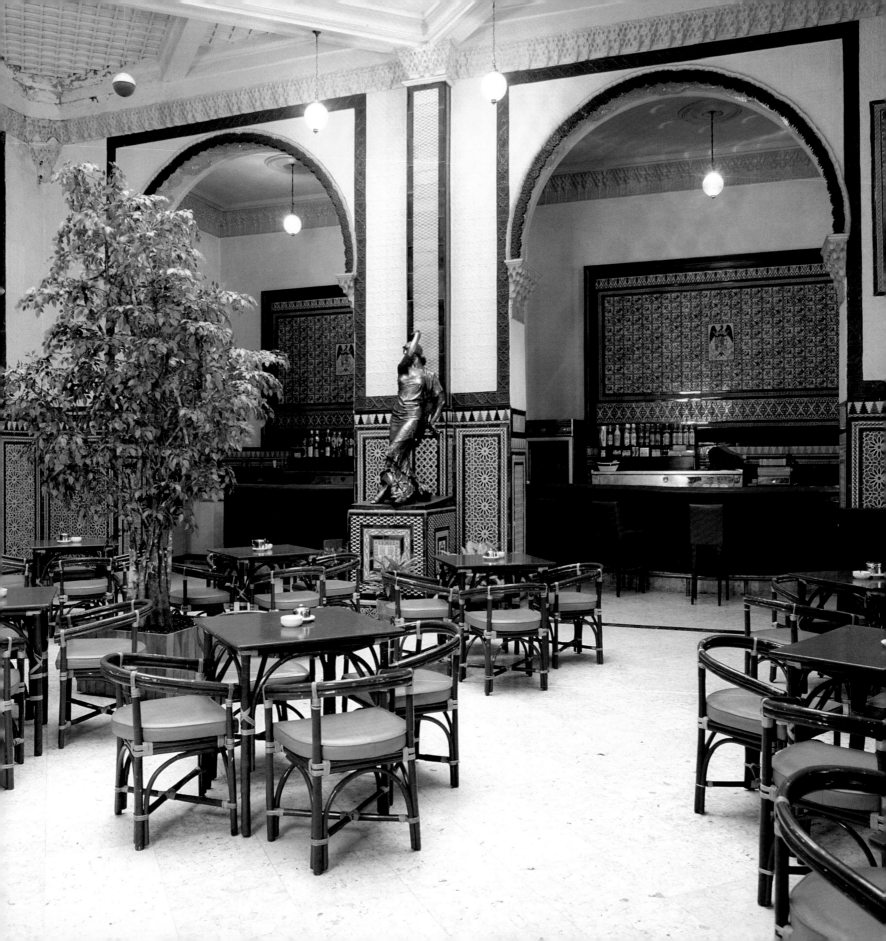

equal the great European capitals. The avenue was laid just out-
side the old city walls, running from the harbourside to a new
square, the Parque Central. Surrounding the palm-filled park are
some of Havana's most lavish architectural achievements.

Facing the park, alongside the fantastical Baroque Gran
Teatro, the Hotel Inglaterra is noted for its grand Neoclassical
exterior and exotic Moorish interior. Constructed in the 1880s, it
was in its time Havana's finest hotel. The rum magnate Bacardi
chose a site nearby for his headquarters, constructed in 1929, a
tiered Art Deco office block that looks distinctly modern amongst
the Neoclassical, Baroque and Art Nouveau styles that dominate
the Prado. Completed the same year was the Capitolio, the polit-
ical headquarters of the new Republic, and a copy of the Capitol
in Washington DC.

Residential mansions also front the Prado, once inhabited
by the cream of society but now mostly converted into flats or
government offices. Their colourful exteriors, often decorated
with lavish plasterwork and Neoclassical columns, still recall the
Prado's heyday.

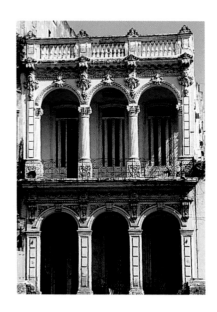

OPPOSITE *The Prado is lined with the former
mansions of rich Havanans. Built in the early
years of the 20th century, the buildings boast a
profusion of ornate flourishes, reflecting the
city's wealth at that time*

ABOVE RIGHT *Typical of the Prado is this
candy pink two-storey townhouse from the turn
of the century, a confection of Neoclassical,
Baroque and Art Nouveau styles*

RIGHT *Much of Havana in the late 19th and
early 20th centuries was modelled on European
tastes. This elaborate, organically formed facade
was built as the entrance to the Palacio Vienna
Hotel in 1906, echoing the Art Nouveau
sensibilities of the Austrian capital*

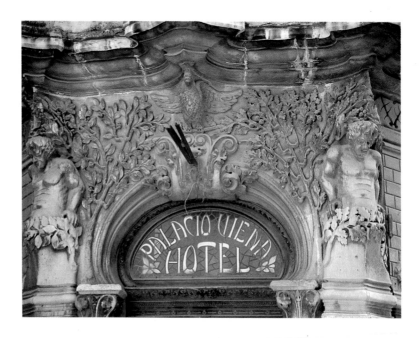

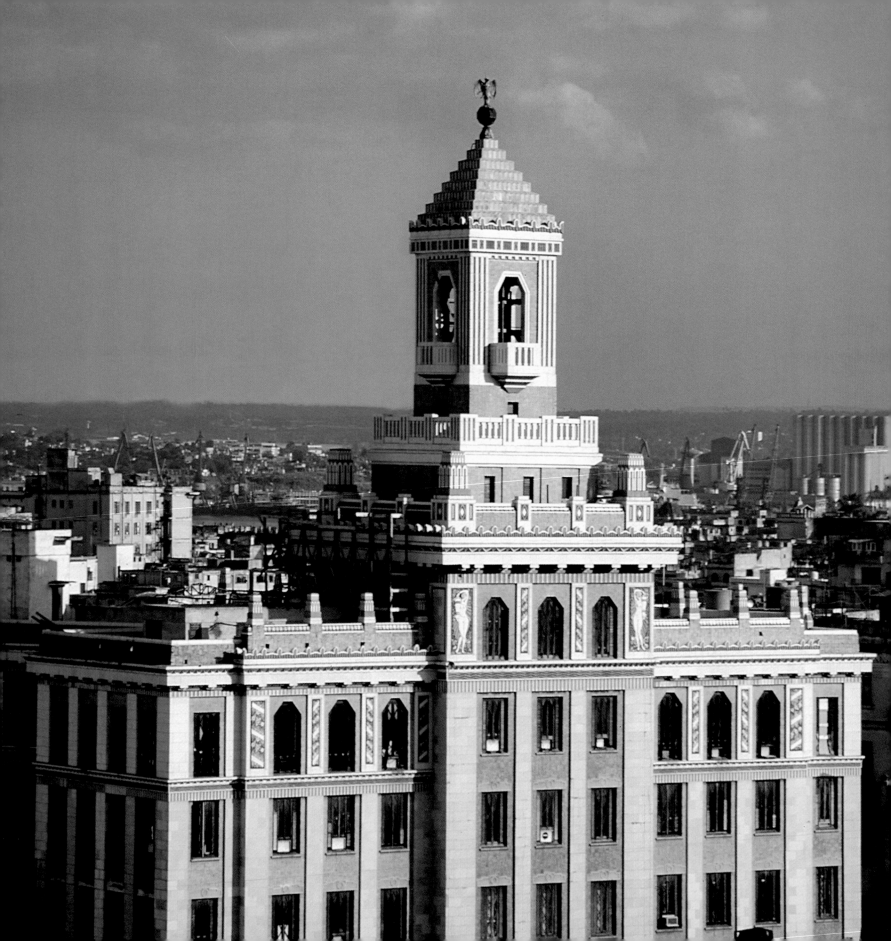

OPPOSITE *The modern lines of Art Deco architecture mark the Bacardi Building, once the headquarters of the rum empire*

RIGHT, BELOW RIGHT *Two exotic apartment blocks display a Moorish influence*

BELOW *Nothing in Havana was exempt from the flamboyant architectural style of the early decades of the 1900s*

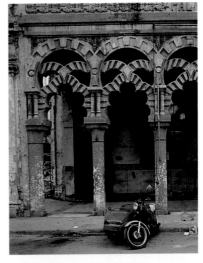

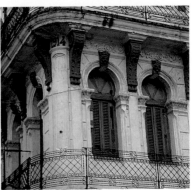

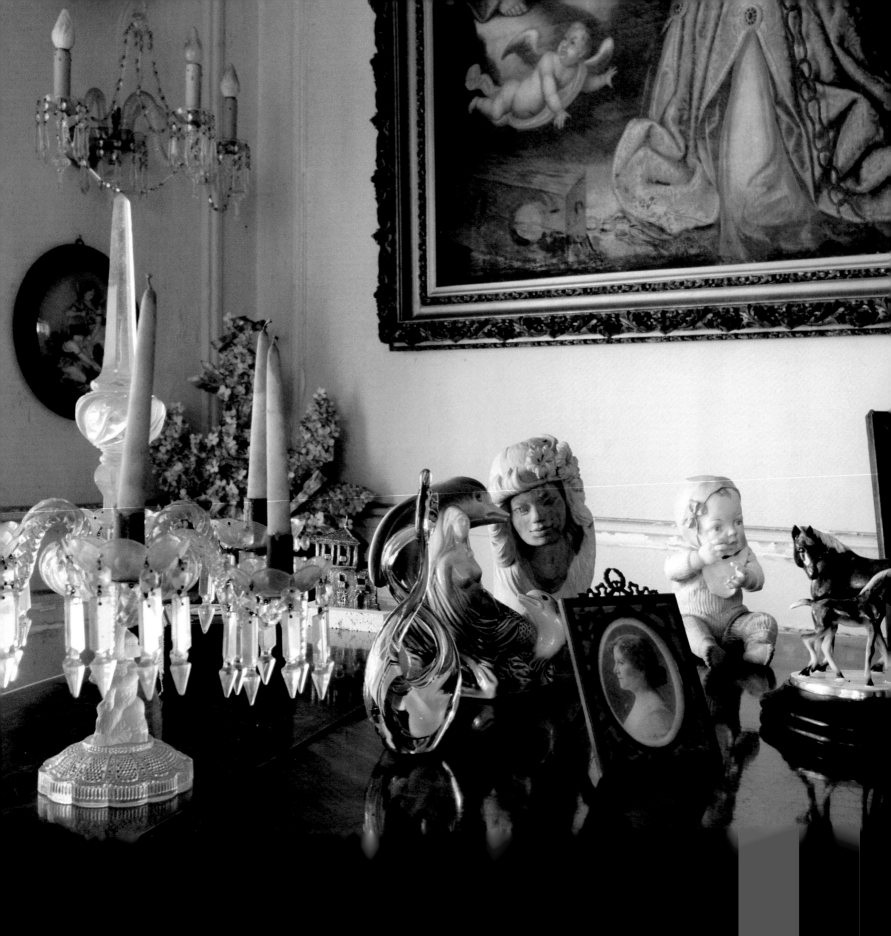

INTERIOR GRACE

In the heart of the Vedado district, amid the grid of numbered streets laid out by city planners at the turn of the century, the Havana of the 1920s is still very much in evidence. As in Europe and North America, it was an age of decadence, romance, and architectural grandeur.

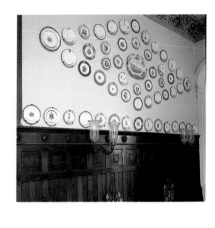

The wealthy residents of Vedado built fine Neoclassical houses with columned porticoes offering a shady vantage point from which to watch the suburban world move slowly by. Inside, their homes featured marble floors, Baccarat chandeliers, furniture from France, and porcelain from Holland and Germany.

As the century passed, European trends brought new ideas and aesthetic principles from which Art Nouveau emerged as the dominant architectural force. Mansions and apartment blocks built in the new style sprang up all over Vedado, and Tiffany lamps and Gallé glass became the new collectors' pieces.

OPPOSITE *On top of a polished grand piano, a crystal candelabra stands alongside memorabilia and glassware spanning several decades*

ABOVE RIGHT, RIGHT *A 1920s mansion is decorated in simple colonial style. Details include a display of family porcelain on the kitchen wall, and chinoiserie below a curving staircase*

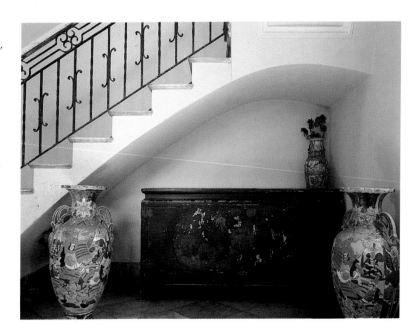

OPPOSITE *Dominating the vestibule of this turn-of-the-century mansion, a bronze eagle forms the centrepiece of a marble fountain*

RIGHT, BELOW RIGHT *Classical statuary and marble columns edge a residential balcony*

BELOW *Elegant furnishings vie for space with collections of porcelain, glass and Spanish fans*

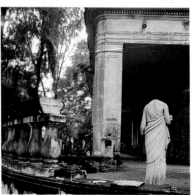

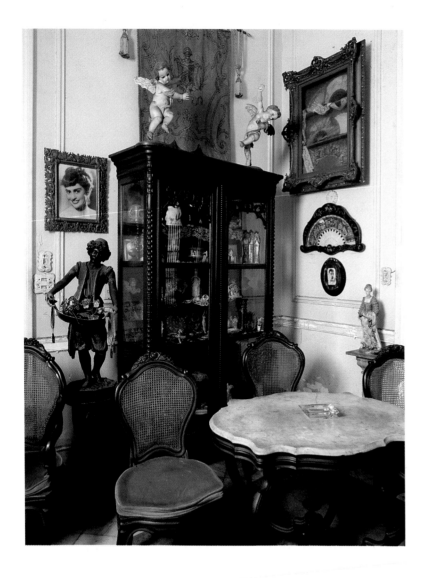

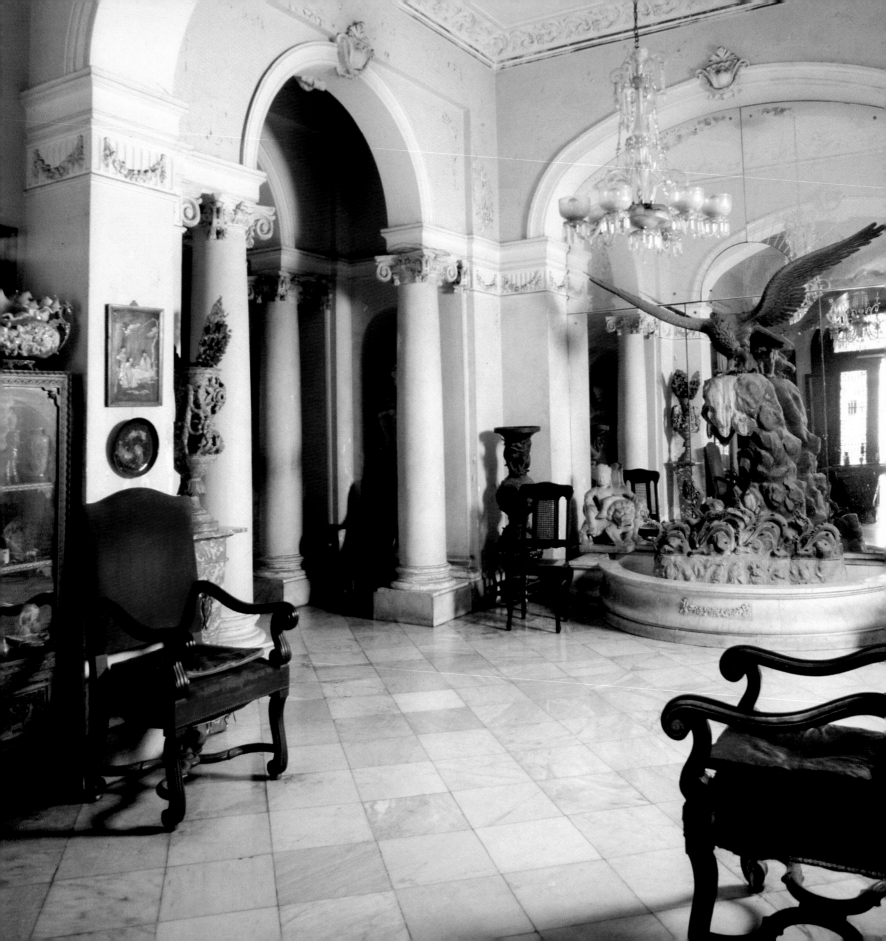

OPPOSITE *A Moorish-inspired apartment*
occupies the top floor of a 1930s building.
Although the interior structure is austere with
its marble floors, rough white walls and dark
timber trim around windows and doors,
light touches provide the perfect balance.
Richly gilded armchairs with intricate backs
upholstered in caramel-coloured velvet add
warmth to the stark style of the apartment

RIGHT, BELOW *The arched windows of*
the front parlour are echoed in the doorways
and iron-framed mirror of the dining room.
Although a private home, it also operates
as a small restaurant, known as a paladar

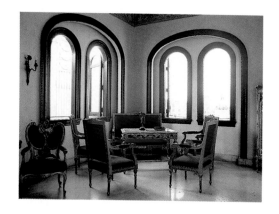

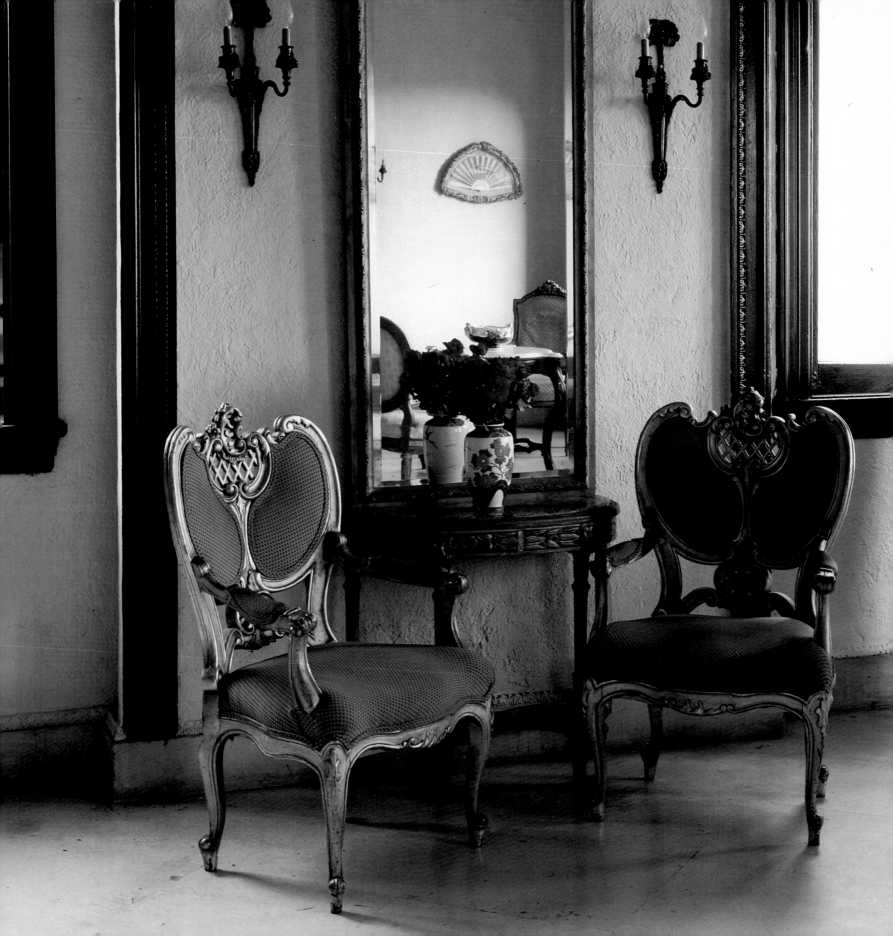

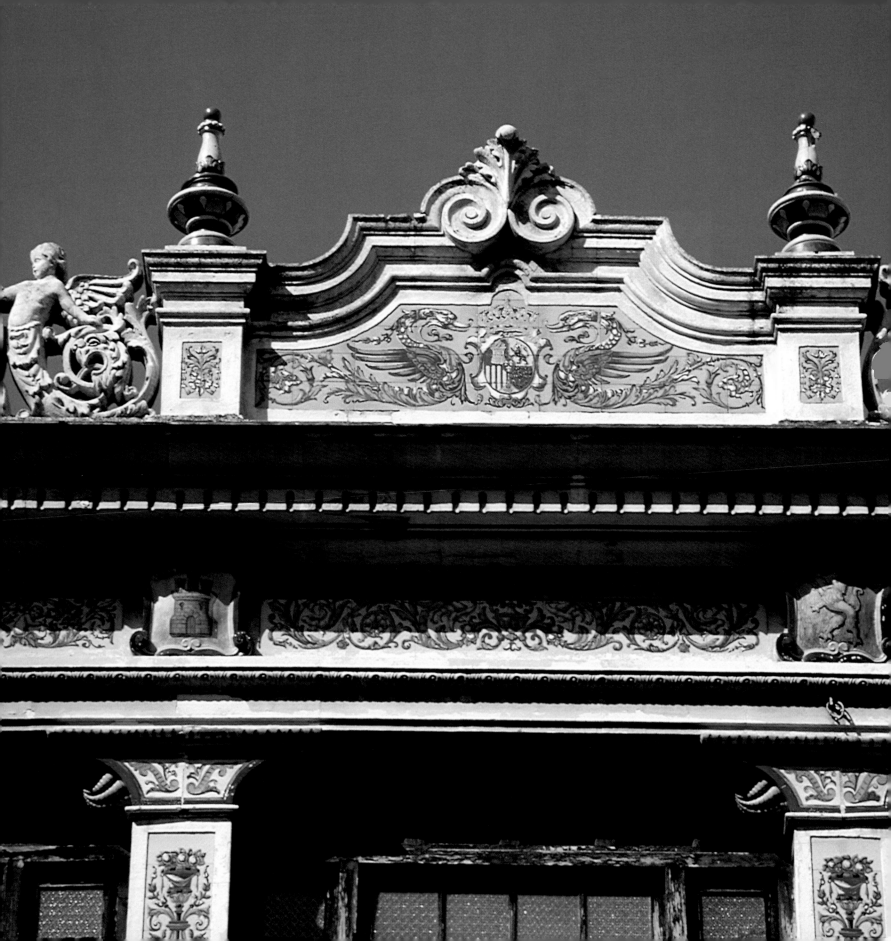

AZULEJOS

From their earliest incarnation in terracotta to later versions in rainbow colours and shiny glazes, *azulejos*, or tiles, are the essential decorative element of Havanan architecture. In Old Havana they make their presence subtly felt in the sober earthenware flooring of colonial mansions and convents. In the buildings of the nineteenth and early twentieth centuries, however, built in keeping with the city's more exuberant dynamic, radiant glazed *azulejos* are an integral part of the new expressionism. They grace not only interior floors and walls, but are also used to clad building exteriors.

As with the *azulejo* tradition that flourished in Portugal, the glazed tiles of Cuba owe much to the Islamic world with its invention of colourful tiles for decorative purposes, and to the Spanish who interpreted the art form with their own patterns and brilliant palette.

OPPOSITE *Tiles of antimony yellow and cobalt blue form swirling crests and floral designs on a Baroque-style facade*

ABOVE RIGHT *An orange pomegranate is the motif for the seat of a garden chair*

RIGHT Azulejos *are applied again to garden furniture, this circular table dating from colonial times*

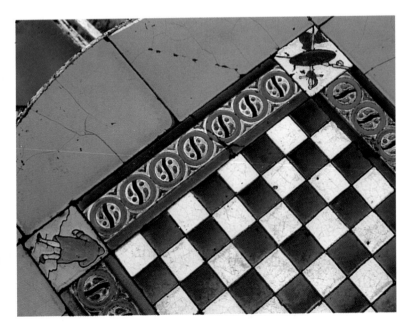

OPPOSITE, BELOW *Arabic and European styles collide in the mixing of figurative tiled panels in the Spanish and Portuguese traditions with graphic Moorish 'stripes' in yellow and cobalt*

TOP RIGHT *The name of the city enshrined in gold, purple and blue glazed* azulejos

BELOW RIGHT *Tiles take on sculptural form in the balustrades of an exterior balcony*

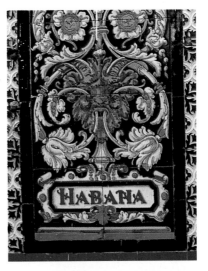

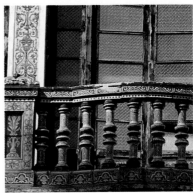

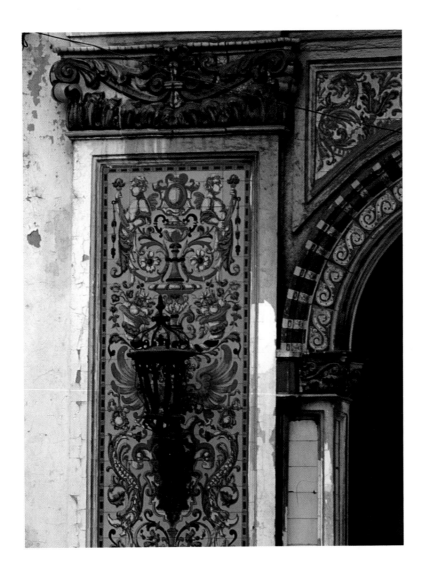

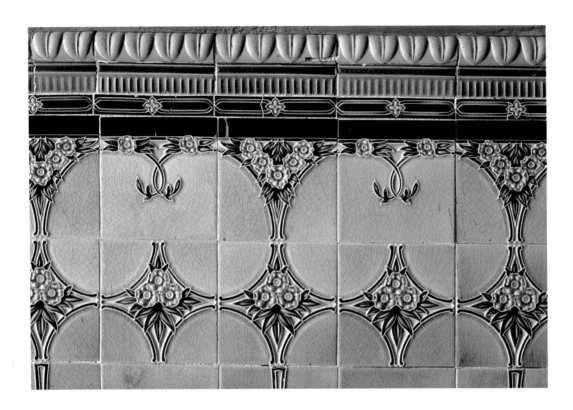

OPPOSITE *Taking pride of place in the hallway of an apartment in Havana, a mosaic fountain in the Moorish style*

ABOVE *Shades of grey-blue and turquoise define a panel of Art Nouveau tiles*

BELOW LEFT *Vibrant twentieth-century tiles with optical impact – a mix of Art Nouveau floral motifs and Art Deco lines*

BELOW RIGHT *The simple white and blue patterned tiles of a colonial kitchen stove*

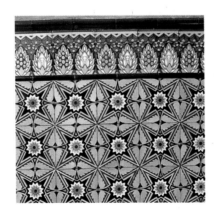

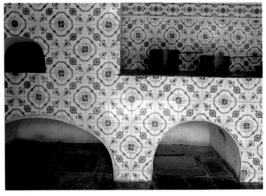

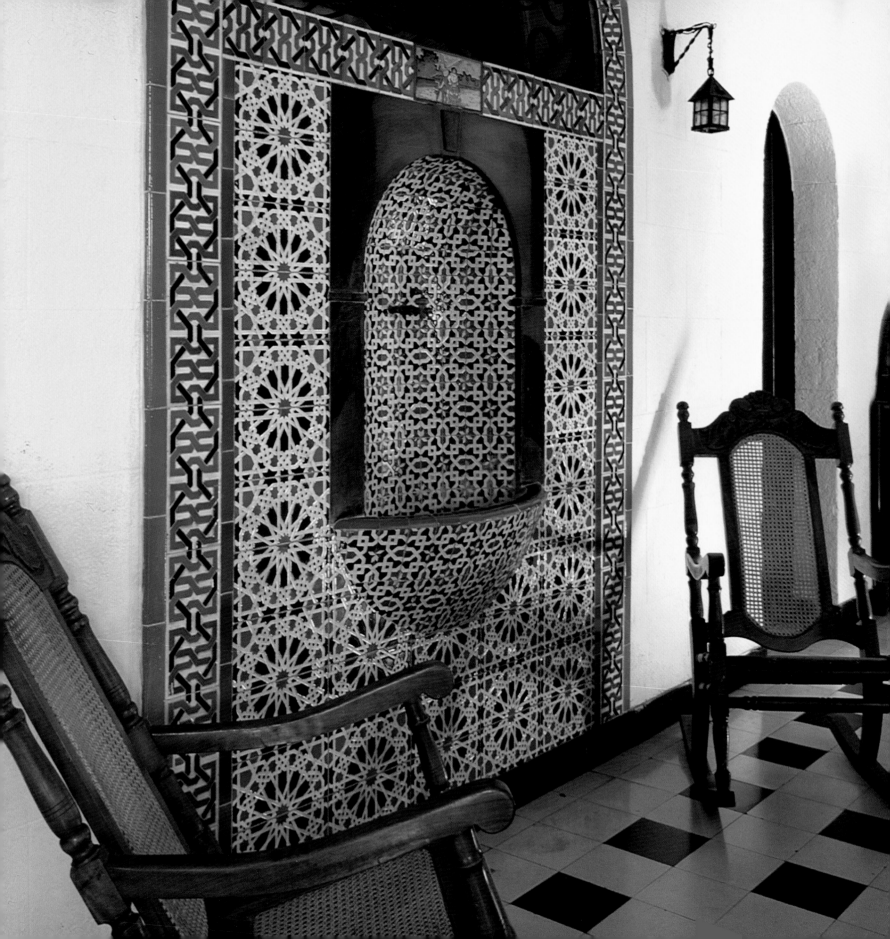

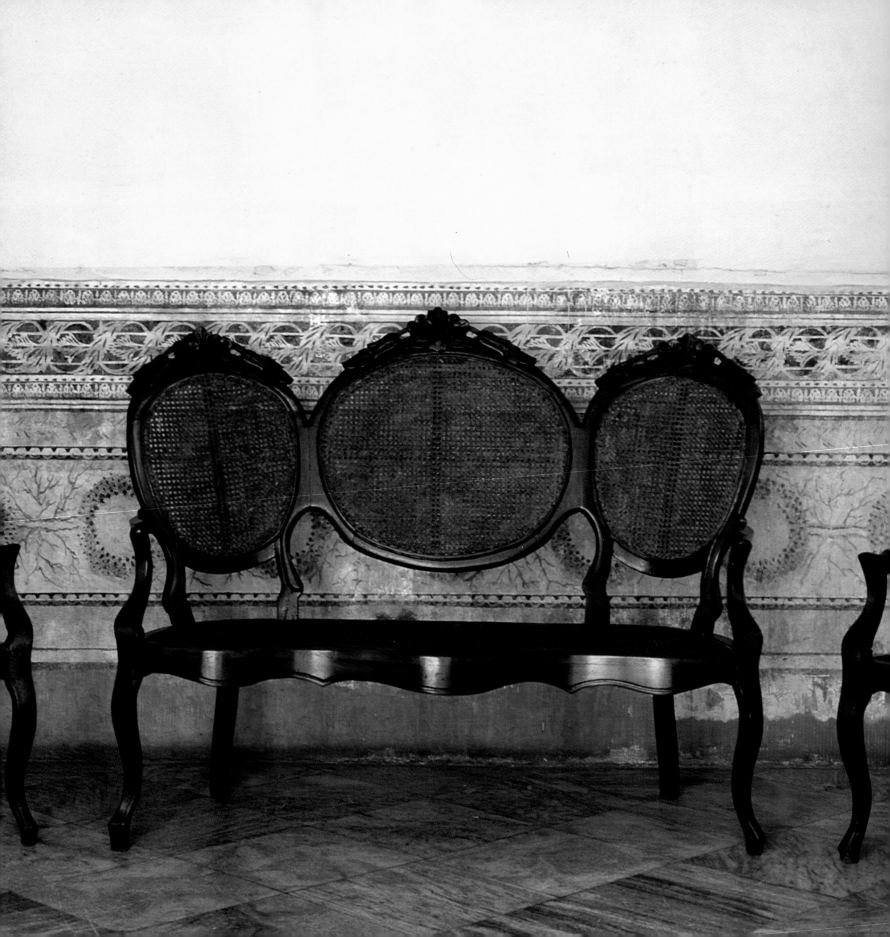

FRESCOES

Looking now at the handsome mansions and beautifully furnished palaces of Havana's colonial age, it is hard to imagine that there was any discomfort faced by those who lived there. But for many, Havana was a far from ideal environment after the cultured pleasures of Spain. It was hot, humid, with unpaved streets and the smell and dirt of a port city. In reaction, and in pursuit of the civilized feel of home, the wealthy classes developed a penchant for luxury and decoration. One of the most colourful expressions of this predilection is the frescoes that stain the interior walls of some of the city's finest buildings.

The art of the fresco came to Cuba with the Spanish conquistadors in the 1500s, when the decorative form was enjoying a resurgence in southern Europe. The Spanish in turn had learnt the craft from their neighbours in Italy, but unlike the ornate figurative frescoes of Michaelangelo's palaces and churches, the Spanish-Cuban version was designed simply to prettify the home with bold colours and dainty designs.

OPPOSITE *In the 17th-century Casa de la Obra Pia, the wall decoration in pastel shades provides a backdrop for wicker-backed chairs*

ABOVE RIGHT *A restored section of fresco shows the original intensity of the colours. Applied onto wet plaster, the pigment sinks into the wall, helping it to retain its brilliance for hundreds of years. With exposure to the Caribbean sun and salt air, however, some deterioration is inevitable*

RIGHT *The faded remains of a fresco adorn the walls of a colonial house in Old Havana*

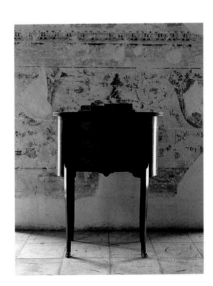

OPPOSITE *Ribbons and flowers –*
familiar subjects in the art of the fresco

RIGHT *A variety of motifs work beautifully*
together when each is positioned on a thick
band of muted watercolour pigment

BELOW *Layers of alternating colour topped*
with a floral wreath create a delicate skirting
above a bare marble floor

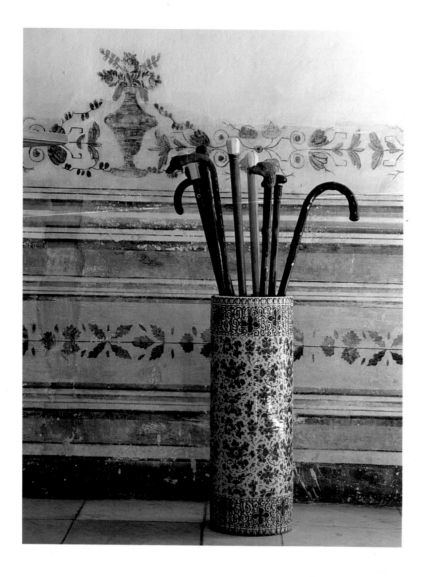

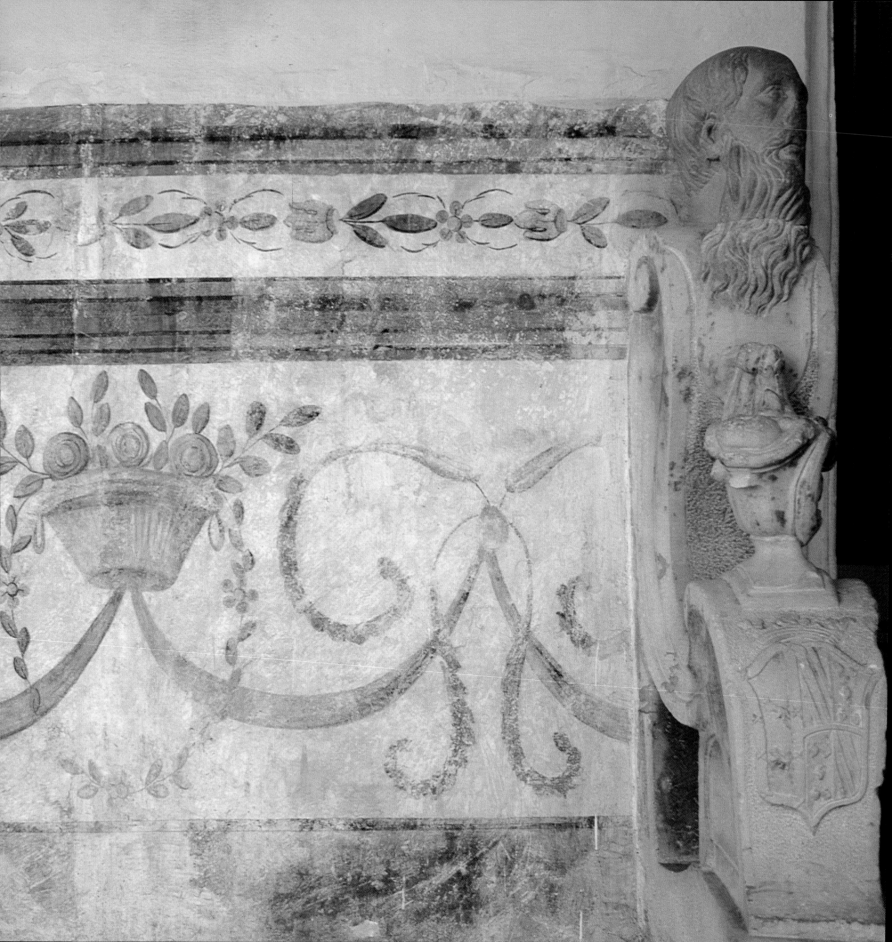

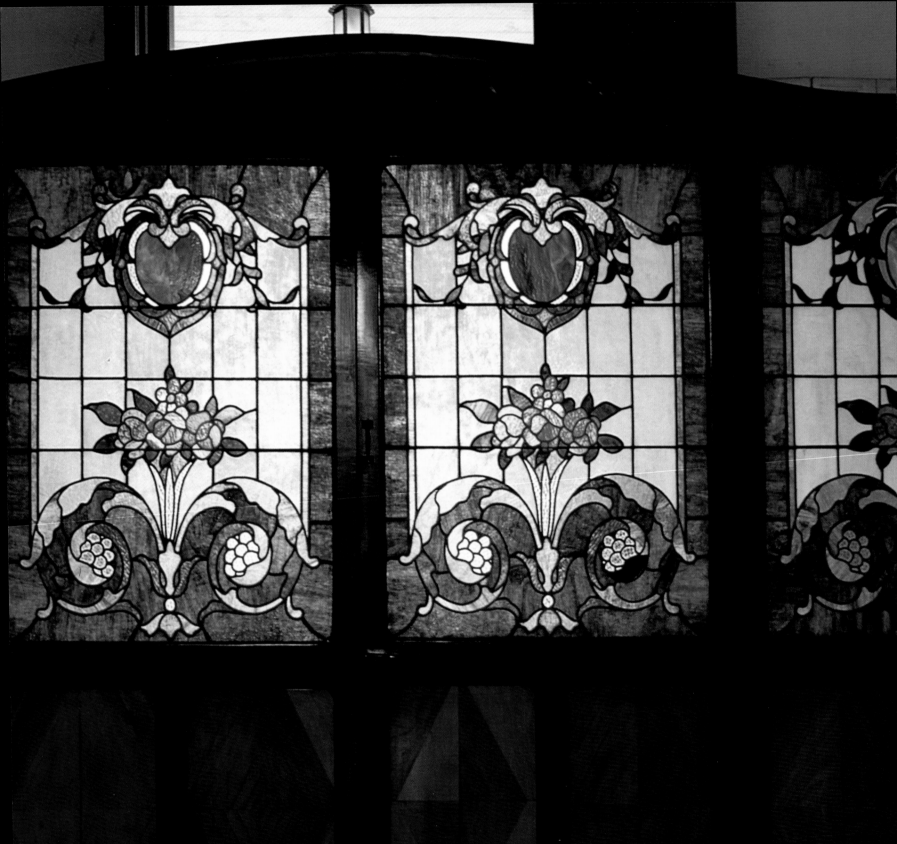

ILLUMINATION

Of all the visual features of the Cuban townscape it is the luminous colours cast by the sun on stained glass that most beguile. Cuba adopted the art of stained glass from Europe, importing the finished product from Spain or France en masse, or commissioning special pieces for the palaces and mansions of the most wealthy or for grand civic buildings.

In colonial times, coloured glass in simple hues of primary red, blue and gold was introduced to fill panels high above doors and shuttered windows. These panels were often semi-circular, hence their Spanish name *medio puntos*. They served two important purposes – one was to add life to the stark colonial architecture; the other was to soften the intense rays of the burning Caribbean sun. Doors and window shutters might be closed against the midday heat, yet the jewel-toned *medio puntos* allowed soft hazy light to brighten the rooms inside.

As architectural styles evolved in Havana, the stained glass adapted to suit. From basic early colours and patterns to exotic Art Nouveau panels, it is an art that encapsulates the Cuban love of colour and frivolity.

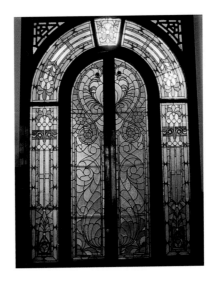

OPPOSITE *A popular adaptation of stained glass in colonial times was in half-height* manparras *or swing doors used inside the home. Here, several* manparras *create a panel that acts as a translucent room divider*

RIGHT *Exquisite detail and a kaleidoscope of rich golds and pinks create a sumptuous wall of colour in a 1920s apartment block in Havana. The design is a mix of Art Nouveau elements – the centre panels with their swirling outlines – and Art Deco – in the modern shapes and pastel shades of the outer panels as well as the dark wood frame with its sense of geometry*

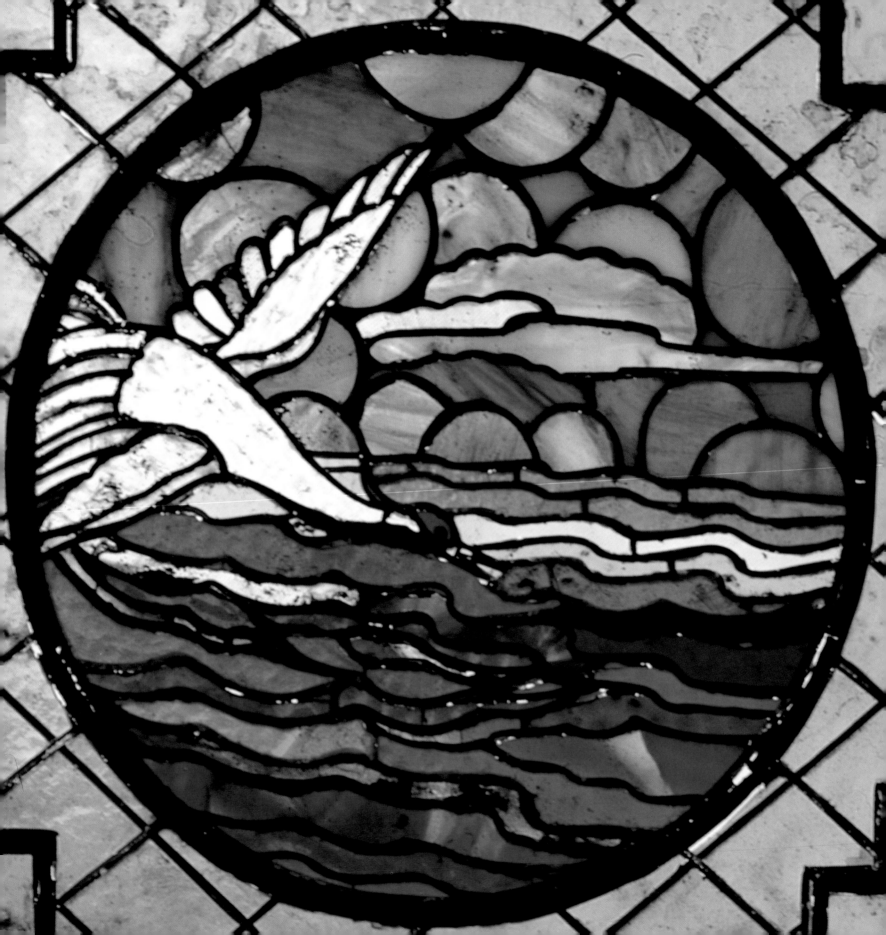

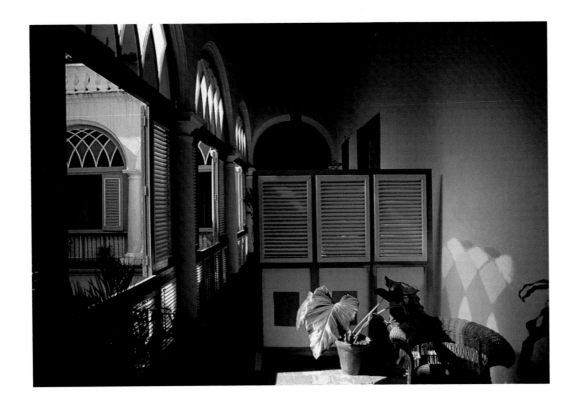

OPPOSITE, BELOW LEFT AND RIGHT *Three distinct stained-glass designs, each with its own appeal: a crane flying over an abstract landscape in the Art Deco style; an Art Nouveau basket of Caribbean fruits; bold blocks of blue and gold in a colonial window*

ABOVE *The colours of the Cuban flag fill the* medio puntos *of a colonial palace. The building dates from the 1750s but, as with many such structures, it was later redecorated, with Art Nouveau stained-glass designs replacing the original arched panels*

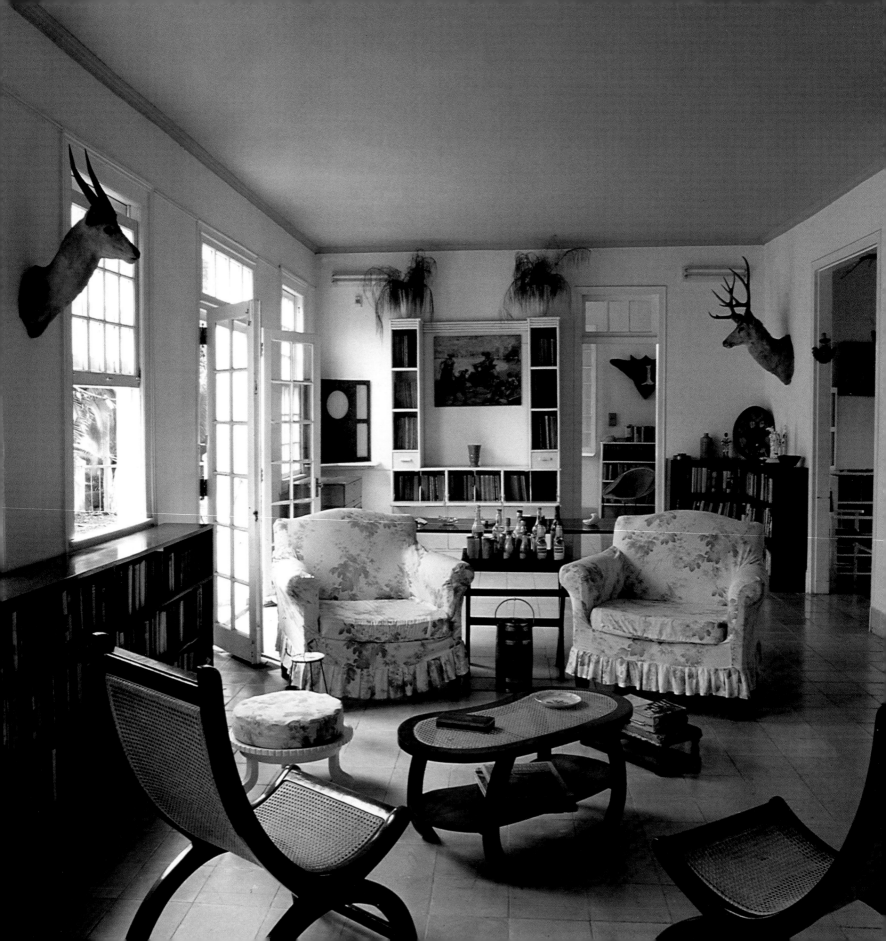

ENCOUNTER WITH HEMINGWAY

The enigma that is Ernest Hemingway is inextricably bound up with his life and experience in Cuba. He made Havana in particular his own, and it is impossible to experience the city without encountering traces of the writer. His favourite bars – the La Bodeguita and the El Floridita – are lined with reminders of 'Papa's' presence. Black and white photographs capture him with the stars of the day who came to play in Havana.

The writer himself, however, often chose more disciplined pursuits. His passion was fishing the marlin that swarm off Cuba's Atlantic coast each spring and he moored his boat Pilar in Cojimar, a fishing village just outside Havana.

During the first of the twenty years he would stay in Cuba, Hemingway lived in the Ambos Mundos hotel in Old Havana, but in 1940 he moved into a spacious country home, Finca Vigía – not in the city centre close to his favourite bars, but in the hilly suburbs beyond. Here he withdrew to write, feeding off the exotic atmosphere, tropical glamour and spirit of adventure that for him defined Havana.

OPPOSITE *Finca Vigía, the house where Hemingway lived until the year before his death in the United States, was built by a wealthy Catalonian immigrant in 1887*

RIGHT *Looking out to the extensive grounds surrounding the house, including a pool where Hemingway swam with stars Gary Cooper and Ava Gardner*

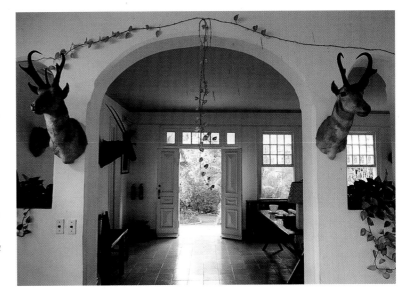

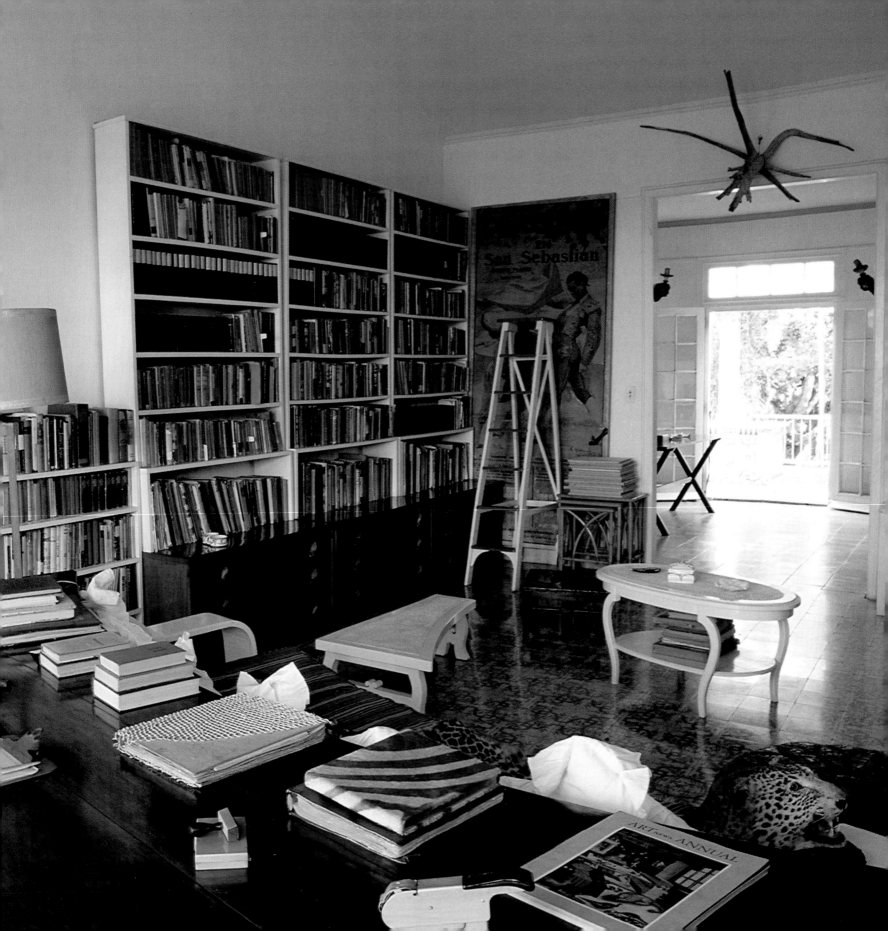

OPPOSITE, BELOW *The house is largely as it was in 1960 when Hemingway left Cuba for the US. When he shot himself the following year, his wife returned to the house briefly, taking with her only some manuscripts*

RIGHT *Among the author's possessions: the Royal typewriter on which he wrote* For Whom The Bell Tolls; *some of his 9,000 books; and the cartridges from his Mannlicher carbine rifle*

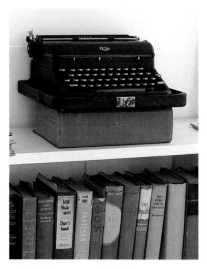

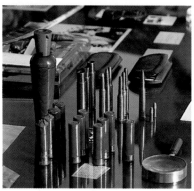

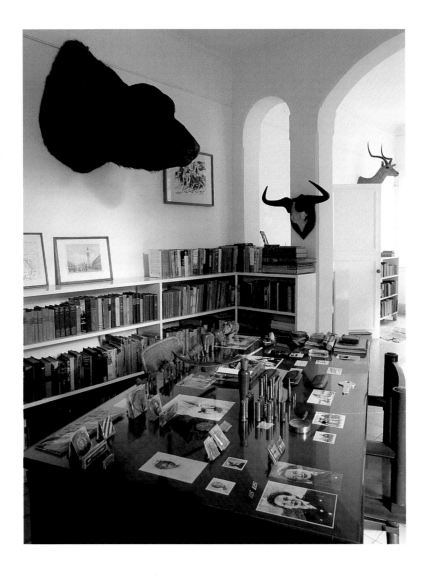

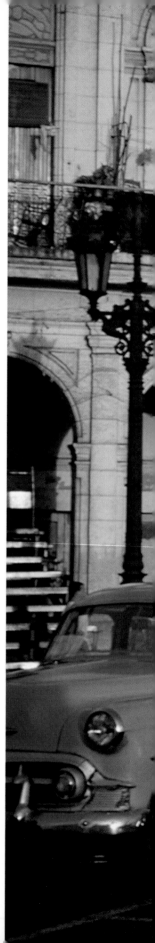

CLASSIC CARS

The image of the classic Fifties American car is synonymous with that of Havana. It is emblematic of the atmospheric time warp which seems to envelop the capital, and a constant reminder of its heady days as the most exciting destination in the Americas. In those days, the latest fashions, fads and inventions of the United States quickly found their way to Cuba, and the automobile was no exception. There are thousands of the gleaming steel chariots, some rusted and heaving, others beautifully preserved despite the difficulties of fuelling them.

With their massive proportions, vast leather seats and streamlined fins, the classic cars of Cuba are hard to resist. Ernest Hemingway drove a 1955 Chrysler convertible, Castro a luxury Oldsmobile, and Che Guevara famously owned a Chevrolet. Buicks, Packards, Studebakers and Hudsons are all household names in Havana. After 1961 when US imports ceased, it was the boxy Soviet Lada that became the mainstay of local transportation, but it has never rivalled the classic American cars of the Fifties for sheer style.

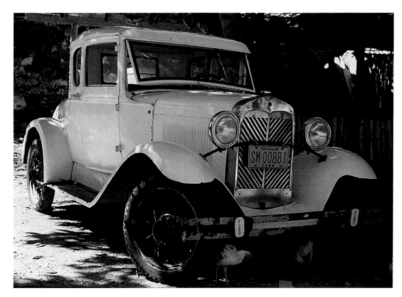

OPPOSITE *A study in pink and blue, set against elegant mansions on the Prado*

LEFT *Even before the Fifties automobile hit Cuba, earlier American models had made their way there. Here, a reminder of the island's wealth in earlier decades, a 1920s Ford complete with running boards and movable windscreen*

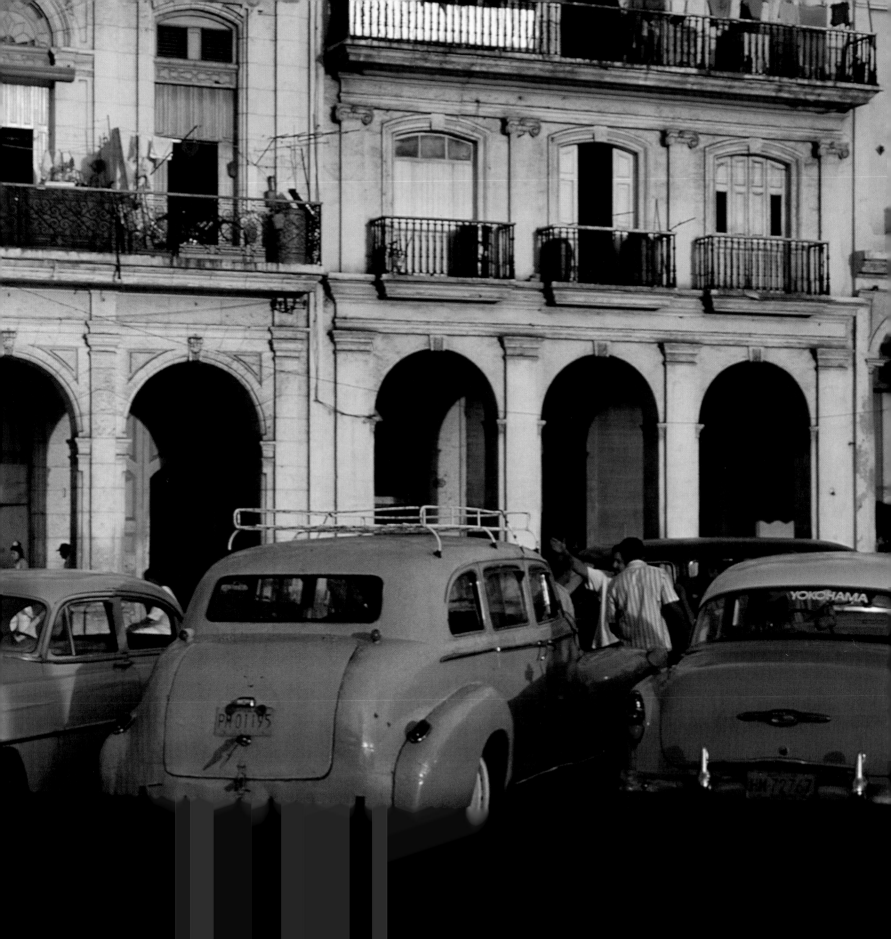

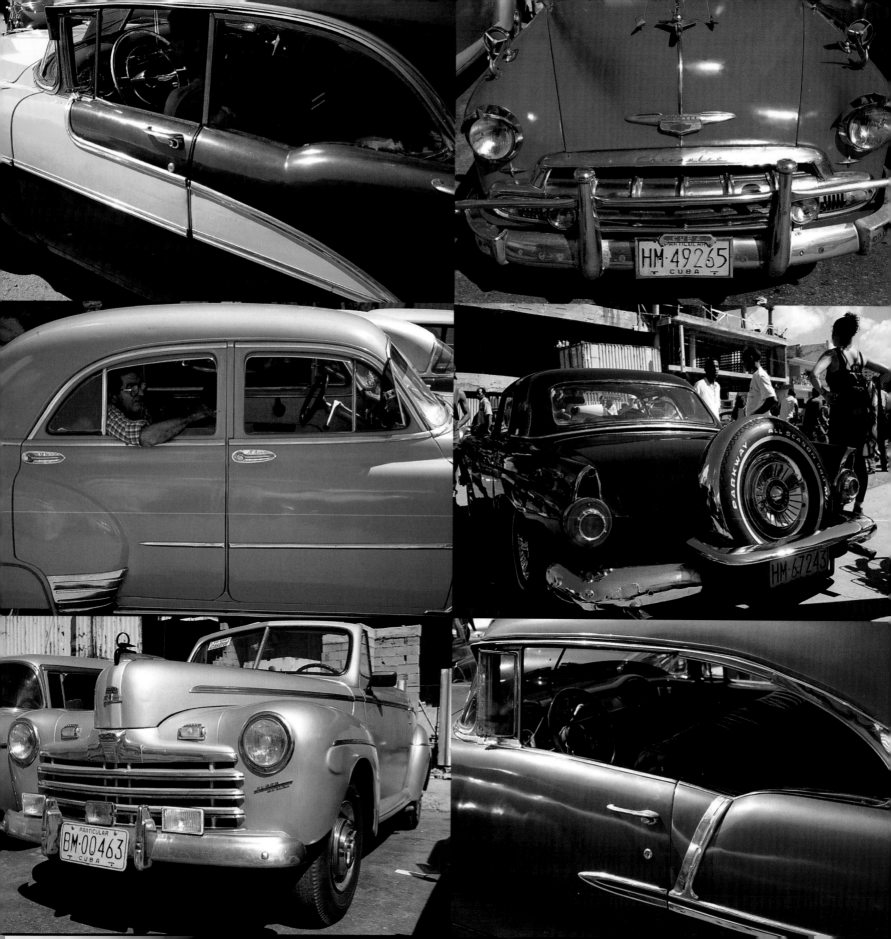

OPPOSITE *A kaleidoscope of shiny finishes and curvaceous silhouettes*

RIGHT, BELOW RIGHT *Two models in basic black, with shiny chrome details an essential part of the streamlined Fifties look*

BELOW *The colours of a faded Chevrolet echo the stained glass in a restored former palace*

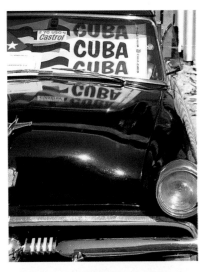

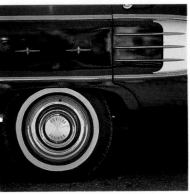

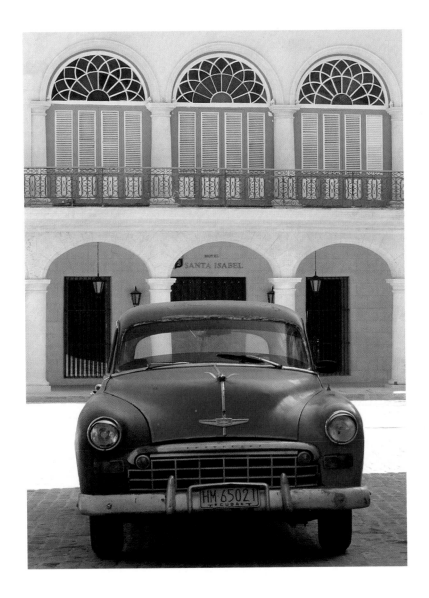

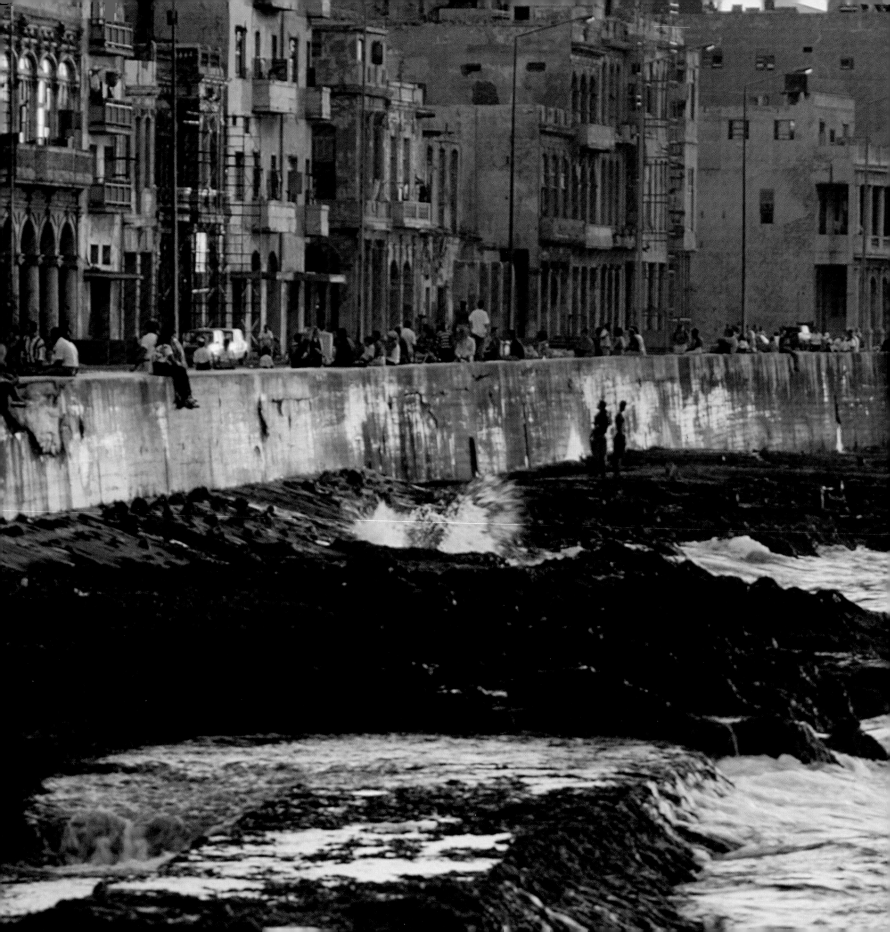

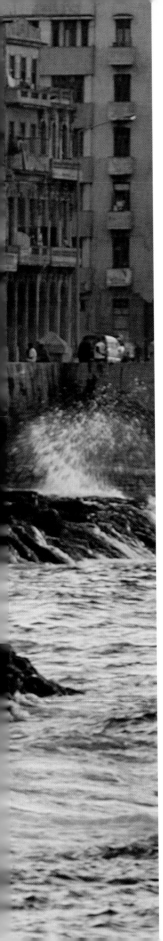

HAVANA SUNSET

Havana's long harbourside avenue, the Malecon, is the thread that links the old city to the new. It begins in Old Havana where it wraps around the edge of the deep harbour moorings, and follows the shape of the inlet out to sea, past the start of the Prado and the borders of the old city walls. At the seafront the Malecon turns to run parallel to the crashing waves of the Atlantic.

With their views out to the Florida Straits, the buildings along the Malecon face the brunt of the tropical elements: the salt-spray, the raging winds which accompany seasonal huricanes, and the searing afternoon sun. Those without the care of constant upkeep are battered and peeling, struggling to retain their colour.

As the main thoroughfare connecting all parts of the city, the Malecon is a magnet for Havanans at play. They come to promenade during the long summer evenings, to drink rum and dance to music, to dive for fish or cast off from the pavement at dusk, when the seafront is at its most beautiful. At one end flashes the lighthouse of the Morro fortress, at the other end the lights of residential Miramar twinkle, while all along its length people pause on their bicyles or lean against the sea wall to watch the setting sun.

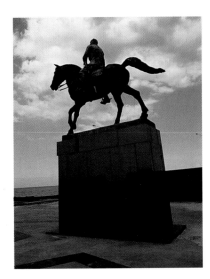

OPPOSITE *The buildings along the seafront may be battered, but at dusk their flaws dissipate in the golden light that bathes the Malecon. Waves lap at the six-kilometre long seawall, but when seas are rough, especially in the winter months of January and February, they crash over it, drenching passing motorists, cyclists and pedestrians who stop to watch the sunset*

RIGHT *Monuments to historical figures from two centuries dot the length of the Malecon. According to local folklore, statues facing the sea commemorate those born overseas. Those facing inland are Cuban-born heroes*

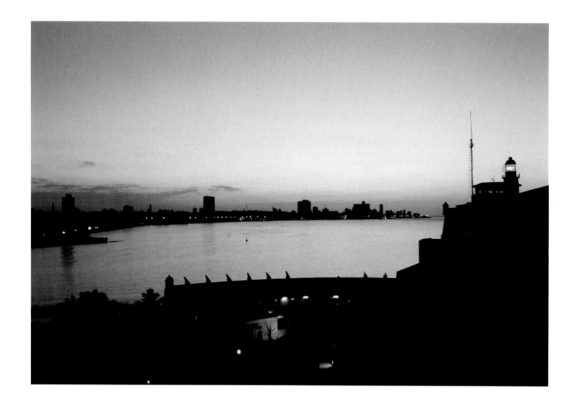

OPPOSITE *The imposing walls of El Morro fortress dissuaded even buccaneer Henry Morgan from planning an attack on Havana*

ABOVE *Overlooking the sweep of the Malecon, the lighthouse of El Morro*

BELOW LEFT *A lookout post at the fortress, built out of coral taken from Cuba's reefs. Soldiers once kept watch here for pirates*

BELOW RIGHT *Fishing from the sea wall yields a fruitful catch*

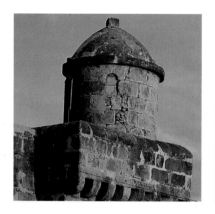

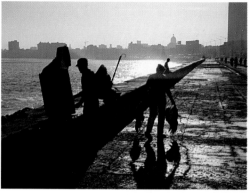

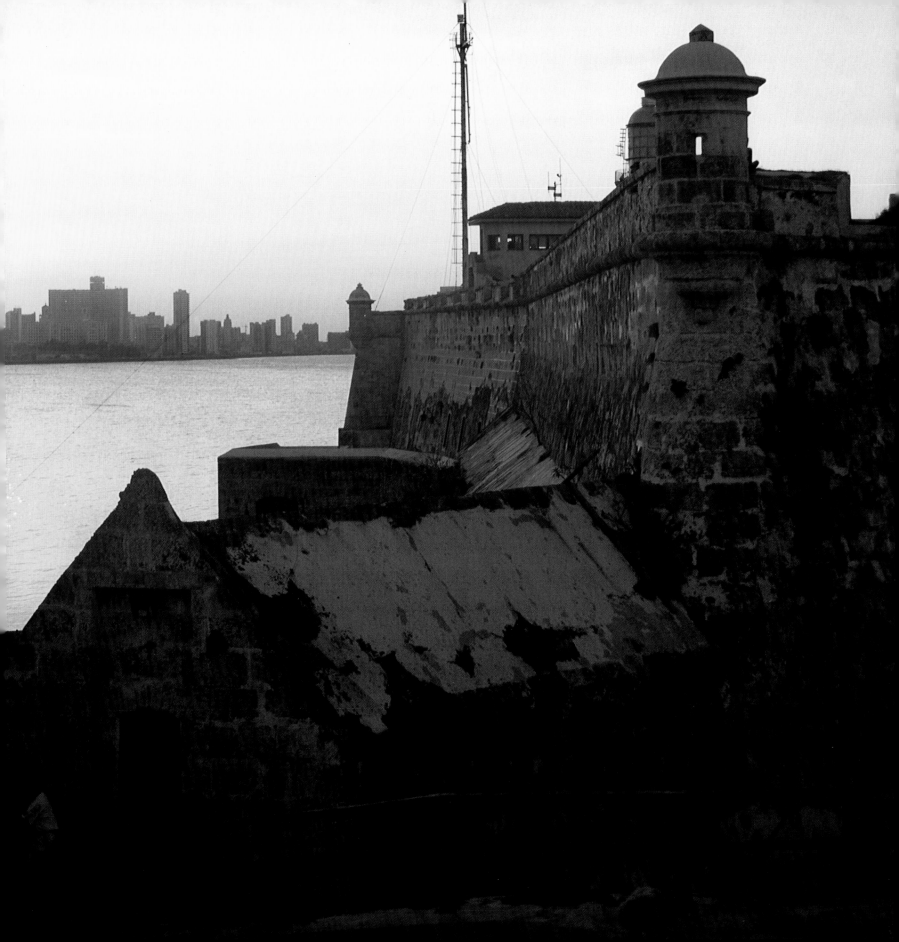

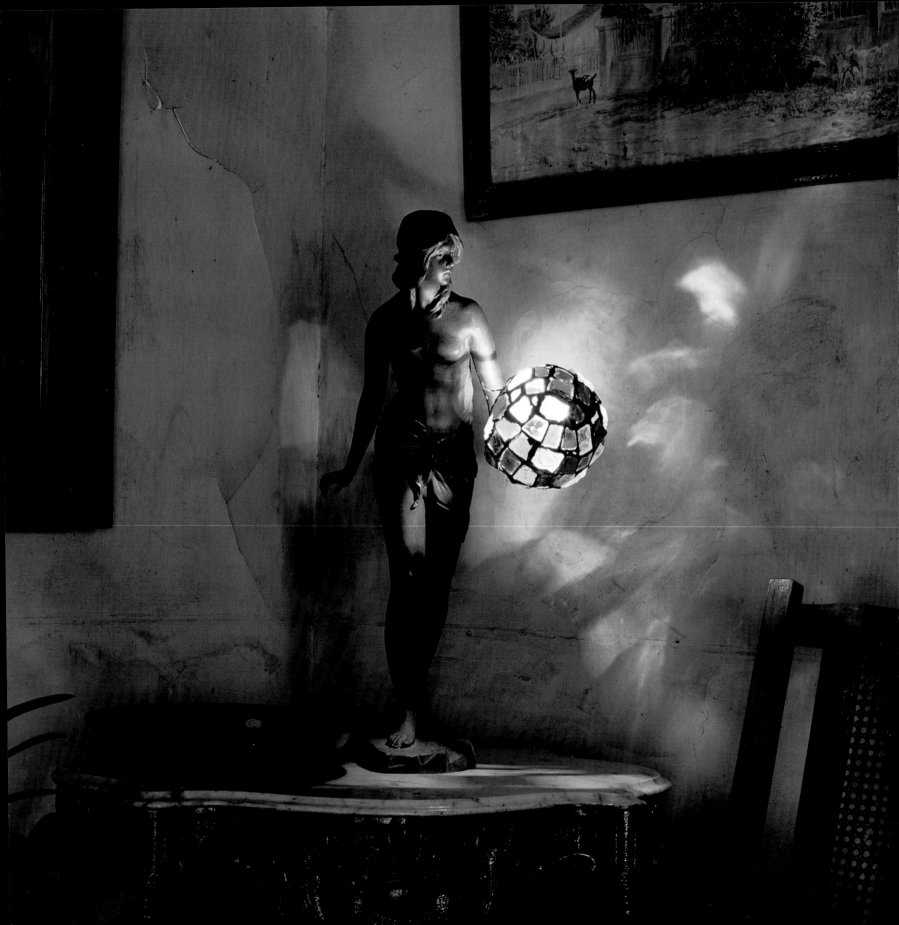

PRIVATE VIEWS

An old world elegance, faded colour, ambient light, and an eccentric display of detail and decoration characterize diverse Cuban homes, from early colonial to modern

M U D É J A R S T Y L E

Diego Velázquez came to Cuba in 1511 with a crucial mission. As an appointed representative of the Spanish crown, Velázquez' task was to transform Cuba from a natural wilderness into a viable colonial satellite. He began in earnest the year after his arrival, moving from his initial base in remote Baracoa to found the city of Santiago de Cuba as his capital. In keeping with his position as the most important European on the island, he set about building a fitting home.

The house that Velázquez constructed was not only his residence but also served as the command centre of the Spanish colony. Dominating the main plaza of the fledgling city, the completed building presented a fortress-like facade to the outside world with its heavy stone blockwork and enclosed balcony high above street level. Yet behind the heavy timber doors the house was designed as a secluded haven, a reminder of home.

Now preserved as a museum, the Velázquez house is the oldest colonial house in Cuba, and some historians go so far as to suggest that it is the oldest in the New World. A nineteenth-century extension came later, bringing with it the elegant architectural elements of the Cuban palace – in fact a refinement of the early Spanish colonial style of the Velázquez house.

The key influence is Moorish, borrowed from sixteenth-century southern

OPPOSITE *The imposing Mudéjar courtyard of the 16th-century Velázquez house, echoing the architectural elements of Moorish Spain, was restored to its orginal state in the 1960s*

LEFT *A giant terracotta* tinajone, *or urn, used in colonial times for collecting rainwater*

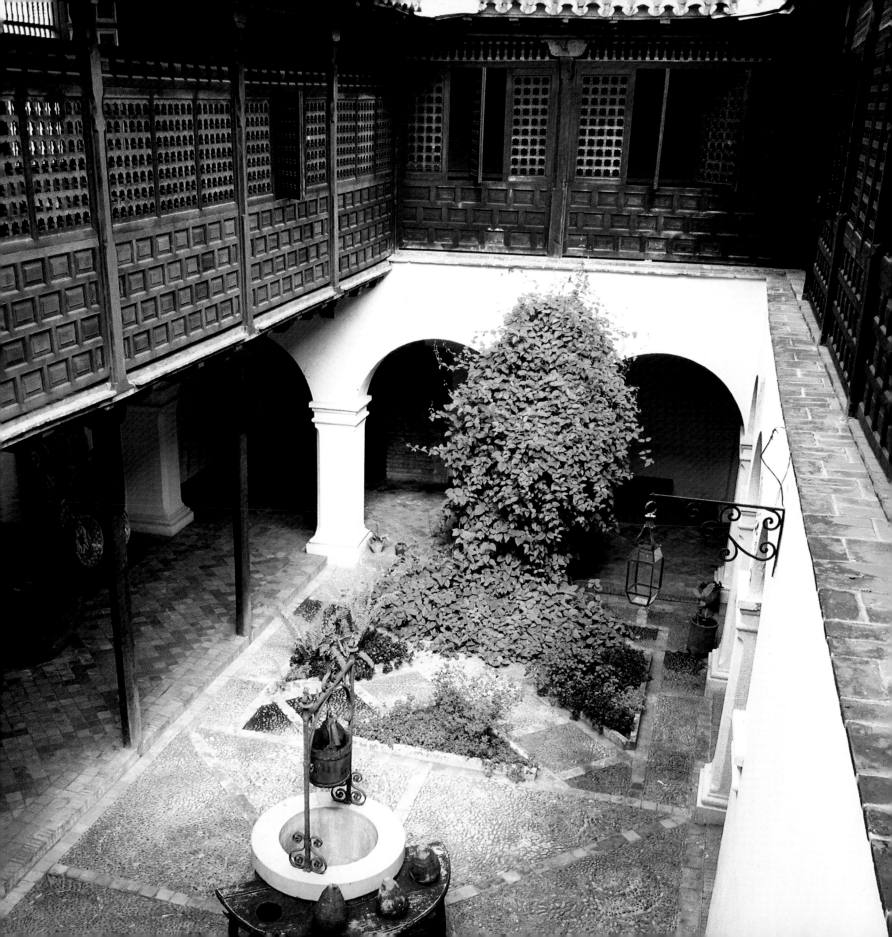

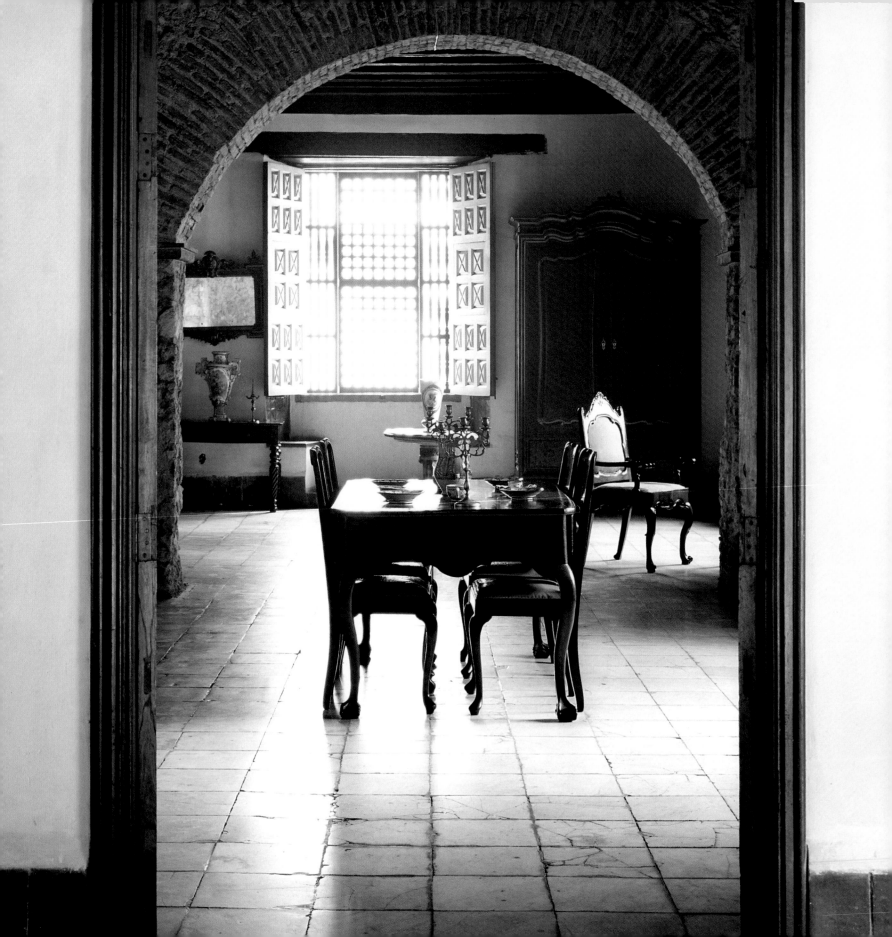

Spain. The colonnaded courtyard, open to the skies, echoes those of Seville and Cordoba, where the Moors incorporated enclosed squares in their homes so their wives might venture outside, yet be protected from public view. Courtyards like this were typically built over a reservoir that supplied the household with water through a central well, beautifully preserved in the Velázquez house, and still used in some of Santiago's older houses.

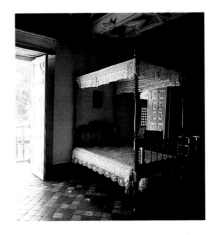

The architecture of Moorish Spain is also here in the high *alfarje* ceilings with their distinctive pitched parallel beams and decorative carving. Resembling the upturned hull of a boat, *alfarjes* are thought to have been created by Mudéjar carpenters who traditionally learned their craft through boat-building. More than any other feature, these lofty structures help to keep the rooms cool, allowing air to circulate above the walls dividing each room during the sweltering Cuban summer.

Downstairs, the grand proportions and impressive woodwork would have provided the ideal setting for conducting the business of empire. In the living quarters upstairs, the rooms are more intimate, shielded from prying eyes, and from the strong light, by the deep wooden grille encircling the second level.

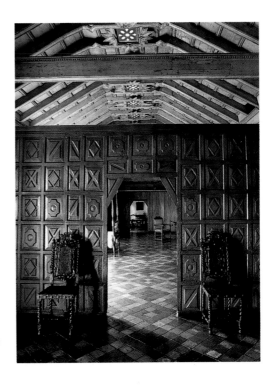

Now, as in the days of Velázquez, the house is sparsely furnished with simple, solid pieces that display the talents of Spain's carpenters, most often choosing to work with the distinctive dark reddish tones of mahogany. This natural Cuban resource would eventually supply the booming colony with the material for some of its most beautiful interiors.

OPPOSITE *The restrained, rustic interior style of the early Spanish colonial period*

ABOVE RIGHT *A bed canopy of handmade lace – a craft tradition that lives on in Cuba*

RIGHT *A characteristic Cuban element – the* alfarje *ceiling carved from fragrant cedarwood*

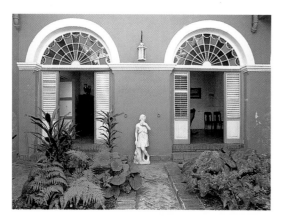

RIGHT *A trio of arched doorways form the focus of the dining hall, with tall louvred shutters opening onto the garden*

LEFT *Built around an adjoining courtyard, this 19th-century addition to the Velázquez house contrasts with the restraint of its neighbour*

BELOW *A 19th-century interpretation of the indoor courtyard fountains instituted in Moorish architecture for purification purposes*

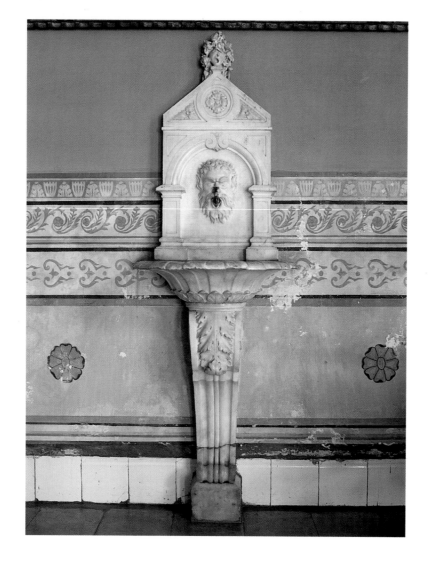

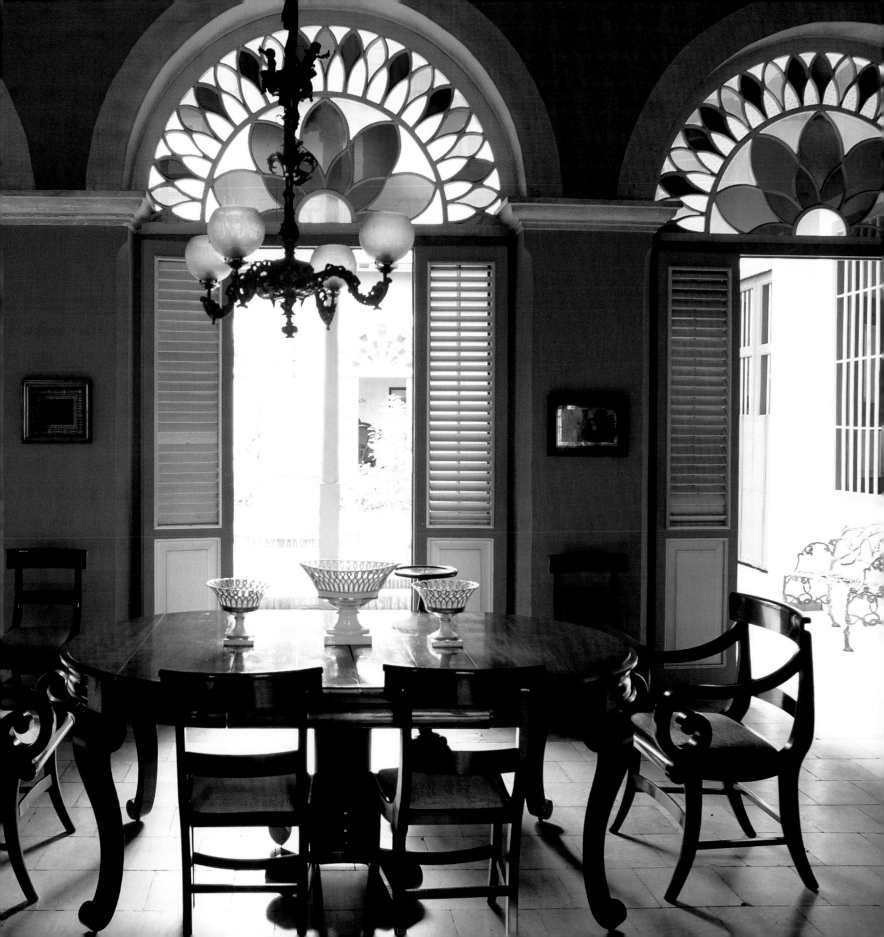

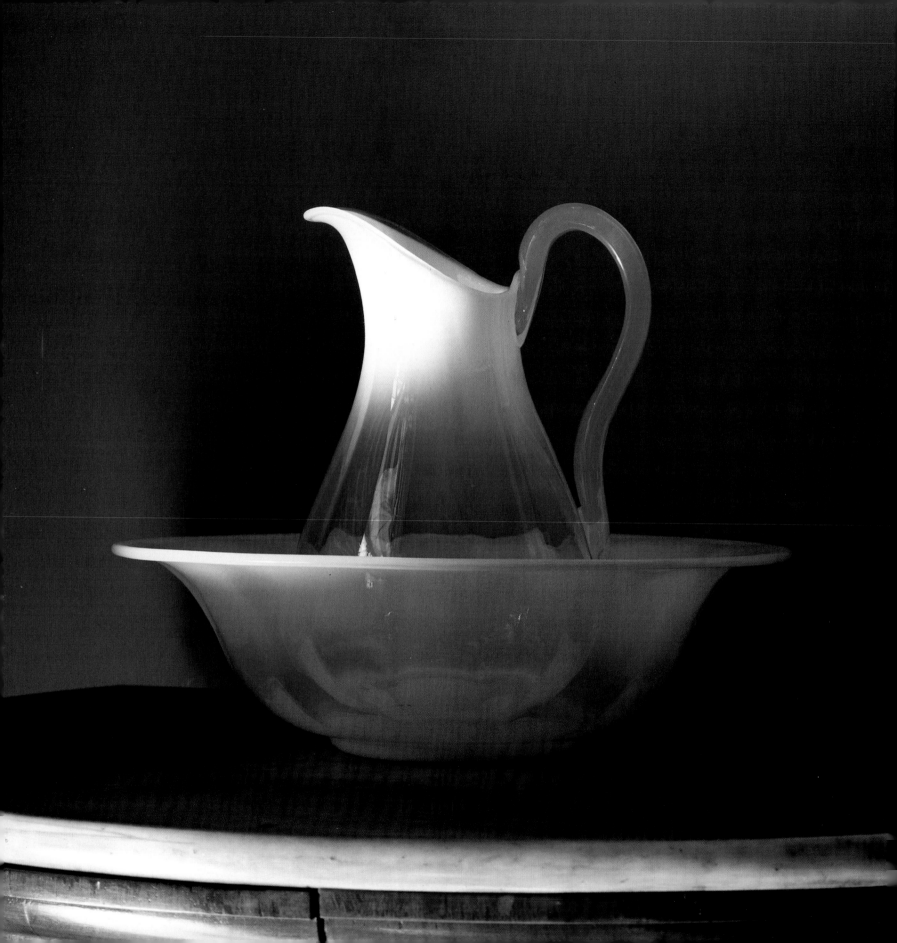

OPPOSITE *Richly coloured glass is a characteristic facet of Cuban décor – here in the form of a delicate pitcher and wash basin*

RIGHT *Shades of teal blue and deep burgundy form an exuberant display of colour and pattern rarely seen in Cuba's colonial interiors*

BELOW, BELOW RIGHT *The timber used in elegant pieces like these came from vast forests of mahogany that once covered much of the country*

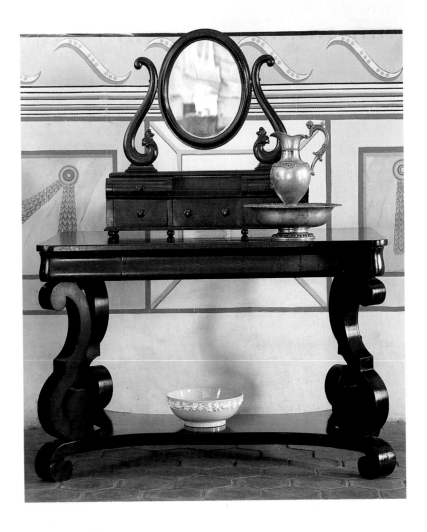

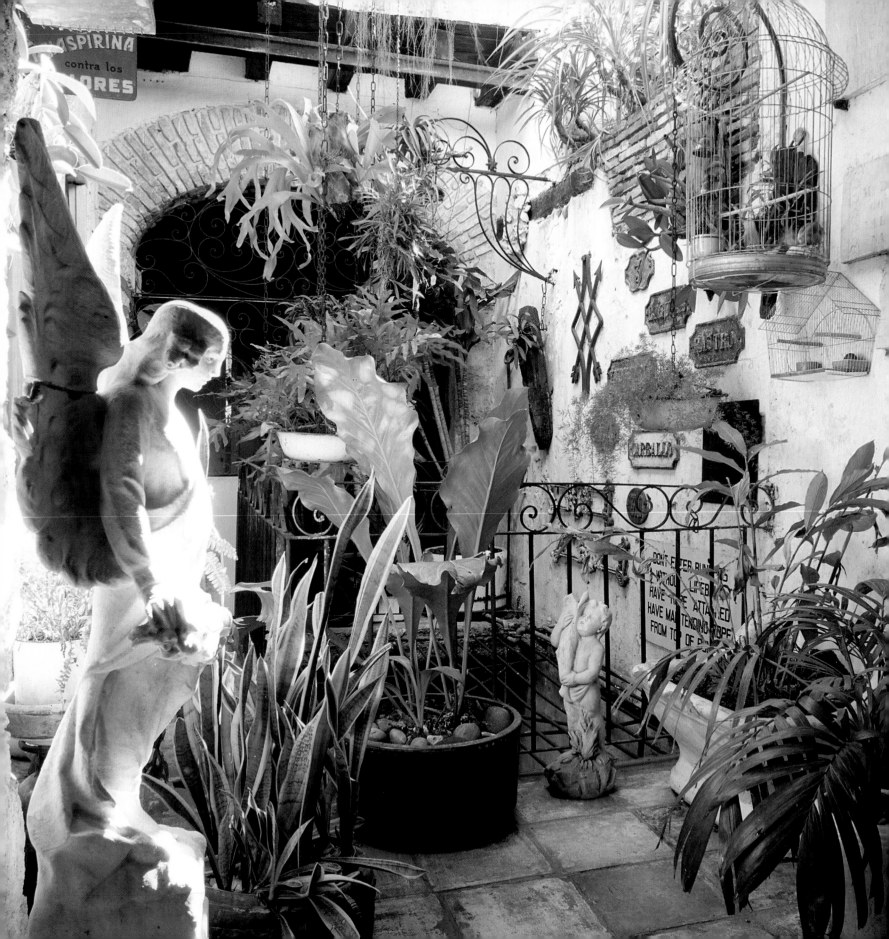

POETIC SECLUSION

Beyond the heart of Old Havana lies another world. Past the Plaza de Armas with its leafy green park and impressive stone buildings, down Calle Oficios with its museums, galleries and restaurants housed in restored mansions, and across the wide square commanded by the San Francisco convent, the historic city dissolves south into long skeins of dilapidated streets.

These are the remains of Old Havana's residential quarter, constructed in the 1700s when the city was a thriving colonial hub. Two- and three-storey terraces of peeling paintwork and crumbling masonry cling together beside narrow lanes. But now and then a glimpse will be offered of a fern-filled courtyard, an intricate door grille inside an arched entrance or a glistening chandelier glinting from deep inside someone's house. It is in just such a street that poet Andres has created a unique garden retreat.

His apartment is converted from an eighteenth-century house, typical of much of Old Havana. When he stumbled upon it sixteen years ago, it had been left in ruins, but gradually he has

OPPOSITE, RIGHT
The entrance to the apartment is up a flight of crumbling stairs, which lead to a vibrant patio of plantlife, bric-a-brac and marble statues, including an angel from the family grave in Havana's San Francisco de Paula Cemetery. Open to the skies, the small courtyard reveals the original wooden rafters and brickwork of the 18th-century house

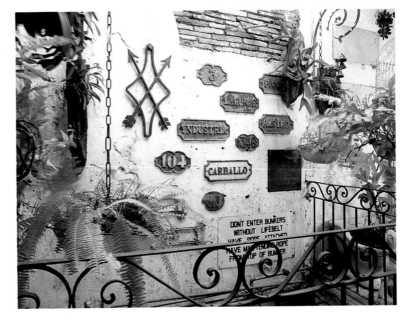

pieced it back together, along the way filling it with a fascinating collection of furniture, art objects and curiosities.

The unimposing doorway at street level and gloomy stairway to the first floor do nothing to prepare for the exotic foyer – a fantastical courtyard crowded with greenery, squawking parrots and marble statuary. A collection of Havana street signs, building plaques and house numbers decorate the rough white walls along with stag ferns, bird cages and hanging baskets. A poignant memento is here too in the haunting form of a winged marble angel, retrieved by Andres from the family grave to protect it from theft.

Inside, some original features survive, like the flagstone floors and timber beamed ceilings. The rest is a wonderful mix of design features and furniture spanning a myriad of styles and eras. This eclectic jumble of possessions spreads out over two levels. The first floor comprises the entrance courtyard and main living areas of lounge, kitchen and bathroom. Upstairs, a bedroom and studio space overlook a serene roof garden, providing an inspiring environment for the poet at work.

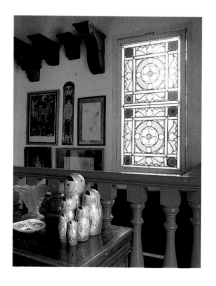

OPPOSITE *A narrow staircase leads from the main living areas up to the poet's studio and outdoor terrace. At the foot of the stairs stands a statue of the Virgin Mary purchased from a closing church. On the walls hang works of art, mostly modern pieces by local artists.*

ABOVE RIGHT *The stairs arrive at the second level under a turn-of-the-century stained-glass window rescued from an abandoned jeweller's. Set in the wall next to it are fragments of roof beams from Old Havana. In the foreground, a set of Russian Durma dolls from the 1970s*

RIGHT *With a view of the garden, the poet works at his typewriter on a homemade table inlaid with mosaic fragments*

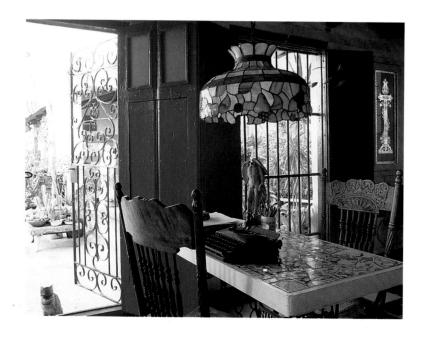

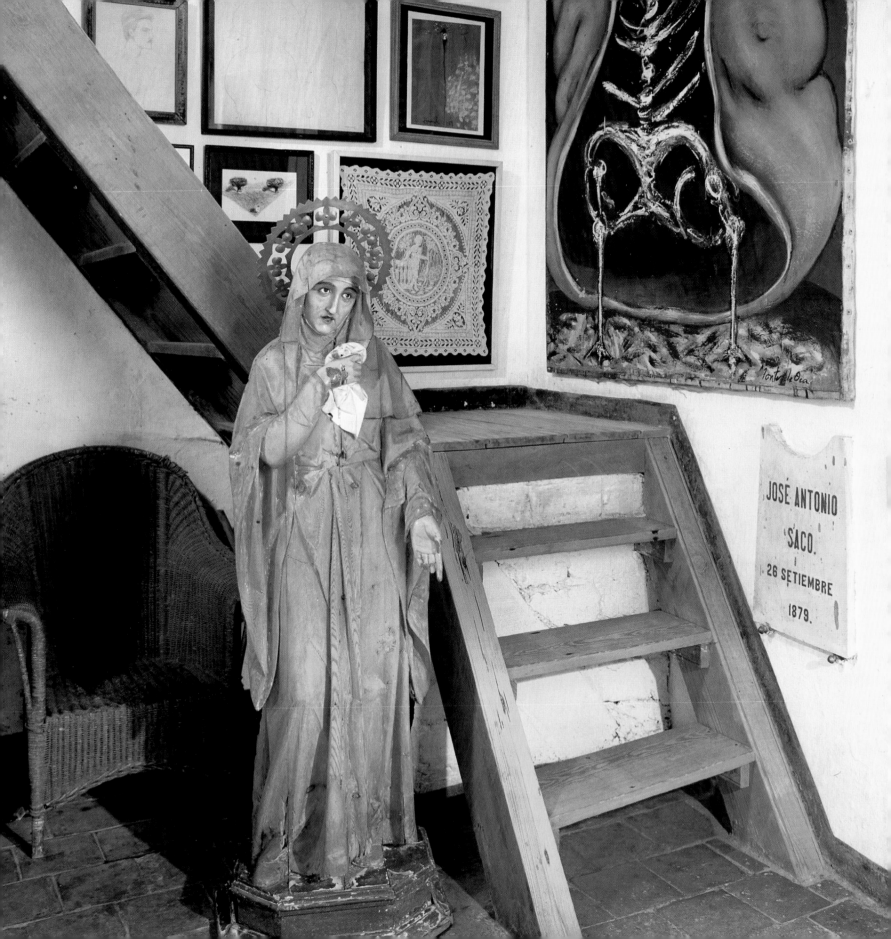

JOSÉ ANTONIO
SACO.
26 SETIEMBRE
1879.

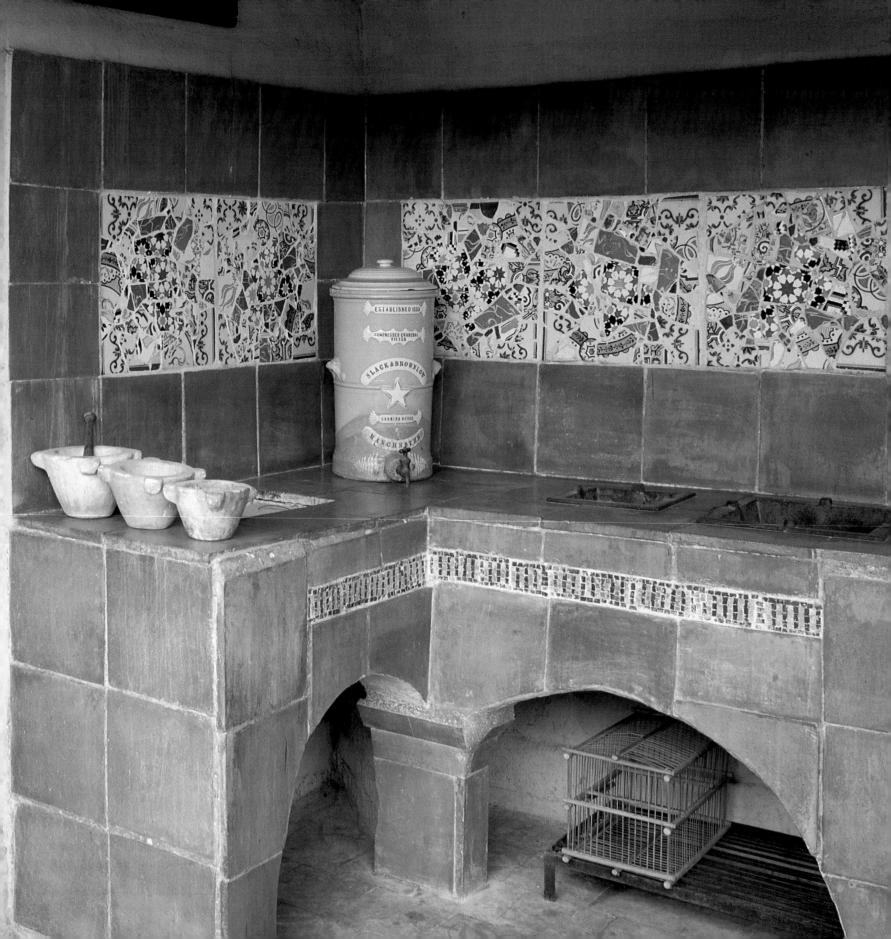

OPPOSITE *On the rooftop garden terrace, the open-air stove with its terracotta and glazed tiles is a reminder of the days when servants lived in quarters at the top of the household*

RIGHT, BELOW *The furniture throughout the house has been bought second hand, found or made from bits and pieces. On the terrace, a garden table has been fashioned from two iron sewing machine trestles and the discarded door of an 18th-century house. From the narrow dusty streets below it is impossible to imagine the expansive oasis created here. The space is divided to create several distinct environments using wrought-iron panels, clusters of greenery and sections of original masonry*

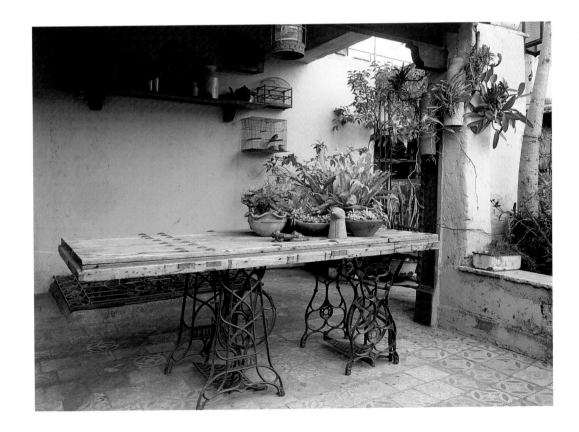

ARCADIAN GRACE

In the town of Trinidad, the pace of life is virtually unchanged since the nineteenth century. This was its golden age, from the beginning of the 1800s when sugar plantations made millionaires out of many Spanish landowners, until falling sugar prices and the wars of independence from Spain took their toll some sixty years later.

The legacy of this era is a town dominated by the houses and palaces of the former sugar barons. Many of the finest, like the two-storey Palacio Brunet, are clustered around the Plaza Mayor, the handsome central square, and in Calle Desengano which runs south of the plaza down the steep terrain so typical of Trinidad. But at number 518 on the same narrow street is an architectural find of another era. The house of Lidice Zerquera Mauri has an atmospheric distressed beauty that is a world away from the perfectly restored details of Calle Desengano's imposing sugar palaces.

A long facade of plain, yellow-washed walls, a patio extending the length of the street frontage and wooden grilles over the windows mark the residence of Zerquera Mauri as one

OPPOSITE *Light streams into the front living room, illuminating a saintly figurine offering spiritual protection. The open shutters not only allow light and air inside but encourage neighbours to stop and chat. At night the heavy panelled shutters are unfolded and secured in place across the window*

LEFT *Among the family possessions is a resplendent nativity scene encased in a polished timber box. Although Catholicism is less established here than elsewhere in Latin America, it remains an important part of life for many Cubans, especially those of Spanish descent*

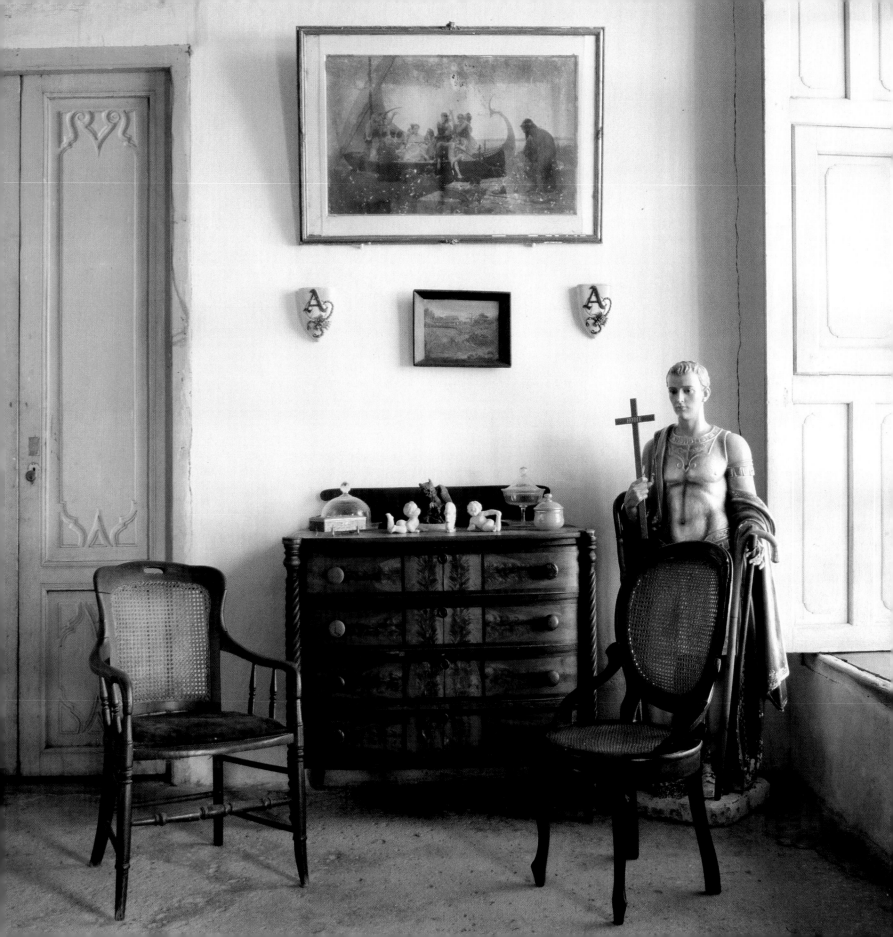

of the single-storey colonial houses of old Trinidad. Many of the former sugar palaces began this way, until the living space was transferred to a second storey, allowing space for offices and storehouses in the original ground floor structure. Unlike many of the Spanish families in Trinidad, the Zerquera Mauri business was tobacco rather than sugar, an unusual choice for a province dominated by cane.

Family patriarch Antonio Mauri founded a cigar factory in the last years of the nineteenth century with the apocryphal name 'La Nueva Era'. Tobacco had been an important part of the economy of Trinidad since the early seventeenth century – when a lucrative trade developed from smuggling the leaf out to ports in the Caribbean and Europe. It was eclipsed by sugar the following century, but when the sugar boom faltered, tobacco was one of the few industries that kept Trinidad alive into the 1900s. Mauri built a small fortune from his cigar factory, which eventually became the main centre of production in the province.

Mauri's granddaughter now remains in the family house surrounded by the faded features and elegant furnishings of a bygone age. Her collection of sepia-tinted photographs recalls the grand days of La Nueva Era – the cigar factory orchestra, a rose-covered car in the town's carnival, and the immaculately dressed figure of Antonio Mauri taken at the height of his empire.

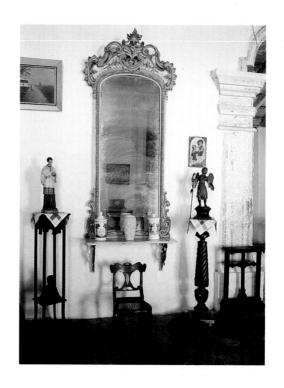

OPPOSITE *Presented to the owner's grandfather as a trophy from a friend's shooting expedition, an enormous stuffed freshwater crocodile takes pride of place in the living room. It is a native species of the vast Zapata swamps, 160 kilometres west of Trinidad. The swamps, now protected, are a haven for crocodiles*

ABOVE RIGHT, RIGHT *The house contains a small but tasteful collection of furnishings, including a splendid pair of gilt mirrors and a mahogany table supported by bronze dolphins*

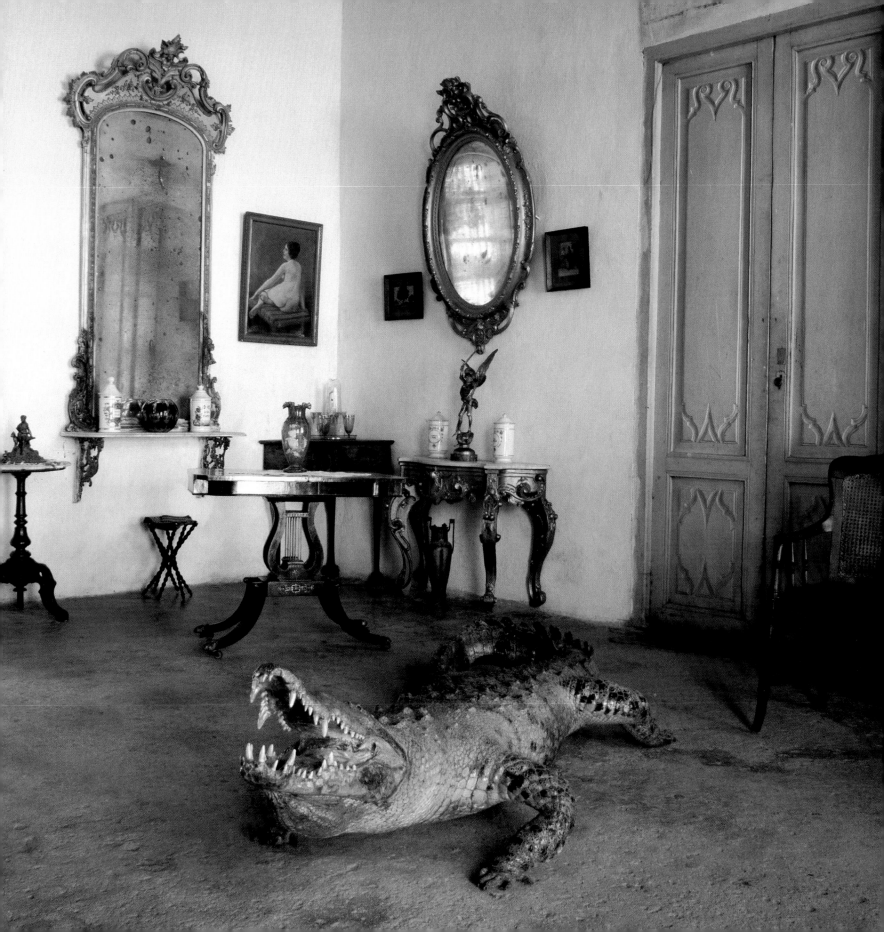

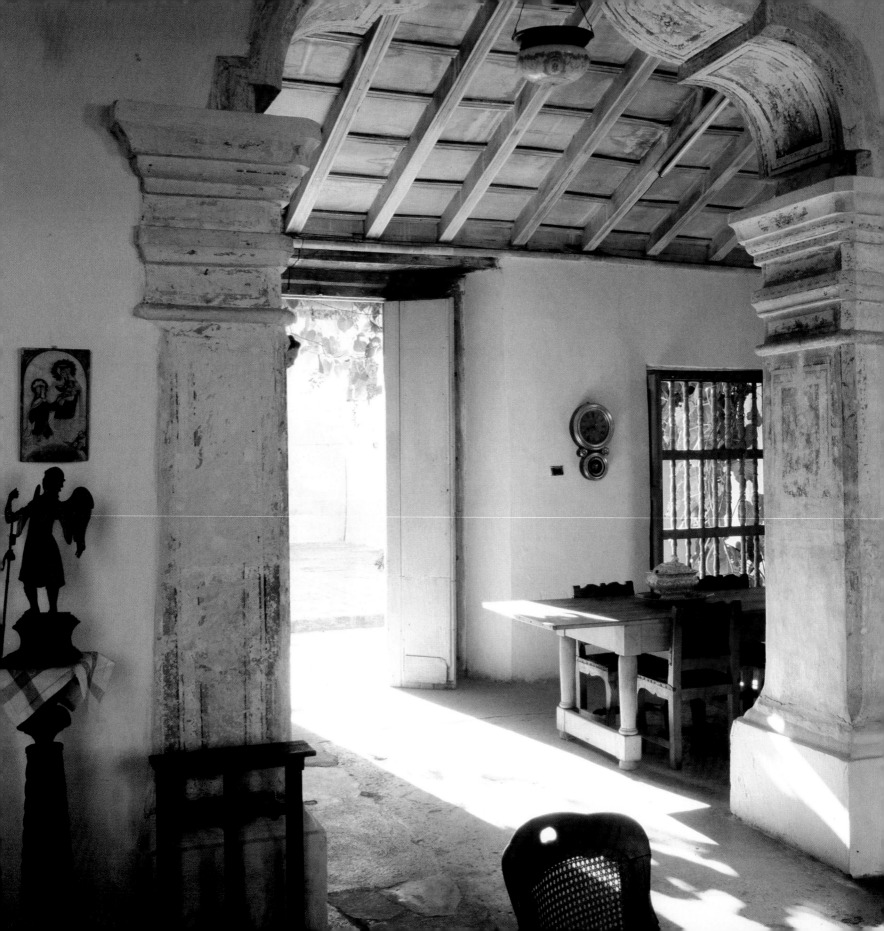

OPPOSITE *At the rear of the house, the dining room looks out through wooden* barottes, *or grilles, onto a leafy courtyard. The* barottes *are typical of colonial homes in Trinidad, although many were later replaced by wrought iron*

BELOW, RIGHT, BELOW RIGHT *The faded remains of dainty Italianate frescoes adorn the inner curves of the Moorish-style arch that separates the front and back rooms*

DESERT ROSE

At the edge of Vista Alegra, a once-grand Santiago neighbourhood overshadowed by the green foothills of the Sierra Maestra mountains, is one of the city's quirkiest and most imaginative homes. The surrounding streets are lined with crumbling Neoclassical mansions and elegant Art Nouveau structures that housed the city's wealthy trading and plantation families in bygone days, so it comes as a surprise to find this pristine bungalow with its brilliant yellow walls and well-tended cactus garden nestled in front.

The building itself is typical of the wave of modern American architecture that came to Cuba in the Thirties and Forties, superseding the decorative European styles that had dominated Cuba until then. This particular example has been updated and restyled by its owner not only to reflect his own eclectic tastes but to also give it a charming regional flavour.

Interestingly, the clean, uncluttered lines of the single-storey wooden house, its raised veranda and brightly painted facade hark back to the very early architecture of old Santiago, in particular the French-Haitian quarter with its rows of colourful

OPPOSITE *The long upright arms of the cacti in the front garden are the perfect counterpoint to the low horizontal lines of the wooden bungalow with its slim louvred windows. A vine-shaded walkway leads to the front door where a pair of rocking chairs sit in readiness for whiling away warm Santiago evenings*

LEFT *The salamander is not real – but its placement on the window grille is typical of the owner's singular sense of style. The louvres behind are angled to protect the rooms from the glare of the midday sun, while still allowing light and air to penetrate*

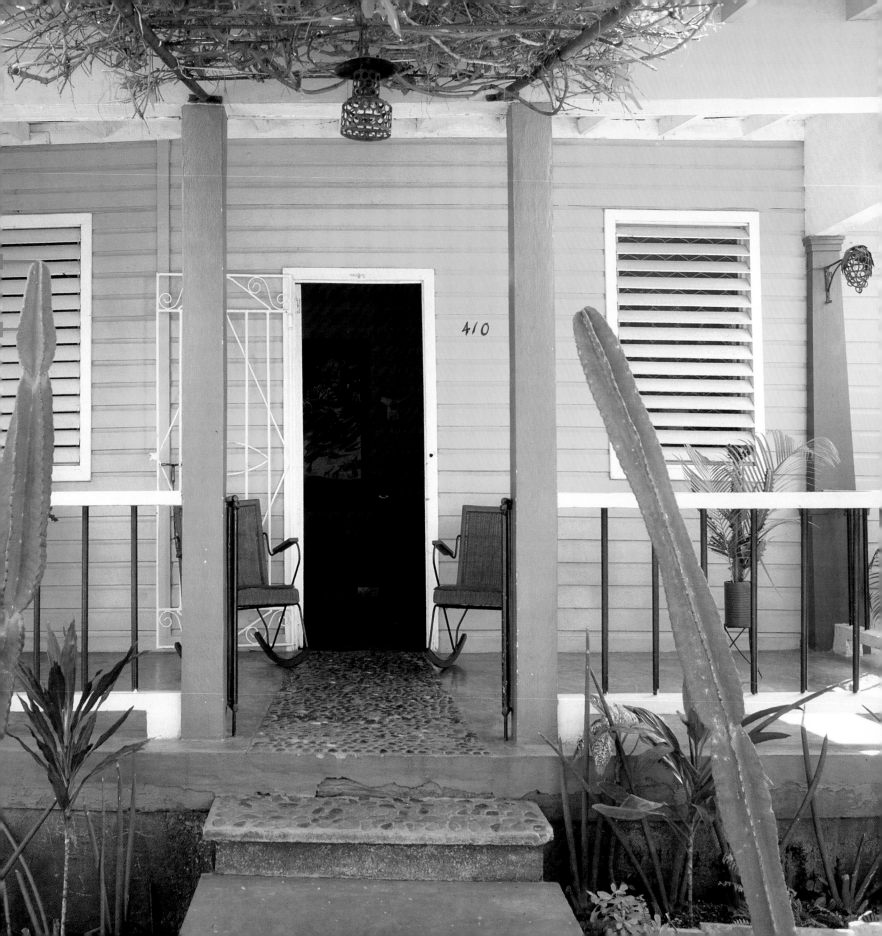

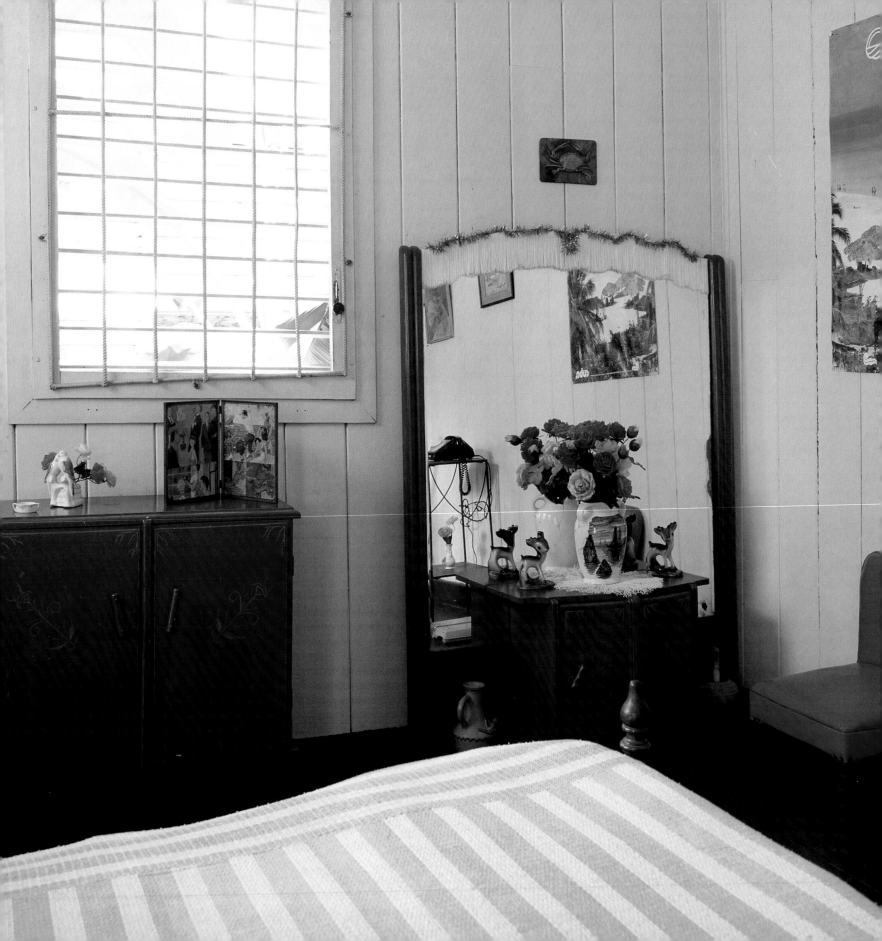

wooden terraces dating from the eighteenth century.

The most striking feature of this sunny yellow bungalow is the front garden of cacti, a plant peculiar to the eastern part of Cuba with its intense dry heat year-round. One of the highlights of the nearby coastal park, Bacanao, is the cactus garden of more than 400 varieties, while the road from Santiago to the eastern tip of the island winds through Cuba's only desert, ablaze with cactus flowers after the summer rains. The plant is also a personal favourite of owner Ruben Rodes who has slowly transformed the house and garden over fifteen years. The theme extends from the front garden on to the patio and throughout the home, with cacti planted in rusted tins, a potting device typical of the region.

Inside, the structural elements have been kept as simple as possible, the ideal foil for the cultural flotsam, local crafts and homemade ephemera that give this home its personality. Rodes has culled inspiration from Thirties Miami, from Santiago's regional crafts, from Cuba's European style traditions and its recent Soviet heritage – a mix he jokingly calls 'baroque kitsch'.

OPPOSITE, RIGHT *The rosy hues of the main bedroom reflect the owner's love of 'tasteful' kitsch. Working with the white timber walls, unadorned windows and simple furnishings, he has created a cheerfully rustic mood, adding a lavender striped bedspread, touches of pink on the window frames, kerosene lamps, and simple vases full of flowers from the garden. The delicate shades of pink and lavender contrast with the wild tropical foliage outside*

ABOVE RIGHT *Recycled art adorns the bedroom walls. The silvery plaques were made by a friend; they are fashioned from aluminium foil that has been pressed onto moulds, then pasted onto old Soviet LPs – reminders of the former Soviet Union's long patronage of Cuba*

OPPOSITE *Red beads placed on the fingers of a spiky succulent in a rusted tin add a humorous touch to the living room*

BELOW, RIGHT, BELOW RIGHT *Functional homemade decorations include a screen of seed pods separating living and dining areas, and lights made from upended wine glasses in macrame holders. The crab shell crawling across the security screen is just for fun*

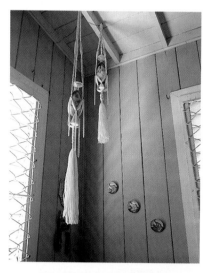

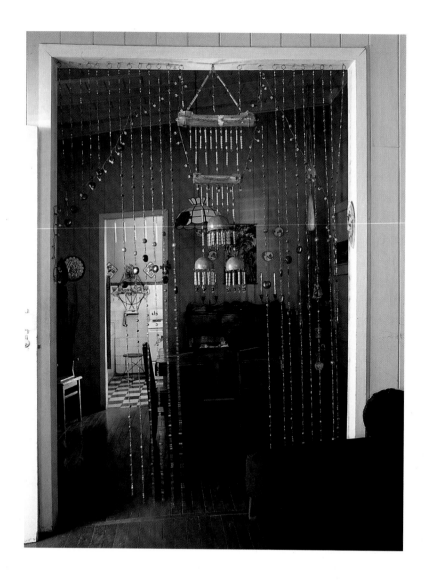

COLONIAL ROMANCE

Fittingly, the grandest house in provincial Trinidad commands its finest view, across the main square it dominates, and over the town to the Caribbean Sea. The original building dates back to 1740, at that time a single storey, but in the early 1800s the house was transformed into a two-storey mansion, setting it apart with its superior aspect. From its balcony, family members could have watched trading ships departing with cargoes of their sugar and returning with payment in gold. In addition to the best materials and craftsmanship that money could buy, the owners also purchased an aristocratic Spanish title with their sugar fortune, that of the Counts of Brunet.

Structured around an open courtyard in the colonial style, the Palacio Brunet with its elegant gallery and colonnaded facade is in some ways more reminiscent of the mansions of Old Havana than of Trinidad, yet it is stamped unmistakably with the distinctive features of the regional style. The entrance to the palace opens on to a large courtyard, overlooked by the second-floor balcony. The family lived upstairs, while the business of the sugar plantation was conducted downstairs.

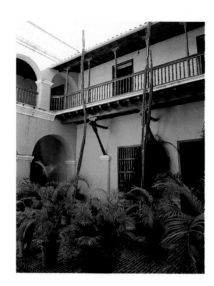

OPPOSITE *The elegant dining room, with fanned ventilation panels over the shuttered windows, is painted green to reduce the glare of the sunlight outside. Green was thought to absorb light and be particularly easy on the eye. It was a popular choice for exteriors and interiors throughout Cuba*

LEFT *In the muted yellow courtyard with its grilled windows and high, second-floor gallery, the Palacio Brunet reveals its architectural origins in Moorish Spain. The cobbled courtyard once served as an entrance for horses and coaches bringing visitors on business*

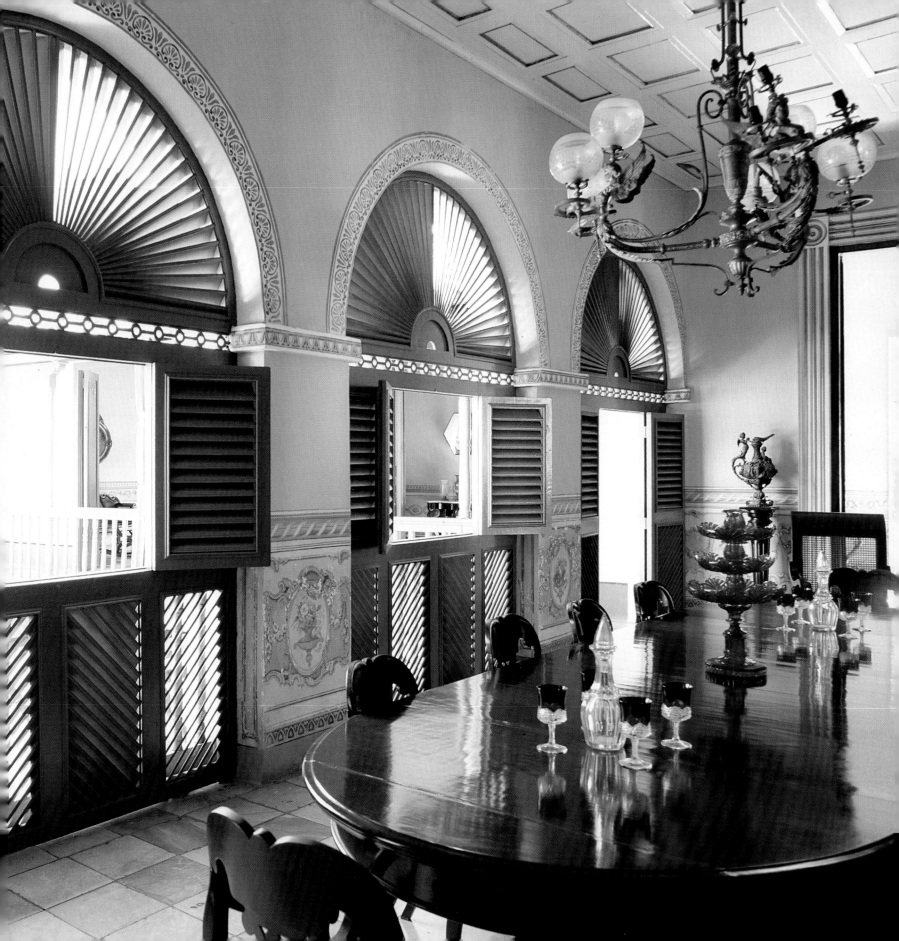

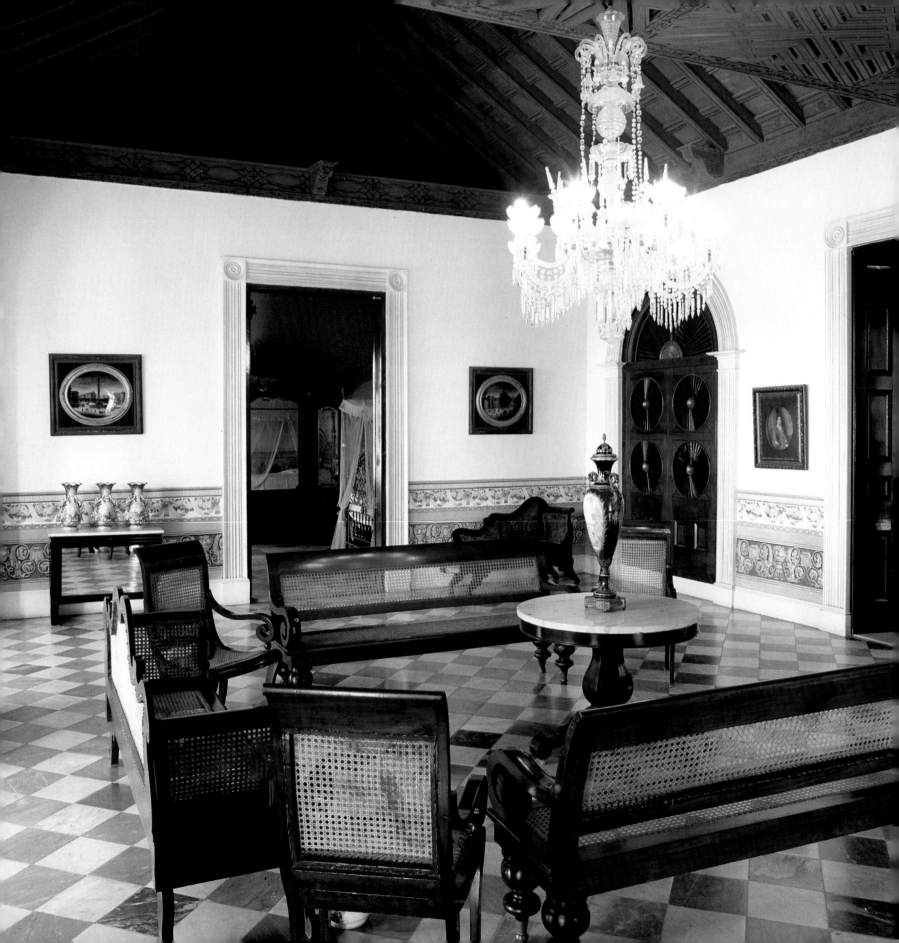

The primary purpose of the building was keeping its inhabitants cool and shielded from the intense sun. To that end, the main living rooms are collected under the one enormous *alfarje* ceiling. The decorative carving on the low horizontal support is considered especially beautiful, a marriage of art and function that harks back to its Arab origins. Left unpainted, the cedar ceiling is in stark contrast to the dainty colouring of the wall partitions and fine, nineteenth-century furnishings.

Another special feature of the house is the fanned wooden arcs above the windows. Called *medio puntos*, these screening devices are more often worked in stained glass. The wooden examples in the Palacio Brunet are among the best in Cuba, and create a soft ambient light in the main living areas. In the pale green dining room the fanned *medio puntos* are repeated in the doors of a porcelain cabinet built into the wall between the dining and living rooms, allowing air to flow between the two. The furniture and fittings throughout the house have been collected from Trinidad's splendid old mansions, painting an authentic picture of the lifestyle of the town's great sugar barons.

OPPOSITE *A magnificent* alfarje *ceiling of Cuban cedar dominates the central salon, creating a vast canopy encompassing the surrounding rooms. A ventilation panel above the arched cupboard extends through to the adjoining dining room to enhance the airflow*

ABOVE RIGHT *The kitchen with its smooth, flagstone floor, beautiful tiled stove and basic implements is unchanged from its construction in the late 1800s.*

RIGHT *With its simple tub of marble, the bathroom of the Palacio Brunet is modest compared with those in other plantation mansions. One in Trinidad was said to contain a bath spouting gin and eau de cologne*

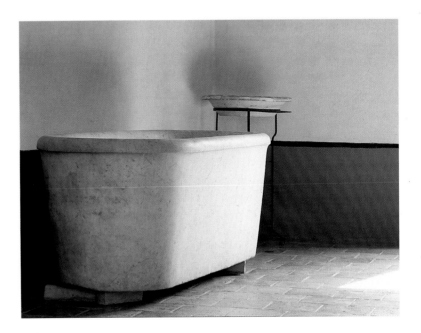

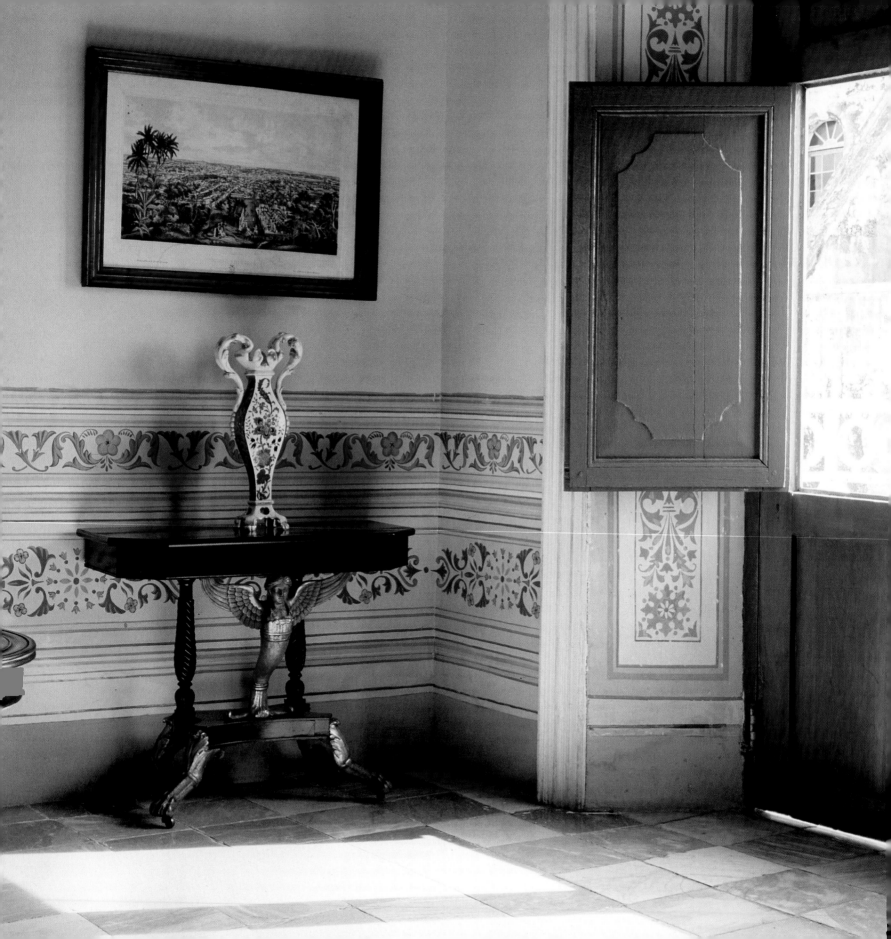

OPPOSITE *A shuttered panel within a door allows the amount of light entering the home to be carefully controlled. Features like this were crucial architectural elements in the Cuban palaces of the eighteenth century*

BELOW, RIGHT, BELOW RIGHT *Delicate shades of Delft blue define the second-floor bedrooms, which open off the main salon. A fresco, restored to its original colour, forms a deep skirting*

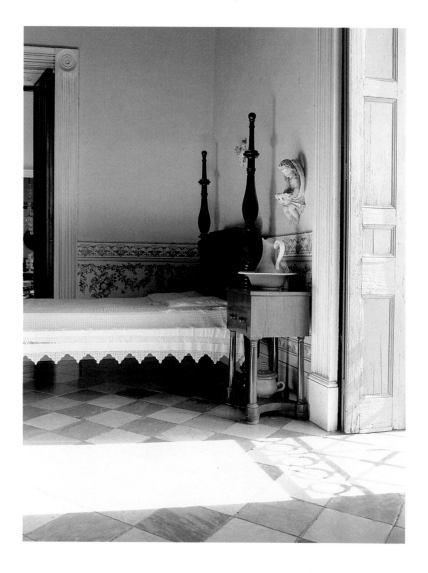

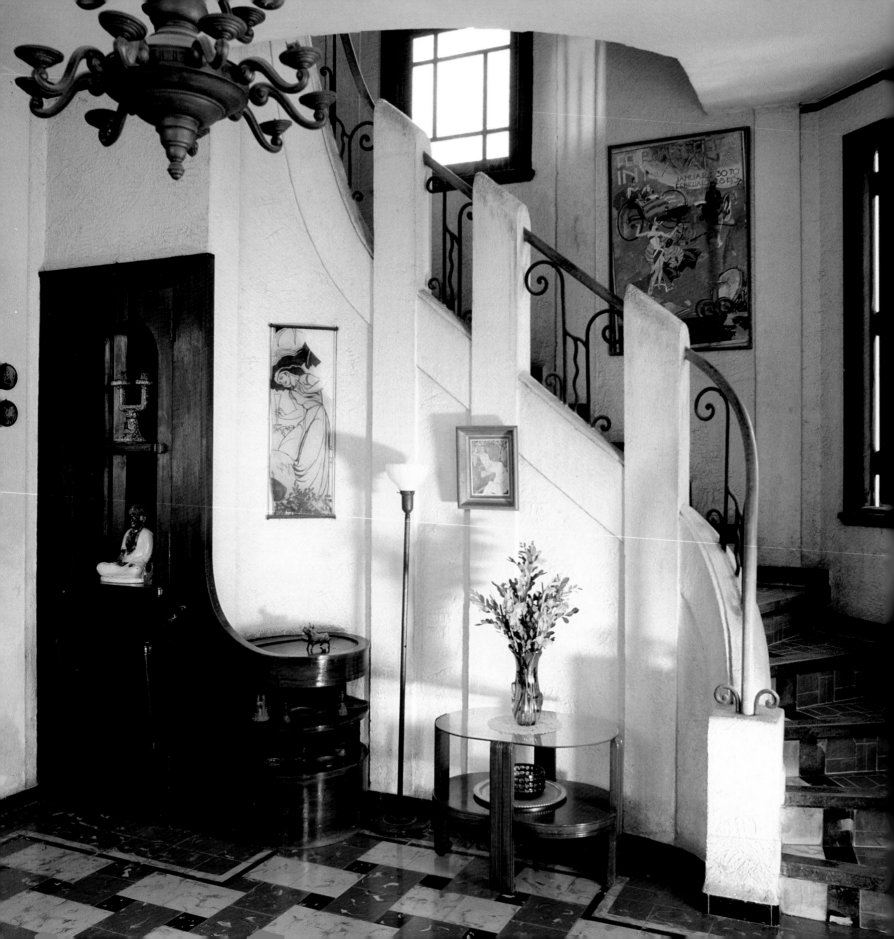

A MODERN VISION

Vedado is a showcase of European architectural styles. In the quiet residential streets of this Havana district Neoclassical mansions sit alongside Art Nouveau houses and Fifties modernist apartment blocks. Many of these buildings look as though they have been translated directly from Europe, others show clear adaptions to the local climate, and some – like the house of Olimpia Menendez – are highly original.

The house was commissioned in the 1930s by the current owner's uncle Enrique Garcia Cabrera, a painter and illustrator, and one of the founding figures of Cuba's fledgling advertising industry. Success in the new business gave him the chance to realize his dream house, designed by architect Max Borges Snr.

When completed in 1936, the house was the talk of Havana's chattering classes, a departure from the grand, heavily decorated mansions of Vedado. With its flat facade, functional design and distinctly graphic qualities it made an appropriate environment for the modern-minded Cabrera.

The central feature of the house is the curving staircase. Its expressive design incorporates exposed vertical beams that rise

OPPOSITE *The foyer features motifs of the Art Deco movement – the graphic flooring, the expressive structure of the staircase, and the panelled windows. Yet the use of dark timber and wrought iron also give it a distinctive Cuban feel. The window shapes, the revealed vertical beams, and patterned floor tiles reappear in the other living areas of the house*

RIGHT *Below the stairs, a wooden panel with recessed shelving and a pouch for holding umbrellas swings open to reveal a tiny bathroom – very much in keeping with the functionalism of Thirties' architecture*

above stair level to create the foundation for the banister. A slim iron handrail threads through them, its delicate curly supports balancing their solid presence. Underneath the stairs, a recessed shelving unit ingeniously swings open to reveal a bathroom. The geometric detail in the stairwell's elongated, panelled windows is echoed in the red, black and white floor tiles in the vestibule and throughout the house.

With the dominant graphic lines provided by the patterned floor and strong window shapes, there is little room elsewhere for extraneous structural detail. The rooms are simply decorated with plain, dark wooden furniture from the turn of the century – brought here from Cabrera's previous house – and bold Spanish-style light fittings.

Behind the house, set in a luxuriant garden, is Cabrera's studio hideaway. High timber ceilings are supported by thick mahogany beams, and the sense of scale is enhanced by a large panel of tiny windows illuminating the studio space. The artist's paintings hang on the walls, and his final work – in progress at the time of his death in 1949 – remains unfinished on the easel.

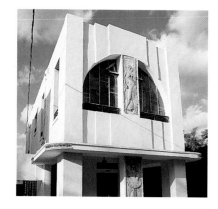

OPPOSITE *In the dining room, touches of primary red on the table and in the heavy Spanish-style light fitting add to the bold quality of the Art Deco interior*

ABOVE RIGHT *The flat, stylized facade of the Menendez house stands in stark contrast to the Neoclassical and Art Nouveau mansions that dominate the Vedado district of Havana*

RIGHT *The distinctive pattern of the windows with their asymmetrical panels provides the unifying architectural feature throughout the house, a departure from the heavy shuttering so typical of traditional Cuban homes. Vertical beams are picked out in cream against the white walls, enhancing the graphic style of the décor*

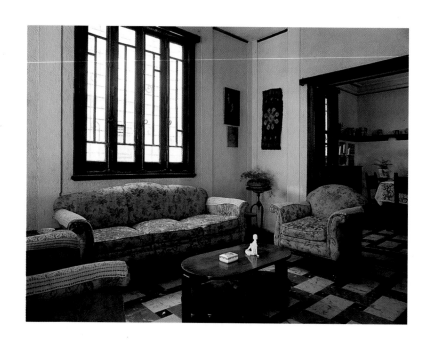

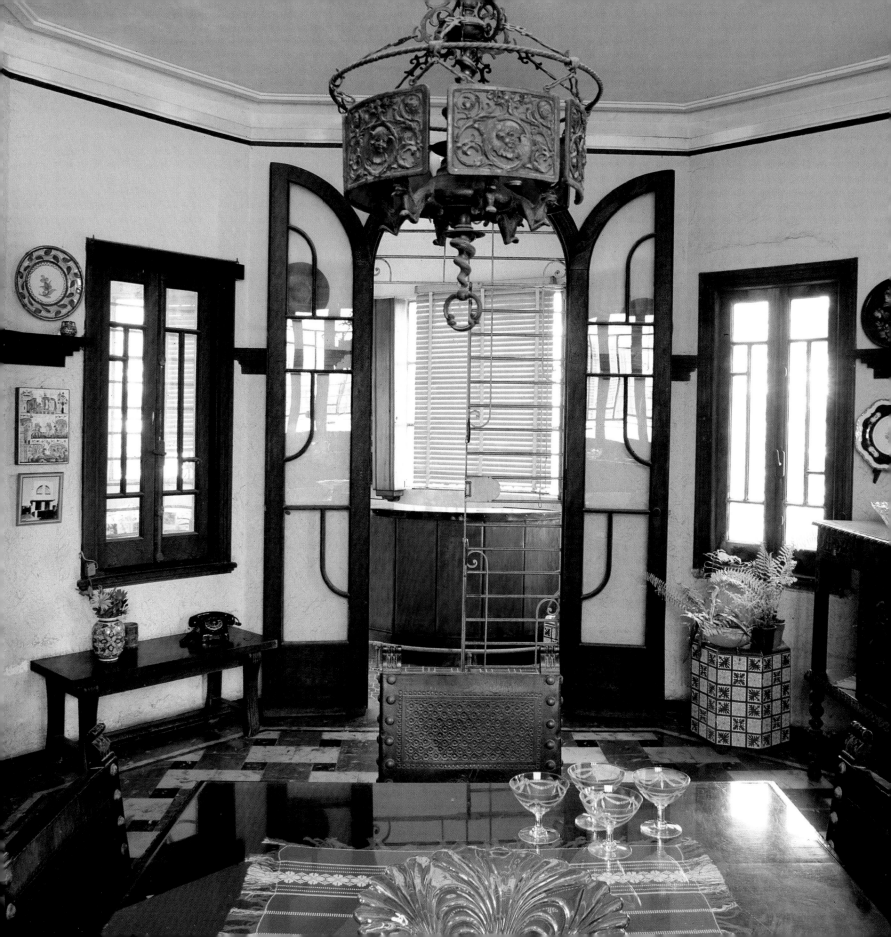

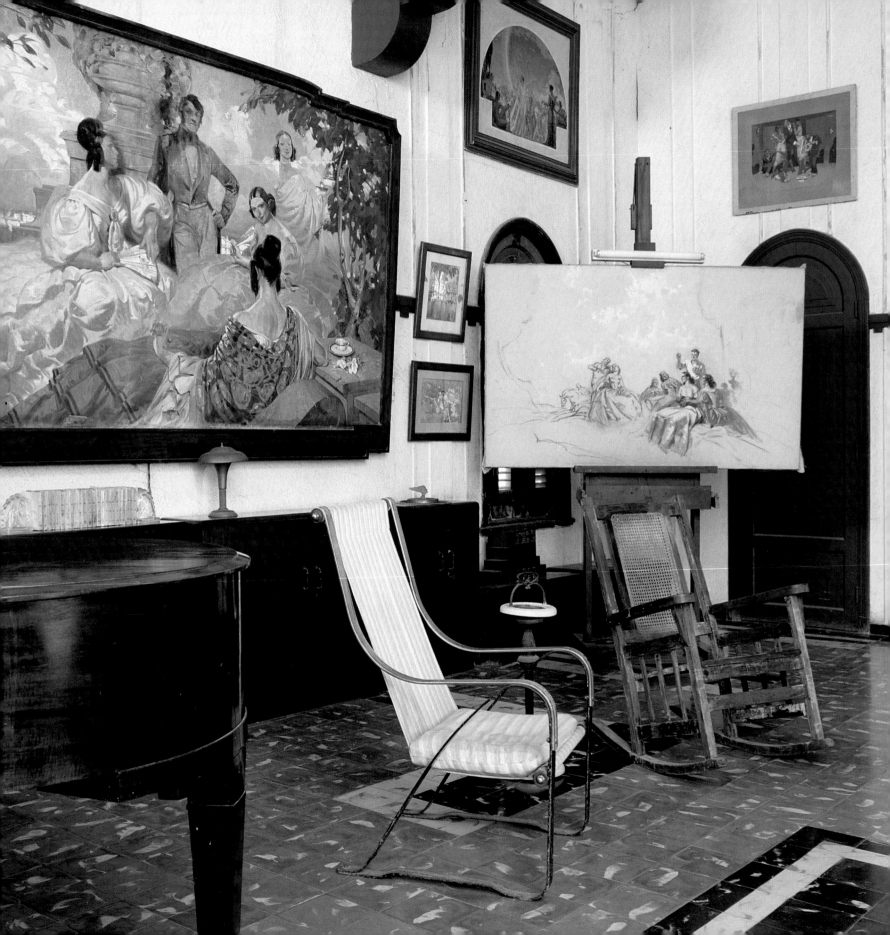

OPPOSITE, BELOW *A separate studio was constructed behind the main house. An unfinished painting by Cabrera still stands on the easel*

RIGHT *A poster-style painting of provincial workers, a typical subject of the artist, dominates the studio entrance*

BELOW RIGHT *Enrique Cabrera's writing desk is preserved, complete with Remington typewriter*

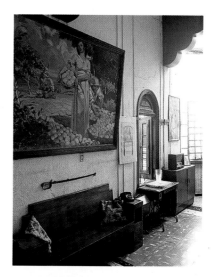

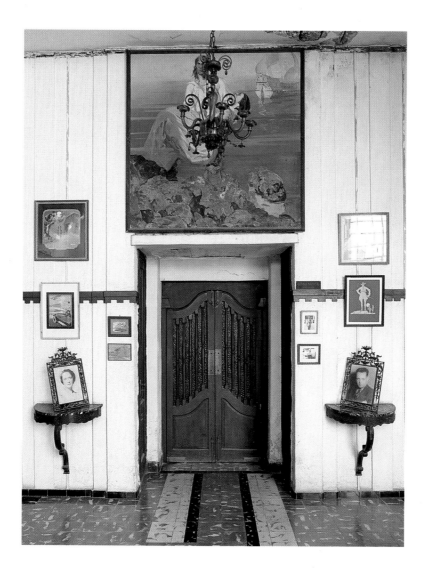

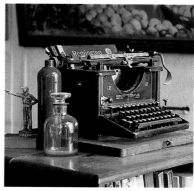

THE MARBLE MANSION

The historic houses of Old Havana have been well documented, the focus of much of the architectural world's fascination with Cuba. Within the limited confines of the old colonial centre it has been possible to piece together the development and history of the most significant buildings, now hundreds of years old. But the twentieth-century district of Vedado is quite another matter – not only because the passing of time has yet to make its houses seem as historically important but also because many of the mansions lining its tree-lined residential streets are shrouded in mystery.

Villa Lita is one such place. Acknowledged by historians as one of the finest Vedado homes still intact, it has been spared the ravages of decay. Yet the full details of its design, construction and interior are privy to only a very few. It may be that, like many of the private houses built by rich Cubans in the early 1900s, Villa Lita has intentionally been shielded from prying eyes. After 1959, when Fidel Castro and his band of rebels brought revolution to Cuba, many of the inhabitants of Vedado mansions left their beautiful homes to start new lives abroad. Those that stayed have been understandably hesitant to discuss such recent and politically charged history.

What is known about this extraordinary mansion is that it was built in the 1920s, very much in the Art Nouveau style that

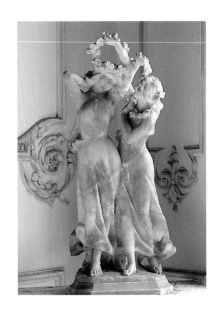

OPPOSITE *The inky silhouette of a winged figurine balances on a pedestal at the foot of the staircase, in sharp relief against the dusty pinks and greys of the marble vestibule*

LEFT *Marble details are everywhere, as in this pair of delicate Art Nouveau maidens*

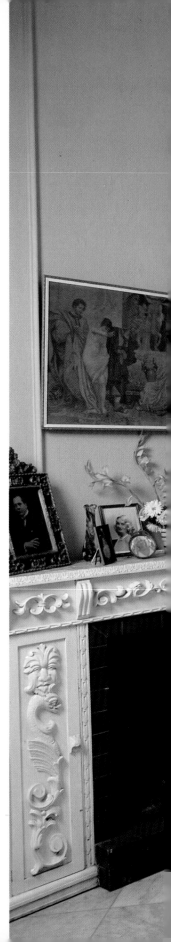

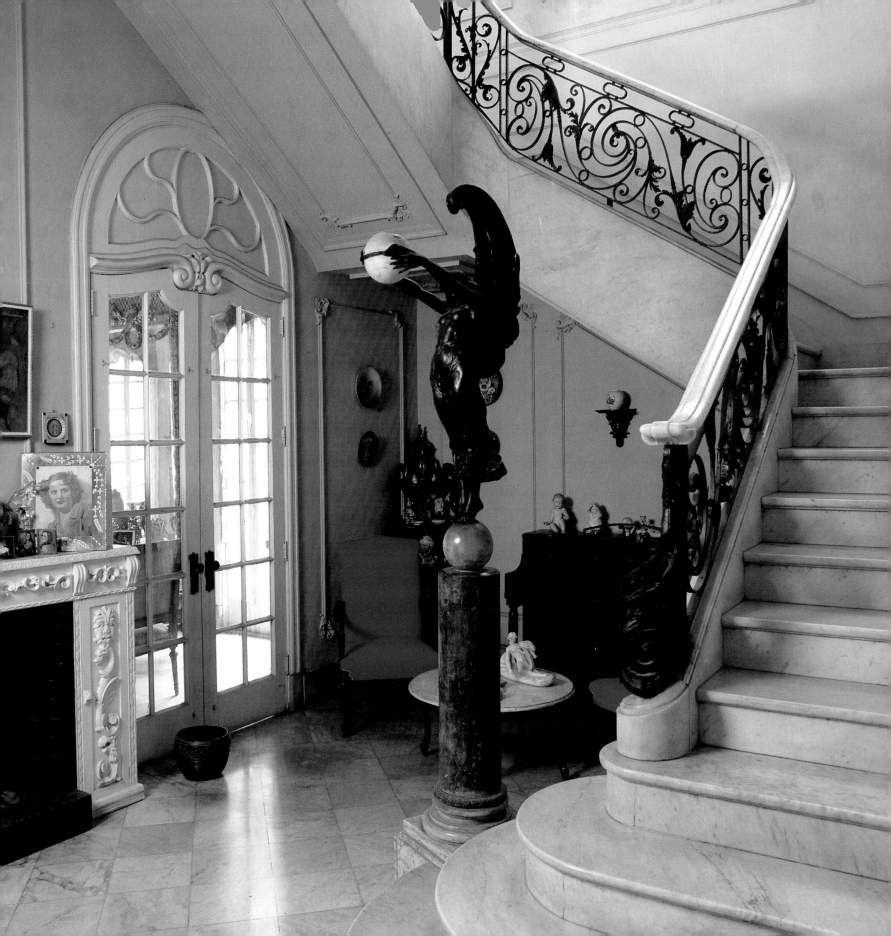

influenced so much of Havana at that time, and that it had a most auspicious start. Construction of the house was begun by Carlos Manuel de Cespedes, the son of a national hero. His father, a plantation owner, had sparked the flame of revolution against Spain in 1868 when he freed the slaves working on his estate. Cespedes junior, however, was never to live in the house he had begun, for when it was only half built he sold it to marble tycoon Jose Penino Balbato, who would have been impressed by its commanding position on the Paseo, a grand avenue sweeping through Vedado that linked the Prado with newer residential areas west of the old city.

Dubbed the King Of Marble, Balbato finished the house with his stock in trade. The floors are still covered in the smooth grey marble tiles he laid to create a seamless surface with almost mirror-like qualities, creating the perfect backdrop for luxurious European furnishings and a wall of radiant stained glass in the conservatory. Marble appears in numerous other guises throughout the villa – in gracious statuary and in the immense marble light fittings that dominate the house. Balbato's true love though was not the stone he worked with, but his wife Lita, for whom he built the house. Although none of the original family members live here, the present owner still touchingly maintains the mansion as a shrine to the woman who inspired it.

OPPOSITE *Gold festoons decorate the walls and high ceilings of Villa Lita's drawing room, dominated by a crystal chandelier. The French doors feature Art Nouveau scrolling*

ABOVE RIGHT *More lighting exotica – here classical maidens cradle a globe of alabaster.*

RIGHT *The study is decorated in a sturdy Spanish style with dark wood skirting and mahogany furniture. Adding contrast and light are pale green walls, and the delicate threads of a Thirties' chandelier*

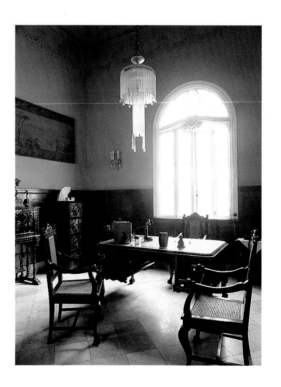

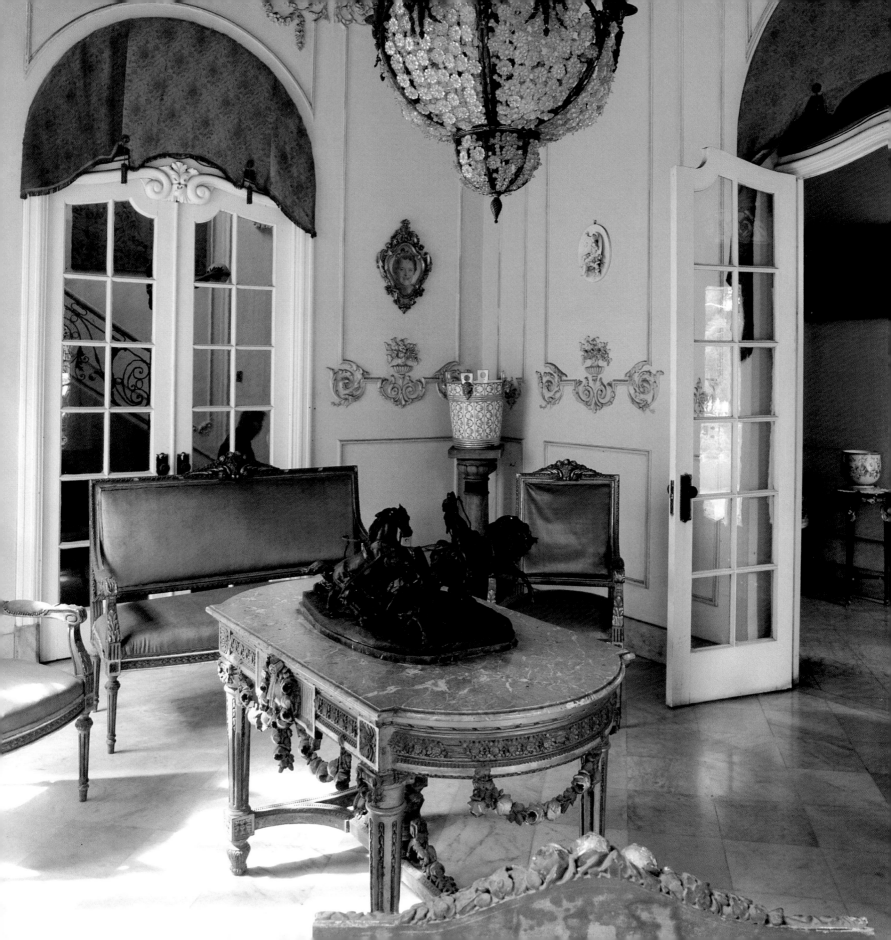

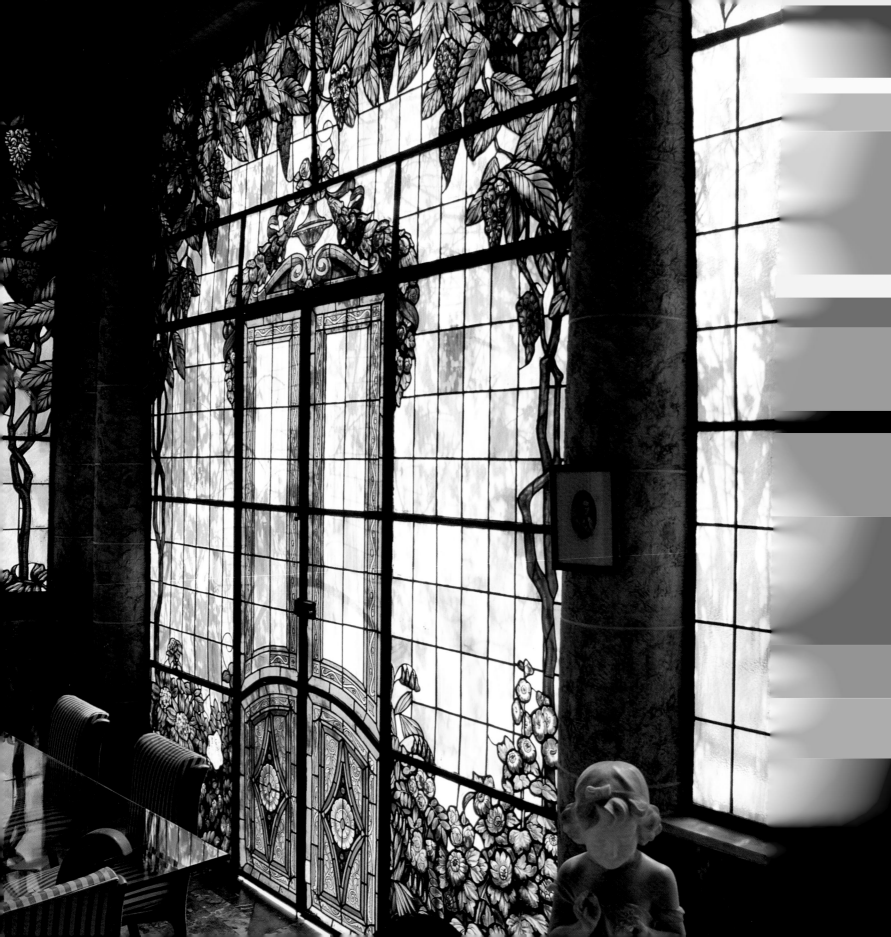

OPPOSITE, BELOW *Coloured glass has been used in Cuba for centuries to diffuse the tropical light. Here it reaches its logical conclusion – a wall of vibrant stained glass depicting an exotic sun-drenched garden of grapevines and climbing flowers. The scene forms the rear wall of Villa Lita's conservatory, and provides a startling view from the front door of an Art Nouveau Garden of Eden*

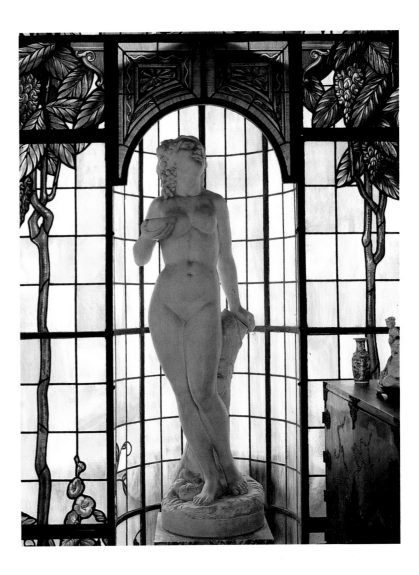

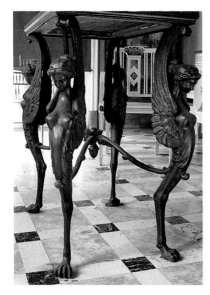

OPPOSITE *The blue panelled salon, with its checked marble floor, is decorated with a mix of French Empire, Art Nouveau and Cuban-influenced furniture*

LEFT *A striking Art Nouveau table base of nymphs, whose winged backs and feline feet recall the mythological griffin*

BELOW, BELOW LEFT *Elegant chairs in the French Empire style*

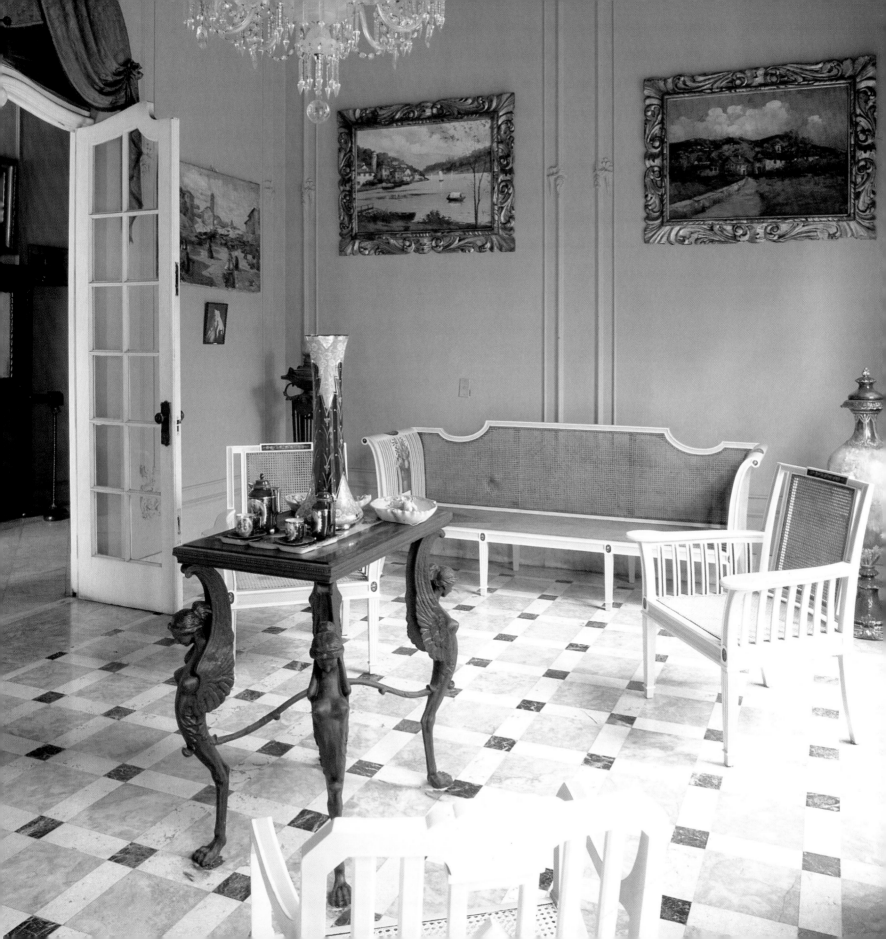

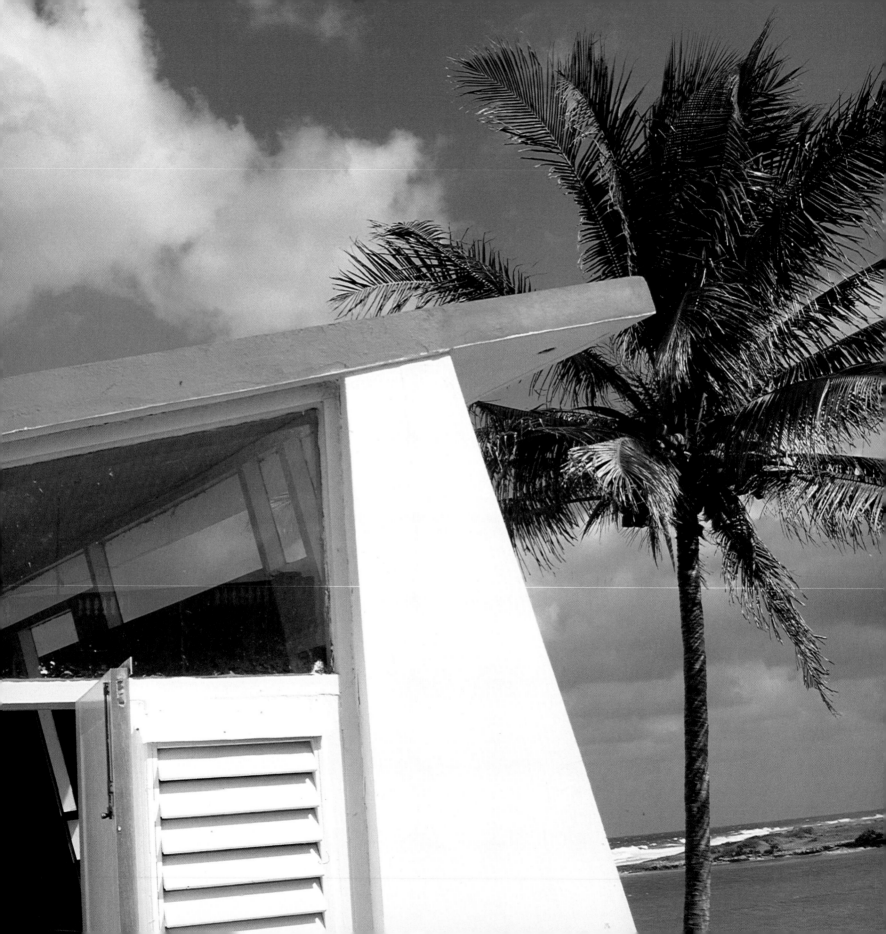

NAUTICAL LINES

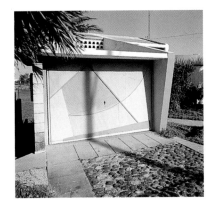

It was in the fishing village of Cojimar, about half an hour west of Havana, that Hemingway moored his cruiser, drank with the locals and embarked on his legendary marlin safaris. What, then, could be more appropriate than a house which so cleverly evokes the organic curves and sharp lines of a boat. Perched on the edge of tiny Cojimar Bay, it looks out to the Atlantic Ocean, as if expecting to set sail at any moment.

The house was commissioned in 1957 as a holiday retreat by the present owner's grandfather, who paid the then-extravagant sum of US$40,000 for its design and construction. The architect was Arguimidez Poveda, at one time also the Korean ambassador, and in 1958 he won an award for his innovative plans for this house.

He shaped the building around a steep slope of land, creating a one-storey structure at street level that evolves into two

OPPOSITE *The rear deck opens out to views of Cojimar Bay and the Atlantic Ocean beyond*

ABOVE RIGHT *'Fossilised' shells pave the way to the garage, setting the mood for the nautical theme inside*

RIGHT *The dining area is a small gallery above the lounge. Space is maximized with a custom-built table in the shape of a whale*

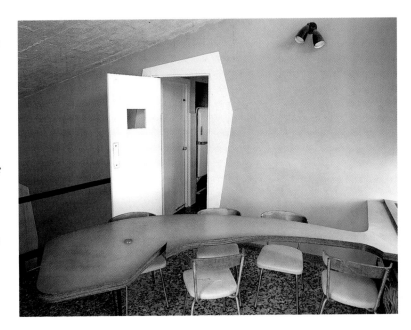

surfaces and geometric planes. The back by contrast is almost entirely of paned glass, complemented by balconies that extend from the living areas for wonderful views across the bay. The wooden deck at ground level leads to a small jetty, providing instant access to the water.

The star-crossed front door opens onto a light-filled lounge room with stairs leading up to the galleried dining area, kitchen and outdoor deck, while a smoothly curving hallway with port-hole lighting leads to the bathroom and secluded bedrooms.

Shades of pale blue and turquoise throughout the rooms reinforce the marine theme, but the house does not take itself too seriously. The entrance path and driveway are studded with fossil-like concrete shells, and the bathroom window is a port-hole. Best of all, however, is the Moby Dick table in the dining gallery. Constructed from formica on wood, the whale-shaped trestle was custom-made for the room and features a cheeky red flashing strobe for an eye.

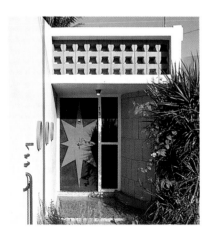

OPPOSITE *The shape of the bright orange starburst on the front door is repeated in the detailing around the door handle*

ABOVE RIGHT *The front door offers a taste of the colours and graphic shapes to come. Inside, black and orange feature strongly as highlight tints in classic Fifties style. Open block-work above the front door allows light and breeze to penetrate a largely windowless front facade*

RIGHT *Terrazzo floors, sharp lines and unstructured spaces lend a distinctly modern look to the lounge area. In contrast, two framed seascapes add a homely touch. The staircase leads to a gallery level housing a compact kitchen and dining area*

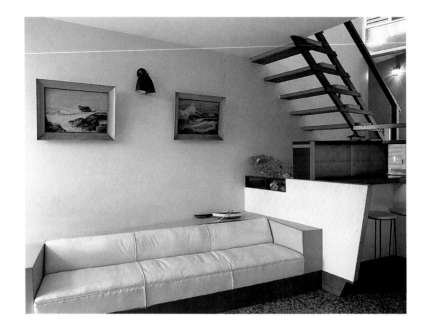

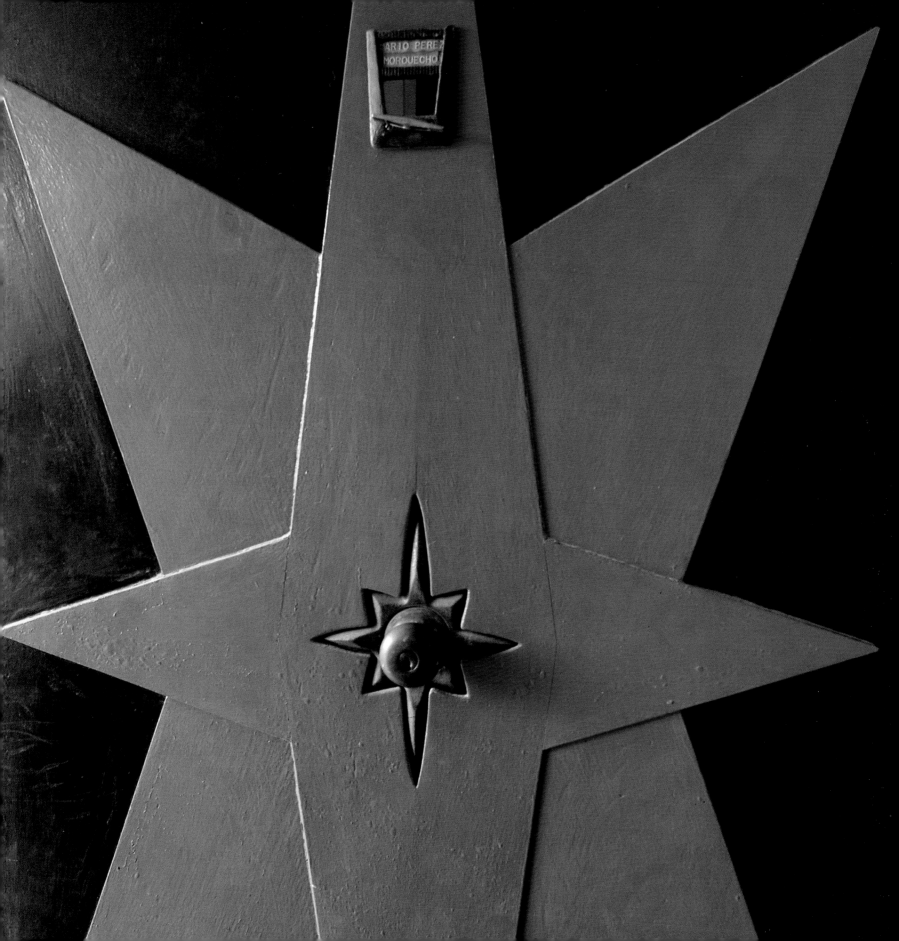

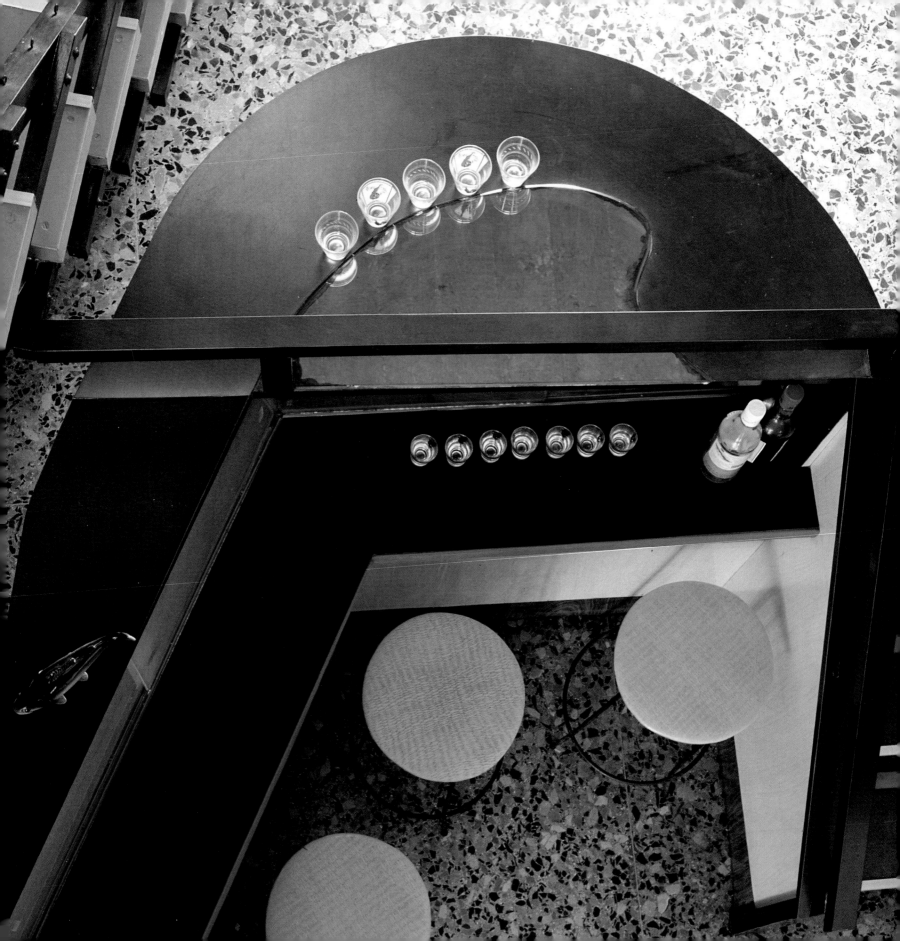

OPPOSITE *Viewed from the dining gallery, the bar below takes on an aquatic curve. The bar is one of several pieces of functional 'built-in' furniture in the house – a hallmark of Fifties style. The lounge is also created as a permanent part of the interior structure, as is the dining table upstairs*

BELOW *The lounge area combines clean geometric lines with fun Fifties' colours in the turquoise sofa and bright red chair. Beyond the wall of mismatched glass panes and louvred panels extends a timber deck overlooking Cojimar Bay, providing the ideal setting for summertime living*

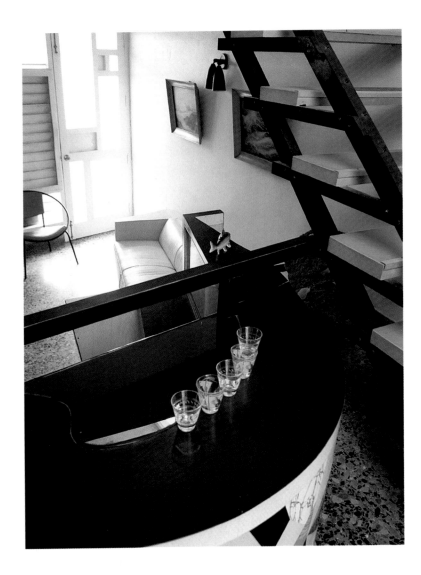

NOUVEAU BAROQUE

The Mauri clan is one of the few dynasties still present in colonial Trinidad. Many of the town's aristocratic families left the town, their fortunes in tatters, in the late 1800s after the crash of the sugar market; others emigrated in the Sixties after the Communist Revolution. The Mauris, however, remain in homes that have been in the family for generations, like the palatial residence of Miguel Suarez del Villar y Mauri on Calle Gloria, in the heart of old Trinidad.

The house, a gregarious mix of styles spanning two centuries, was passed down from Miguel's uncle Don Antonio Mauri Urquiola, and from his father before that. Dating from colonial times, it has been restyled over the years to reflect changing tastes and wealth. Although the original structure itself remains largely unchanged, a cosmetic overhaul in 1926 – at the peak of the Mauri family fortune – dramatically altered the look of the house.

A columned balcony runs the length of the facade, as per the original construction, offering soothing views of a lush tropical garden. Where once the exterior walls were painted with the

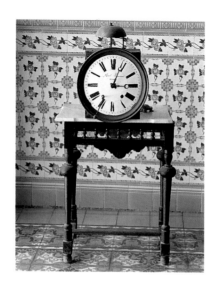

OPPOSITE *The sumptuous tiling of the interior is inspired by the Art Nouveau movement with its emphasis on colour and exuberant decorative surfaces. Yet the use of such ceramics dates back to the early Islamic world when a ban was placed on representative art. In its place, elaborate abstract designs were developed to add colour and interest to the interiors of mosques and palaces. Decorated tiles were also sometimes used for cladding entire exteriors*

LEFT *Dainty garlands of pink roses on glazed tiles provide the perfect backdrop for an antique timepiece with chiming bell*

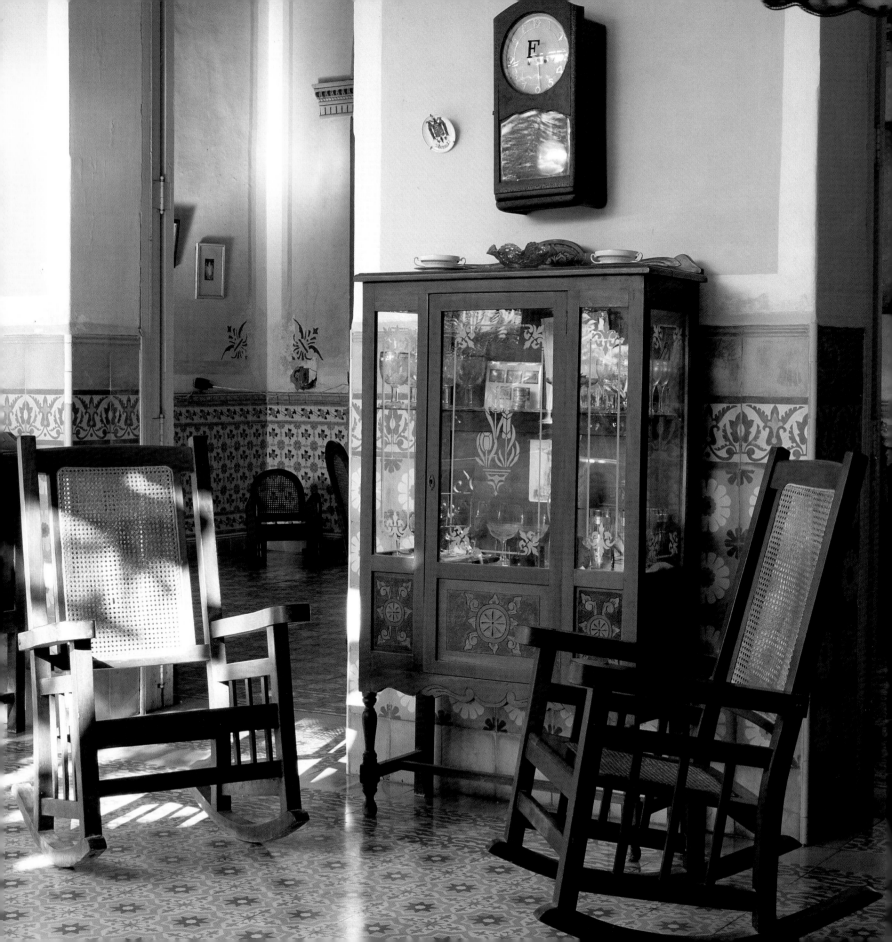

characteristic Trinidad colours of muted yellow or green, vividly patterned tiles have taken over. And the original wooden railings of the veranda have been replaced by swirling wrought-iron panels. There are few other houses in Trinidad to match it for its extravagant exterior details, which bring to mind the intense ceramic surfaces of the Art Nouveau movement.

The decorative flamboyance continues inside with glimmering tiles in shades of turquoise and claret forming a deep skirting around the walls, while the expansive floor is covered in rich reddish browns and golds. The layout of the house is typical of a colonial residence – two large interjoining salons with rooms extending off these to either side. In this case the two central salons are divided by a pair of sweeping classical arches resting on marble columns reminiscent of the Beaux Art style. Coloured glass insets above the external doors and in the swing doors leading to neighbouring rooms complete the kaleidoscopic effect. The Mauri house is a rare example of post-colonial styling in Trinidad, and its exotic décor has earned it a place in UNESCO annals as a cultural treasure.

OPPOSITE A delicate wrought-iron grille marks the entrance to the main salon and its adjoining rooms, offering security but allowing air to circulate throughout the house. The grille pattern is echoed outside in the swirling panels of the veranda railing

ABOVE RIGHT The grand scale of the main salon with its dramatic arches and high ceilings is balanced by the colourful ceramic skirting and patterned floor. Sparse but elegant colonial furnishings provide a simple counterpoint to the lavish decorative surfaces

RIGHT A beautifully inlaid drinks cabinet, supporting a collection of fine cut crystal, is one of many period pieces still used by the family

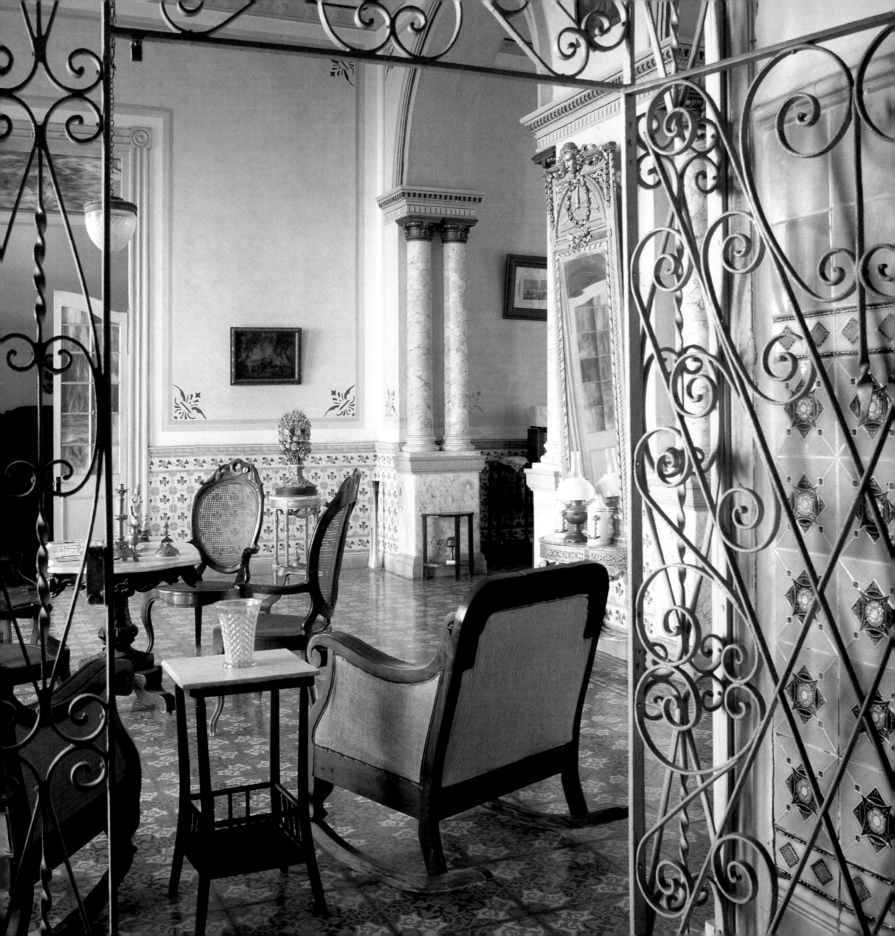

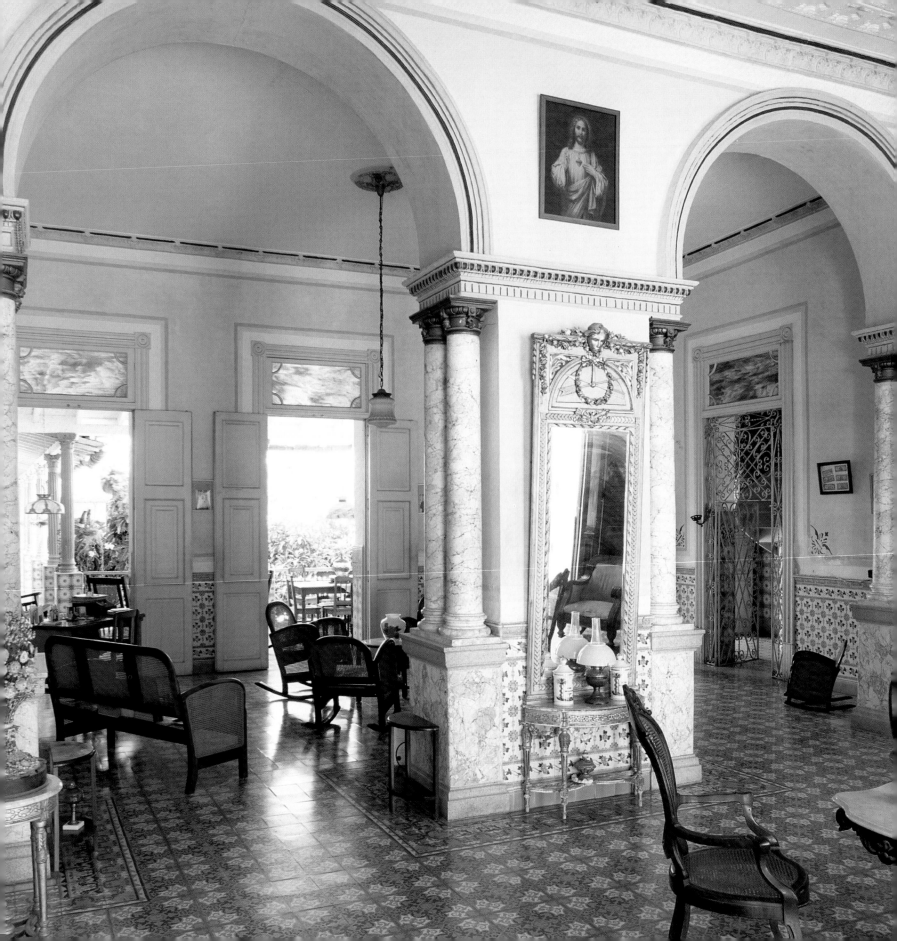

OPPOSITE, RIGHT *The boundary between indoor and outdoor living is blurred to create a flowing sense of space. The tiled flooring extends outside, creating the illusion of the veranda as an additional room*

BELOW, BELOW RIGHT *The focus of household living is the veranda with its shady eaves overhead, wicker-backed rocking chairs, and cool ceramic tiles underfoot*

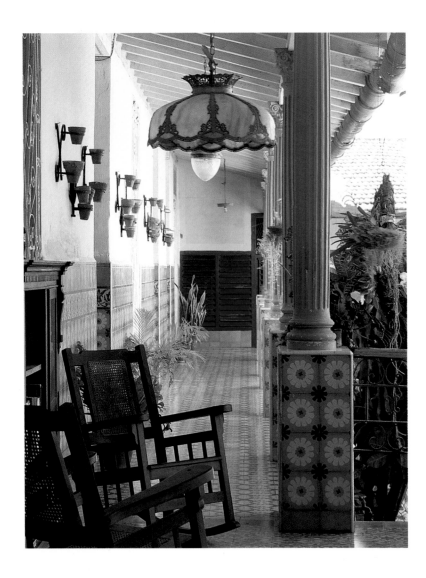

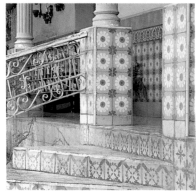

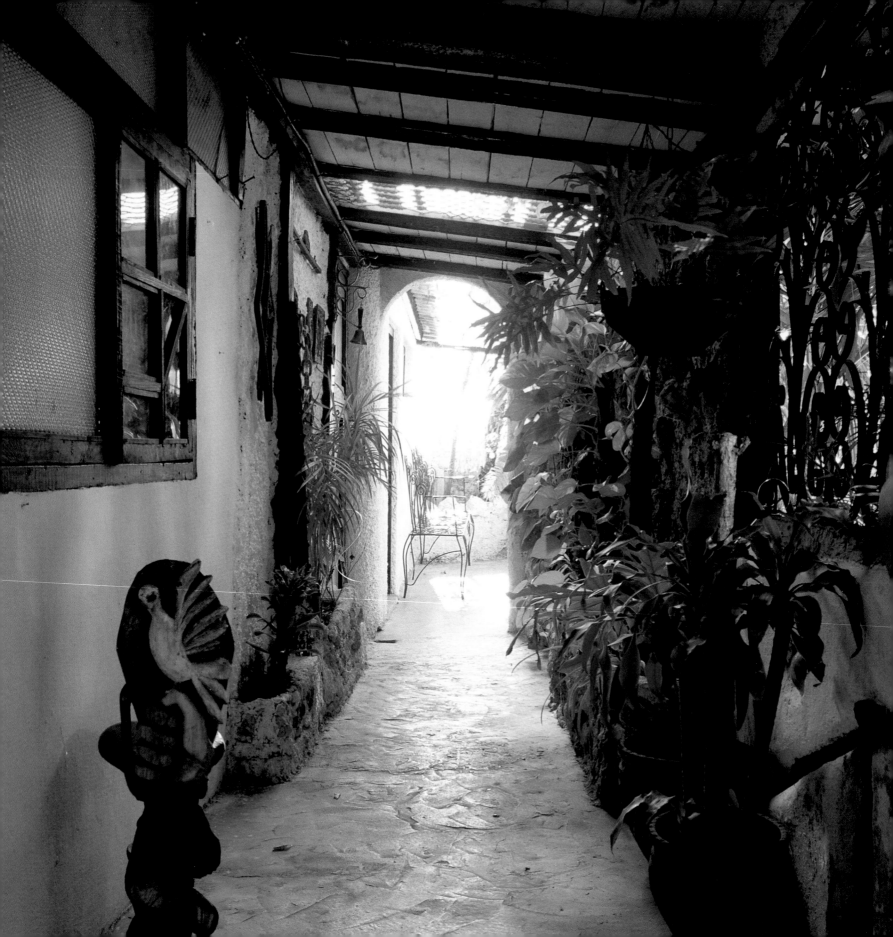

ROOFTOP BOWER

Looking out over the treetops and mansions of Havana is a unique living space that represents the contemporary face of Cuban design. It is an inspiring example of creative solutions to both a shortage of conventional materials and a most unusual setting.

When artist Adela Herrera moved here fifteen years ago, her home consisted of little more than two tents pitched on the flat concrete roof of a four-storey apartment block dating from earlier this century. Gradually she began to shape a home around her, using flotsam, jetsam, sand and shells from Havana's nearby eastern beaches; architectural features, decorative pieces, or structural materials from demolished or deserted buildings; and discarded junk or items donated by friends. Her vocation as a sculptor soon became evident in her textural approach to surfaces and her organic approach to structure.

First Herrera constructed rough daub walls from a mixture of cement, sand, rocks, shells and green glass bottles. These

OPPOSITE *A living corridor of greenery leads from the garden terrace to the common living areas. Bedrooms are situated to the left, while to the right is another open garden. The wrought-iron grille and windows were salvaged from sites around Havana*

RIGHT *A whitewashed bar with wooden counter greets visitors to the apartment*

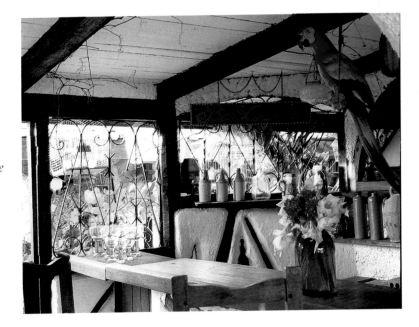

walls marked out the main living areas, creating a crescent of rooms that flow from one to the other, each also looking out to a central core, left open to the skies. A combination of flat timber planks and rough wooden support beams were used to form a simple roof. The terrace flat gradually evolved, with new rooms added as resources allowed. Special finds incorporated into the design included an old well, slave chains from a former sugar plantation, and an antique stained-glass door.

More than a decade later, the space has become an exotic rooftop oasis, the open courtyard now a profusion of greenery, with striking views across the city to the seafront. In one secluded corner an outdoor shower offers a summer cool-down closer to home than Havana's waterfront or beaches.

The garden theme follows through inside to the kitchen where plants and creepers jostle for space with kitchen pots and pans and strings of garlic. With entertaining an important part of household life, the kitchen and garden terrace provide an ideal environment with several areas set up for dining.

An adjoining room provides a large studio space where Herrera paints her signature watercolours and works on sculpture commissions for clients in Cuba and abroad. She also designs and prints her own fabric, used in curtains, bedspreads, wall-hangings and cushions around the flat.

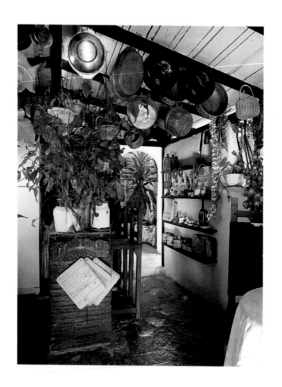

OPPOSITE *The apartment has been purposefully designed so that the boundaries between outdoor and indoor spaces are all but invisible, making it perfect for the relaxed, tropical style of Cuban living*

ABOVE RIGHT, RIGHT *The airy kitchen has a rough floor of slate and a sloping beamed ceiling hung with strings of garlic and onions, leafy creepers, and an assortment of pots, pans and baskets. On balmy evenings dining moves outside to the patio*

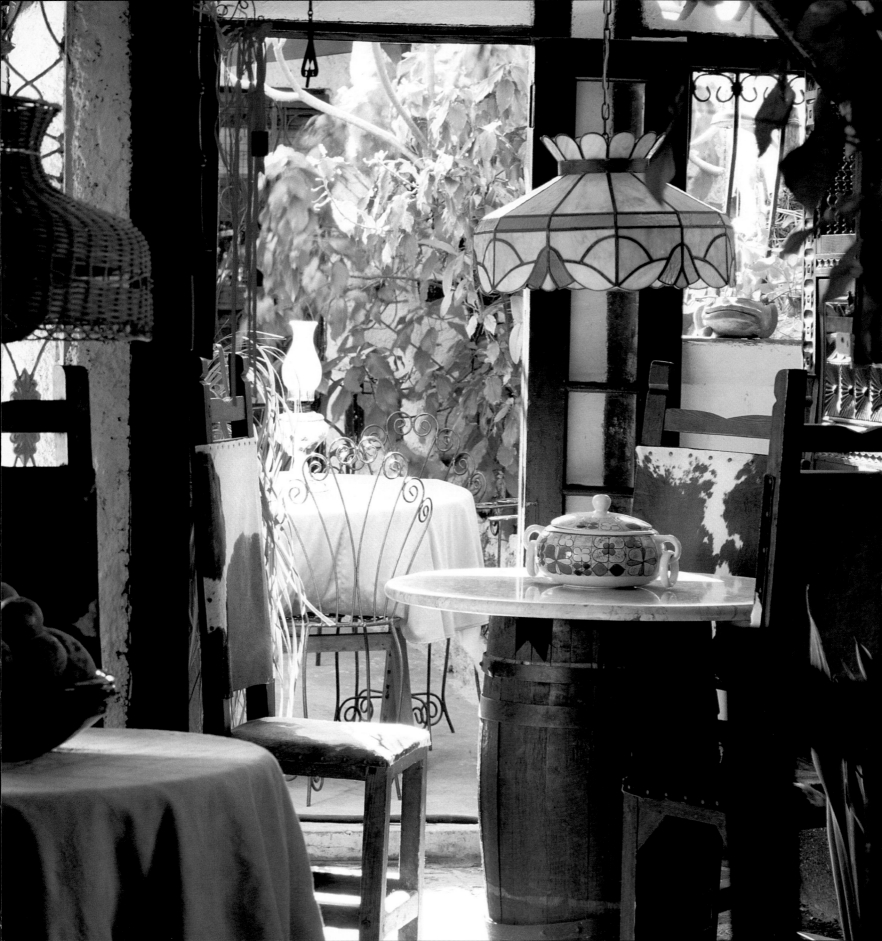

OPPOSITE, RIGHT, BELOW RIGHT *Daub walls were used to construct the first houses built by Cuban settlers. In a modern application, they are inset here with coloured bottles, pebbles and driftwood. The bottles act as a gentle light filter, in the same way as colonial stained glass*

BELOW *Displayed in one corner of the apartment is a collection of African artifacts, from which the artist-owner draws inspiration*

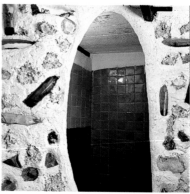

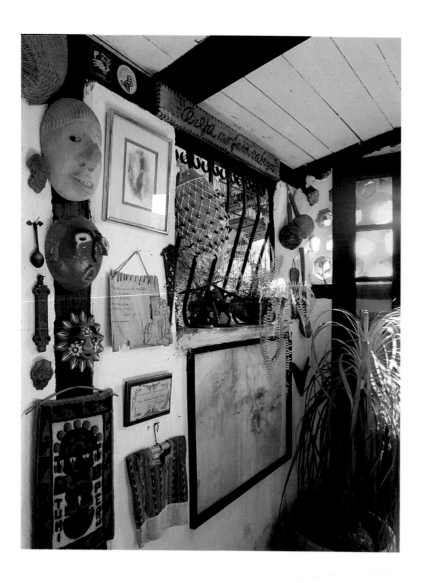

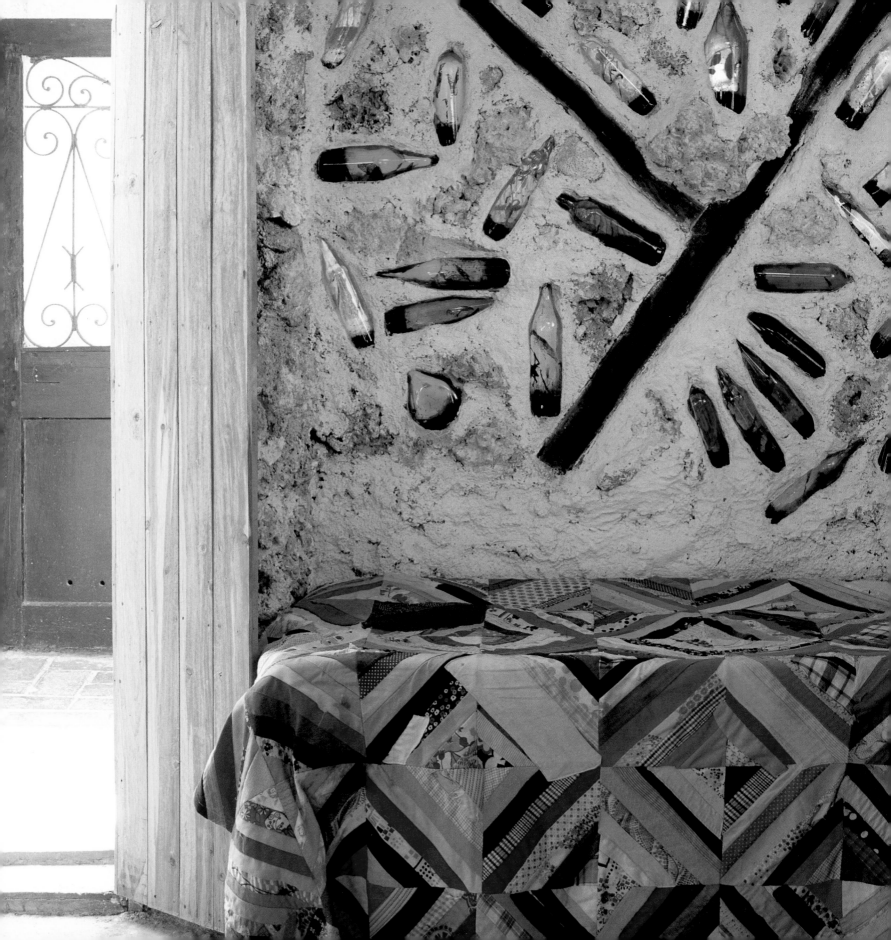

OPPOSITE *The main bedroom is constructed from salvaged timber and other eclectic finds, like a 19th-century swing door and animal horns which serve as a hat rack*

ABOVE *An antique iron bed, covered with a Cuban lace spread and hand-printed cushions*

BELOW LEFT *The artist's collection of beads and accessories collected on trips around Cuba and to Africa, where she travels on study trips and to research commissions*

BELOW RIGHT *In the guest bedroom, bottles set into the wall provide a unique focal point*

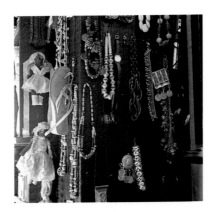

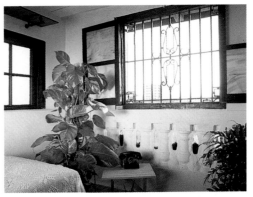

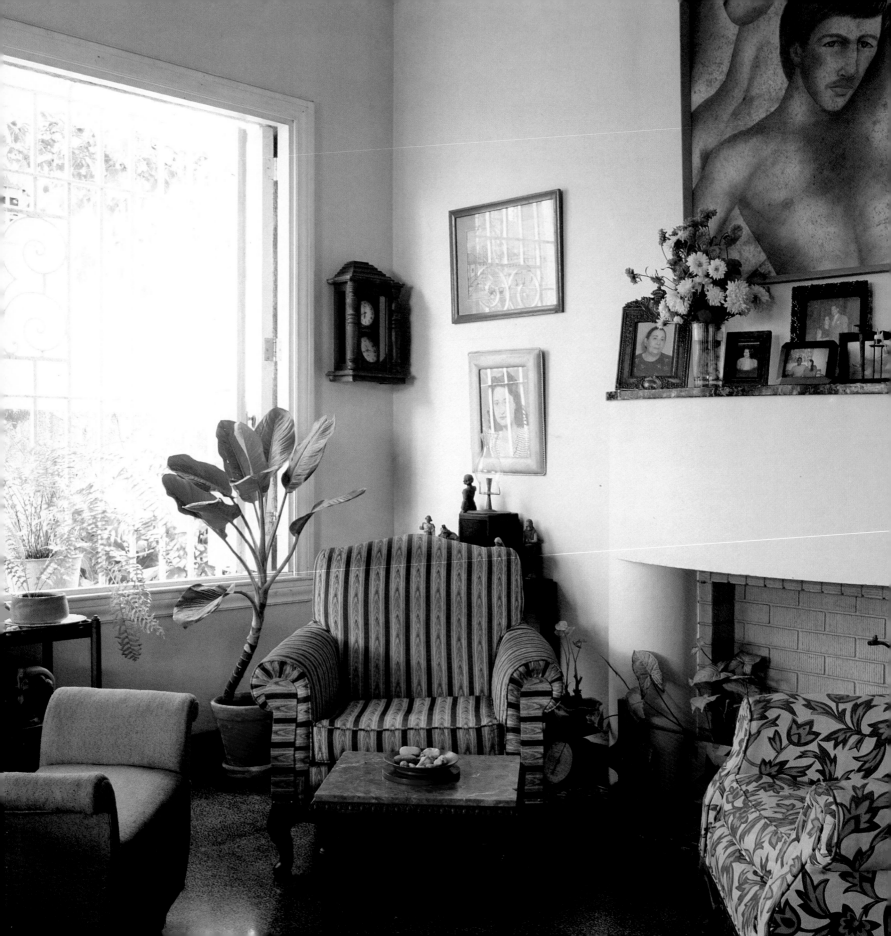

DECO REVIVAL

In a residential street in the exclusive Havana district of Miramar, an unusual restoration work is in progress – not a crumbling colonial mansion, but a late Art Deco house from 1940. It is one of the many elegant homes in Miramar built in the first few decades of this century, when American money, fashions and influence dominated Havana. With many of its original features in tact, the two-storey structure is midway though a careful interior facelift which has seen the ground-floor rooms transformed into an elegant living space that would not look out of place in Forties Hollywood.

The front door opens into a foyer painted in cool shades of green. The idea of owners and restorers Rafael Menendez and Hubert Corrales was to emphasize the contrasting planes of the walls and stairway by using complementary tones, yet remaining within one colour family to enhance the sense of harmony. This is a theme that continues throughout the house.

A bare hallway leads to the open lounge and dining area where the clean Deco lines provide the setting for an eccentric mix of curios, original Forties furniture and antique pieces. The

OPPOSITE *The lounge room combines modern Forties lines in mint green and ivory with an eclectic collection of furniture and art objects. Although rarely required in Cuba's sultry climate, the original fireplace dominates the room. Its solid Art Deco proportions provide a pleasing focus, the painting above echoing its colour and rounded shape. The mantlepiece serves as the backdrop for a collection of photos of family and friends*

RIGHT *Clusters of unusual objects, like this Art Deco side table with potted plant in a ceramic mug, form pockets of visual interest*

paint for the walls was pigmented by hand to create an authentic Art Deco green. The one exception is the fireplace which has been picked out in soft cream to emphasize its curving silhouette.

As a counterpoint to the streamlined style of the interior walls, the room has been brought to life with a characteristically extrovert Cuban look. To achieve this, Menendez and Corrales have concentrated objects throughout the living areas, like the lamp with Cuba's black Virgin for its base and a bust of Antonio Maceo, hero of the war of independence from Spain. Other intriguing features include the sculpted end of a timber beam from a seventeenth-century colonial ceiling, of particular interest to Menendez who works in the city historian's office, which directs much of the restoration work in Old Havana.

Beyond the lounge, a conservatory overlooks the garden. Filled with hothouse plants, the room is designed to provide a cool, contemporary environment for dining by mixing valuable pieces with inexpensive kitsch. Some of the furniture has been in the house since the 1940s; other pieces have been acquired since. The original floor is inlaid with pieces of stone paving from the sixteenth century. This intentional mix of design elements creates a relaxed mood in this and the other open-plan living areas. Yet, with a backdrop of palest green walls and charcoal terrazzo floors, the overall image is one of modern refinement.

OPPOSITE *A gilt mirror and elegant fireplace coexist with colonial-style rocking chairs and a kitsch coffee table with curly vine-like legs*

ABOVE RIGHT *Cuban homes, from colonial to modern, are typically incomplete without the presence of tropical plantlife*

RIGHT *Archetypal Art Deco features recall the grand proportions of a cruise ship. Strong structural elements, like the recessed porthole, make redundant any additional form of decoration*

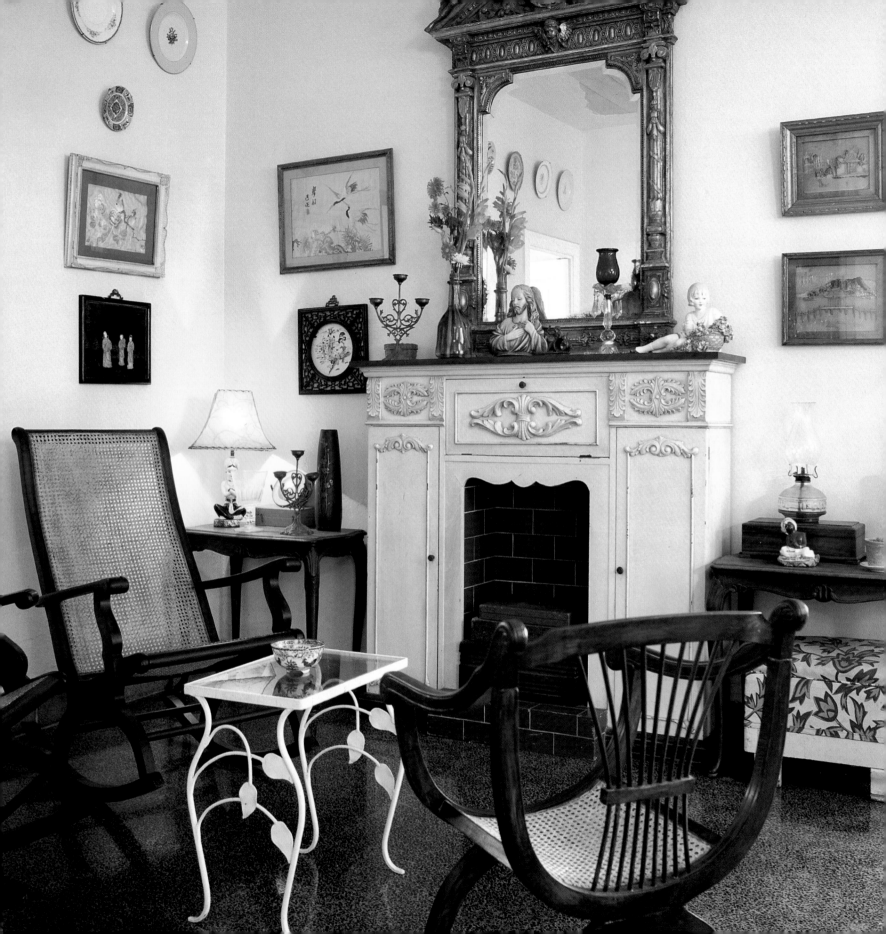

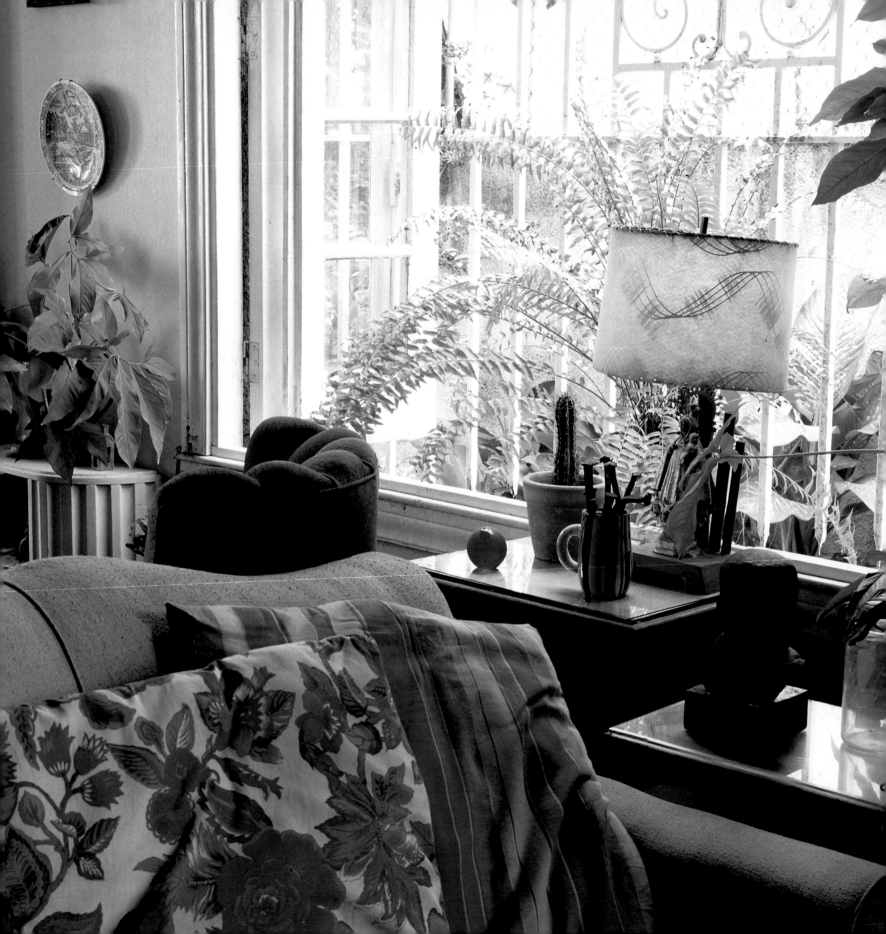

OPPOSITE *A profusion of plants enhances
the relaxed interior style*

RIGHT, BELOW RIGHT *Furnishings in the
conservatory include a table converted from
an old sewing machine, and an elegant dresser*

BELOW *Quirky pieces in unexpected places
are designed to amuse – here a circlet of cherubs
strain to keep their quarry aloft*

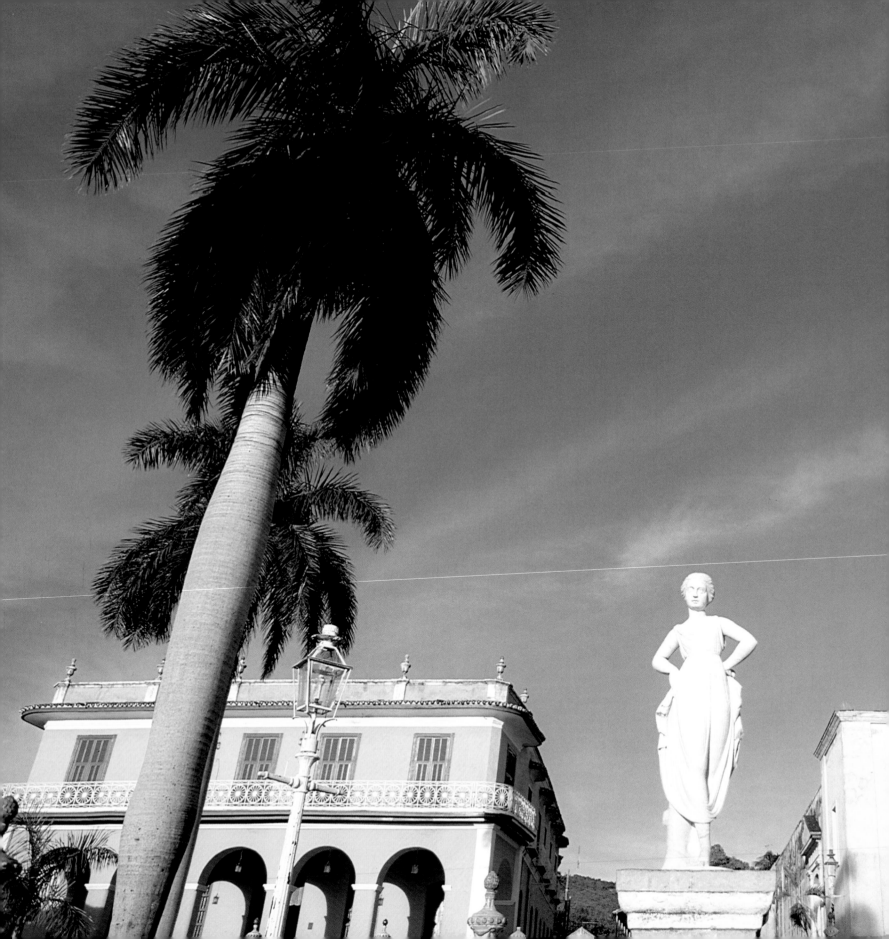

PROVINCIAL HERITAGE

Beyond Havana, Cuba unfolds as a land of gracious colonial cities,
charming country towns and exotic vistas

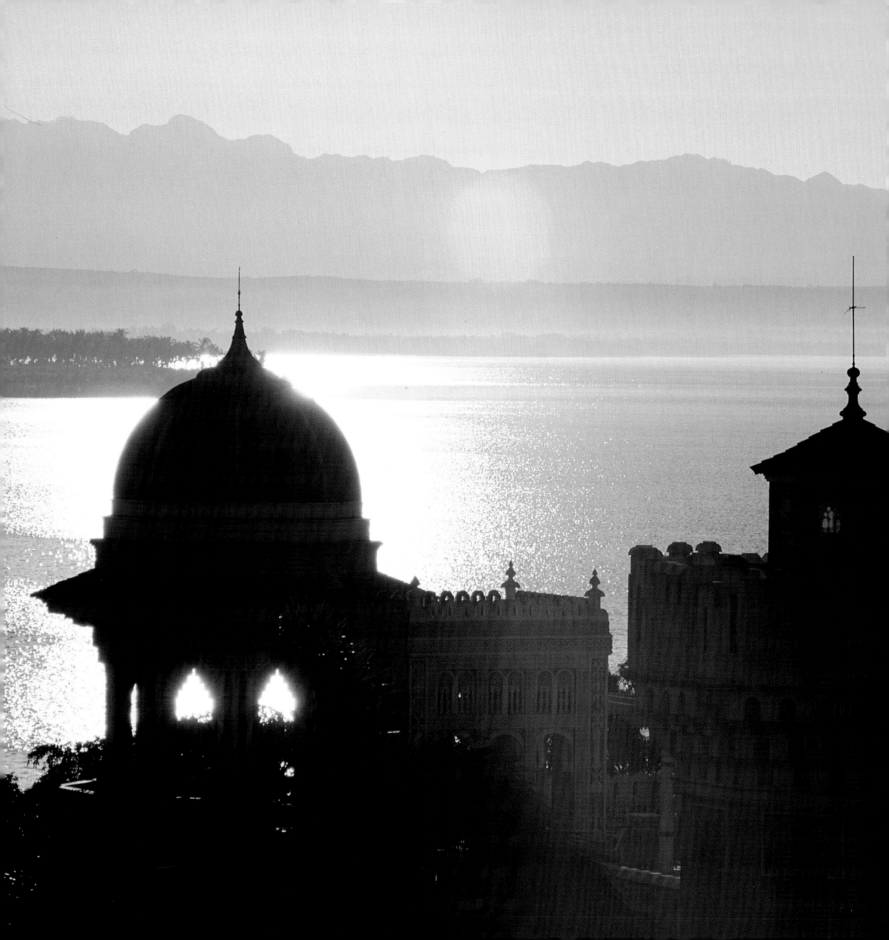

HARBOUR JEWEL

Ｏne of the last of the great Cuban provincial towns to be established, Cienfuegos is a bustling port jutting out into the Bahia de Jagua, an enormous sweep of Caribbean blue enclosed but for a narrow entrance to the sea. For more than a hundred years the bay was fringed by nothing more than a cluster of small communities, some of them local Indians, others colonial settlers, even a handful of pirates. But when the sugar boom of nearby Trinidad drew attention to the area in the early nineteenth century, it was entered in the official record books.

Pirate activity had made Trinidad and the surrounding waters risky, but with its harbour, the safest in Cuba, Cienfuegos quickly became the preferred port of call. The massive Jagua fortress built the previous century at the harbour's entrance helped to safeguard the city's prosperity.

The surrounding countryside provided fertile ground for sugar cane planting, and so business shifted quickly to the new town. Plantation owners, merchants and traders alike moved to

OPPOSITE *Overlooking the vast expanse of the Bahia de Jagua Bay is the exotic Palacio de Valle with its Moorish roofline, constructed between 1913 and 1917 for the Valle family*

RIGHT *The harbour was the key to the wealth of Cienfuegos, but as the sugar market declined in the 19th century, less and less was shipped from the once-thriving port*

take advantage of the booming port, which statisticians declared boasted the greatest concentration of wealth in Cuba.

The results of its relatively late development are clear in the city's layout and architecture. Unlike older towns such as Camagüey with its labyrinth of winding streets, Cienfuegos is laid out in a series of neat grids. Broad avenues mark the main thoroughfares, lined on both sides with colonnaded buildings from the nineteenth-century forming long, shady walkways. The Paseo del Prado is the longest of these boulevards, cutting right through the heart of the city to the Bahia de Jagua.

Although the harbour is essentially the city's *raison d-être*, the original centre of town is set half a mile back, comprising five or so blocks built around the Parque Jose Marti. Among the buildings clustered around the square are the handsome Cathedral of the Immaculate Conception and the former palace of a sugar baron, a delightful architectural oddity with its baroque facade and turret. Enrico Caruso stayed here on a visit to Cienfuegos and performed at the nearby Teatro Tomás Terry, built in 1889 when it was one of the finest theatres in Cuba.

OPPOSITE *Behind the colonnaded exteriors of the city's terraces lie genteel courtyards edged with shady verandas. The high, arched doorways and ironwork details are typical of 19th-century Cienfuegos*

ABOVE RIGHT *Characteristic of the 19th-century port city are picturesque houses like this one with its columned facade, pastel colouring and delicate exterior decoration. Architectural styles were influenced by the French immigrants who settled in Cienfuegos in the early 1800s*

RIGHT *On the south side of Parque Marti stands the atmospheric El Palatino bar with its beamed* alfarje *ceiling and rustic décor*

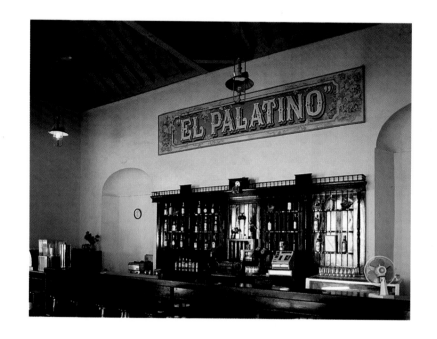

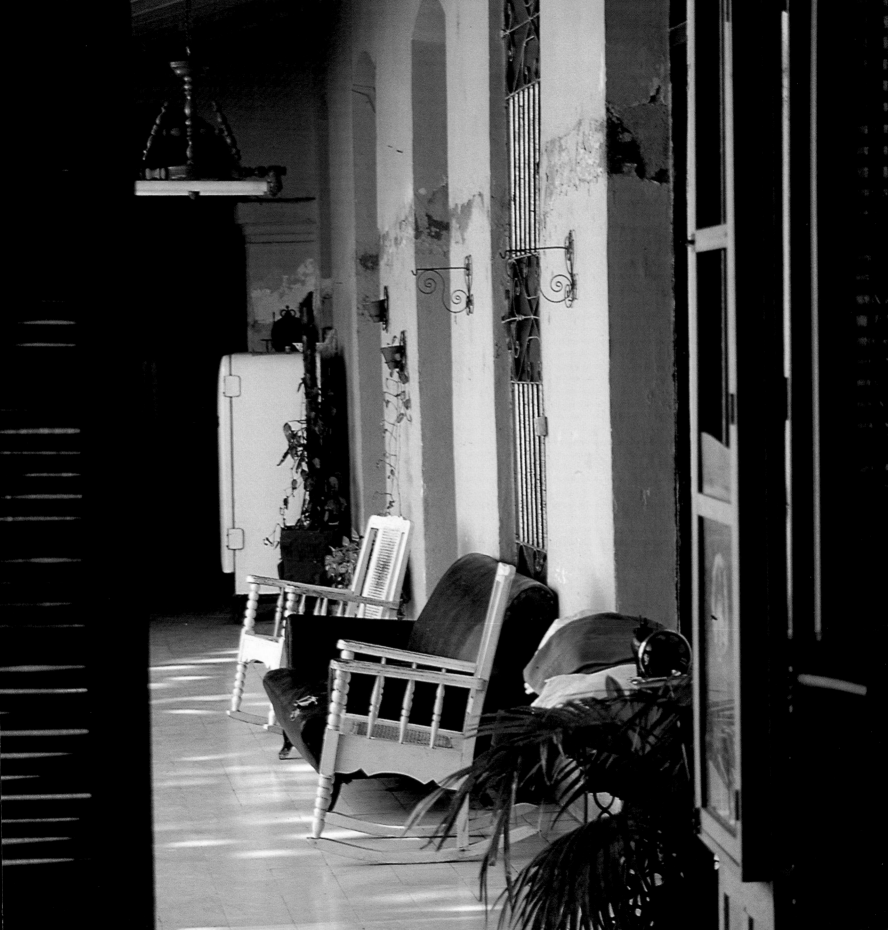

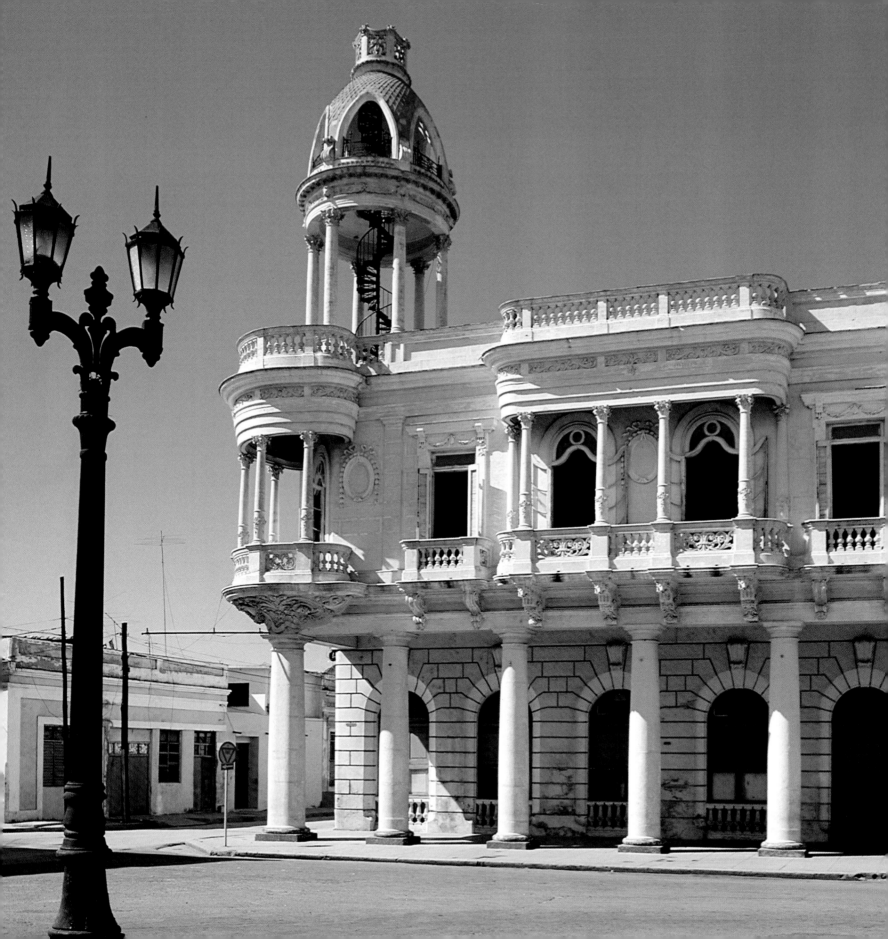

OPPOSITE *Built early this century by a sugar millionaire, the sky-blue Palacio Ferrer on the main square, Parque Marti, is a blend of Baroque, Neoclassical and Moorish elements. The ornate turret with its tiled roof offers splendid views of the bay. The palace is now a cultural centre, the Casa de Cultura*

RIGHT *Gates within a wall of intricate wrought iron and a spiral staircase with carved details recall the city's zenith*

BELOW *The Parque Marti marks the point where the city was formally founded in 1819. Studded with royal palms, a species native to Cuba, the square is surrounded by picturesque 19th-century mansions*

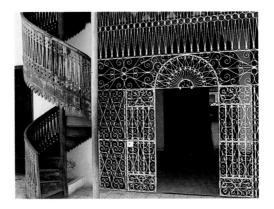

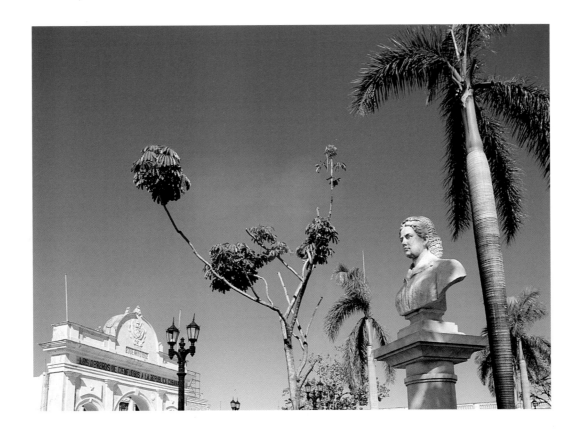

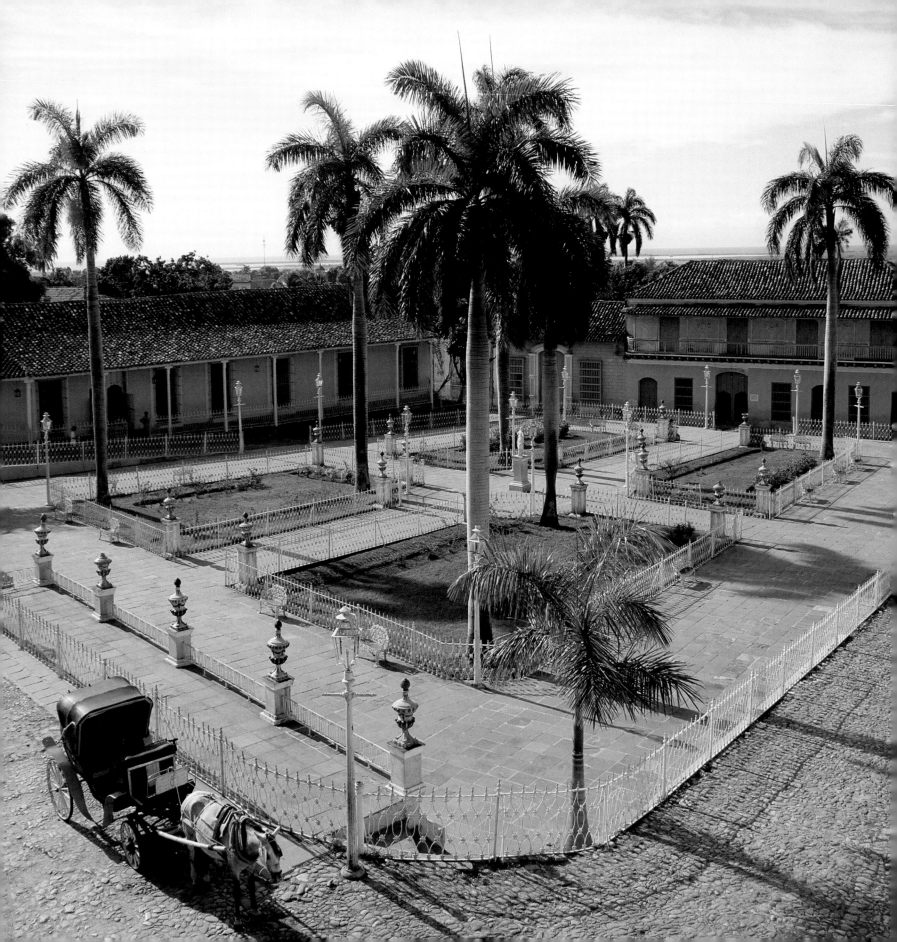

FORGOTTEN REALM

Few places in Cuba can match Trinidad for its quiet colonial ambience and perfectly preserved town centre. Historians say that time has stood still here since the 1850s. It is only the telegraph wires strung lazily between houses and the occasional Fifties car that indicate otherwise.

With its elegant main square, a central park of palms enclosed by neat white wrought-iron fences, and the pastel hued mansions that line the inner core of the cobbled streets (laid with stones brought as ballast on the first Spanish ships), Trinidad was one of the richest, and most refined, provincial towns in Cuba little more than 150 years ago.

It began as a colonial outpost in the early 1500s, with sixty or seventy Spanish families settling here alongside the native Indians to raise horses, pigs and sheep. The population grew very little over that first century, but by the early 1600s it had become a relatively important strategic post for protecting Cuba's waters from the pirates that operated all over the Caribbean. Throughout the next few hundred years, Trinidad's location helped the town prosper through trade, and, shielded from the capital Havana by the Escambray mountains, through smuggling. The rich soil in the neighbouring valley also provided the ideal environment for growing sugar cane, and by the mid-1800s vast riches had been

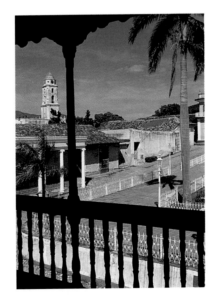

OPPOSITE, RIGHT *The elegant main square of Trinidad, the Plaza Mayor, looks much today as it did in 1850, surrounded by the mansions of the town's wealthiest families, including the canary yellow Palacio Brunet. Like many of the houses in Trinidad, the original structure dates from the mid-1700s, with later additions made early the following century*

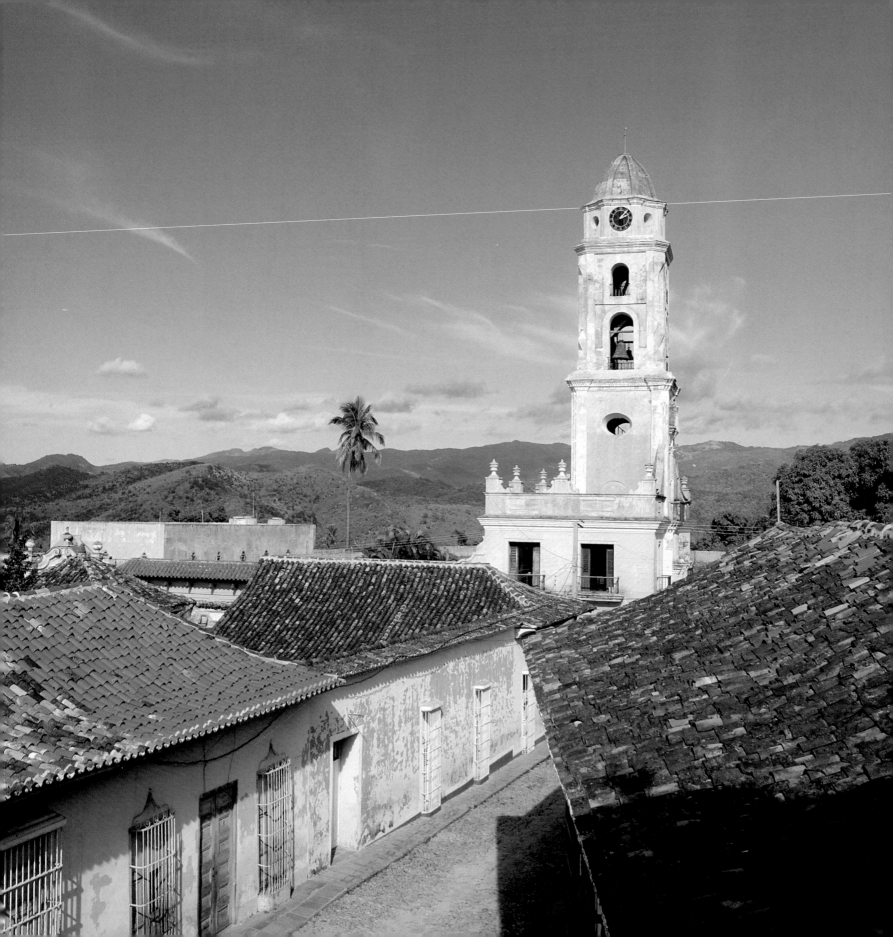

made by plantation owners, traders and shippers.

Trinidad's fortunes changed almost overnight when the sugar market crashed in the 1860s, although the once-prosperous town retained its fine architecture and the elegant contents of many of its mansions. The town lay virtually abandoned until the 1950s, when the first road was put through to connect the town with the rest of the island. World Heritage listing in the 1980s brought it international recognition, and many of the most significant buildings were restored and reopened as museums.

Even recent tourism has failed to change the essential character of Trinidad. Its central square, the Plaza Mayor, is pristine, ringed by the town's major museums, formerly the mansions of wealthy sugar barons and traders. Dominating the square is the Museo Romantico, the former palace of the Brunet family and one of the few two-storey buildings in the town. Opposite is the Casa de Alderman Ortiz, built early last century for the mayor Ortiz de Zuniga, who also moonlighted as a fitter of pirate ships.

Fanning out from the Plaza Mayor, the cobbled streets are lined with terraces of characteristic low-slung houses, positioned so that their eaves always keep one side of the street in shade. Their facades, once stained in the brilliant colours of Andalusian Spain, have faded in the sun, but the terracotta roof tiles – a local specialty – are still in place despite the ravages of hurricanes that regularly sweep across the Caribbean. Distinctive protruding window cages overhang the pavement. Their grilles, or *barrotes*, are sometimes the turned wooden bars of the 1700s, but more often display the elegant ironwork of the early nineteenth century, Trinidad's golden age.

OPPOSITE *The Escambray mountains provide the backdrop for the four-storey belltower of an 18th-century Fransiscan convent*

ABOVE RIGHT, RIGHT *Dusk casts cool shadows over Trinidad's distinctive yellow houses and rough cobbled streets*

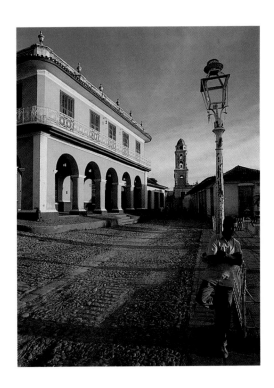

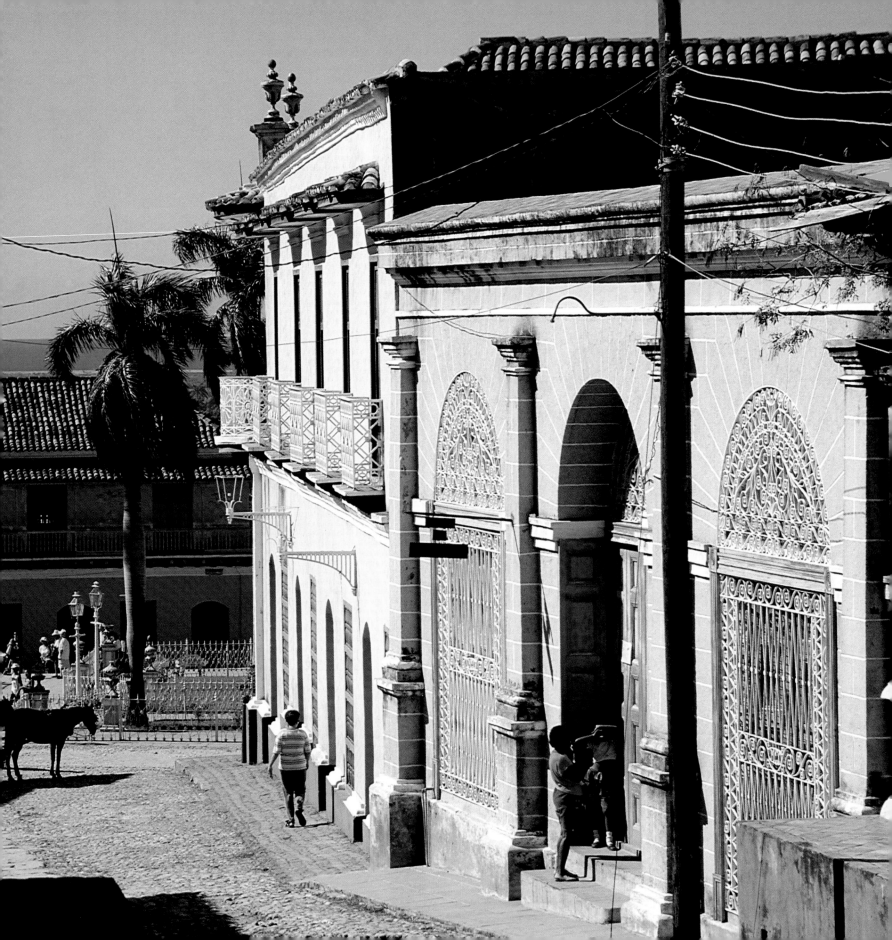

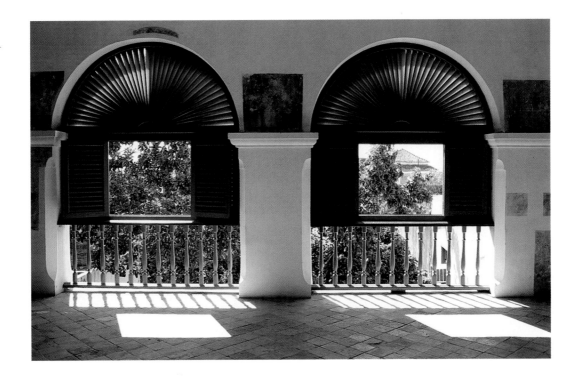

OPPOSITE *Beyond the quiet streets lies the Caribbean. Many of the pirates who once sailed these waters were locals who used their bounty to build fine homes just off the main square*

ABOVE *Large wooden fans clevery filter the light while still allowing air to circulate*

BELOW, BELOW RIGHT *Window* barrotes *are a typical feature of Trinidad houses. Adapted from the Andalusians in the 17th and 18th centuries, these grilles allow breeze to pass through the open window while still providing security. Heavy shutters inside can be pulled across to block the sun*

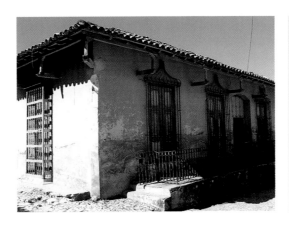

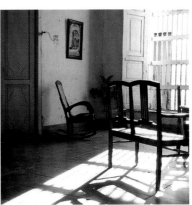

OPPOSITE *The road east from Trinidad leads to the sugar plantations of the fertile San Luis Valley, also known as the Valle de los Ingenios – the Valley of the Sugarmills. The San Luis Valley was the centre of Cuban sugar cane production in the 18th century, providing the foundation for Trinidad's wealth*

BELOW *An eerie reminder of the days when sugar barons made their fortunes with the sweat of African slaves. The seven-storey Torre Ignaza served as a watchtower for overseeing slaves at work. The plantation owners usually preferred to live in comfort in the town of Trinidad rather than on the land*

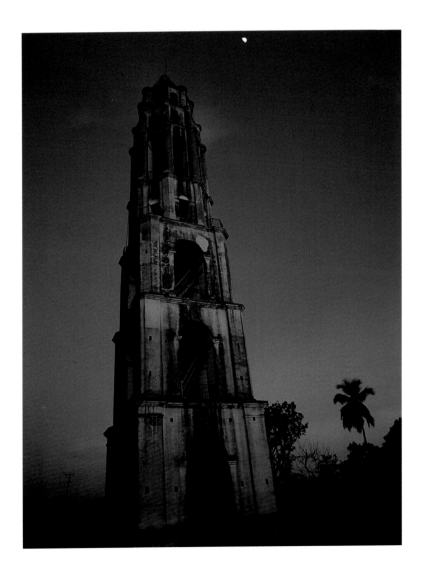

R E N A I S S A N C E S P I R I T

If Havana ever had any provincial rival for the title of cultural capital it was Matanzas. Just east of Havana, the province of Matanzas cuts a wide swathe from the Caribbean coast in the south to the harbour city on the north coast from which it takes its name. No one is sure just why the city of Matanzas, meaning slaughter in Spanish, is so called. One legend claims the name comes from an event that took place on the shores of the city's sweeping bay, when a group of shipwrecked colonials were killed by Indians. The more likely explanation is that Matanzas served as a trading base for beef, which was raised on the surrounding plains and slaughtered in the city.

The cattle trade supported Matanzas in its early days, but from the late 1700s it was sugar that funded its growth. Worked by thousands of African slaves, the plantations of the region were producing more than fifty percent of Cuba's total sugar output by the 1820s. The wealth of the city multiplied well into the nineteenth century as the port developed into a major shipper to sweet-toothed Europe.

OPPOSITE *The tranquil San Juan River winds past the crumbling mansions of Matanzas on its way to the harbour. One of two rivers that cross the city, each spanned by a number of 19th-century bridges, the San Juan allowed sugar to be transported from plantations inland to the excellent port that made Matanzas a natural trading post*

LEFT *Throughout Matanzas grand details are a reminder of the city's former glory. Its citizens were considered among the nation's most refined and their taste is reflected in numerous architectural examples like these ornate panelled doors inset with figures from Greek mythology*

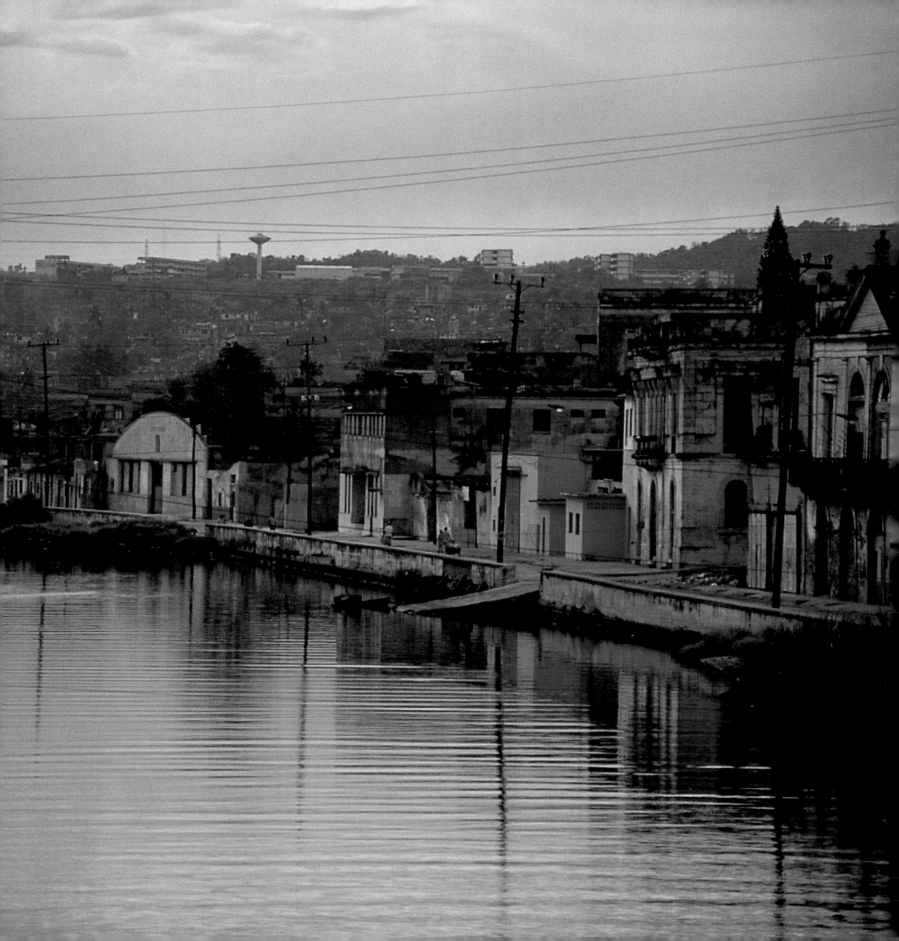

The economic boom enjoyed by Matanzas was equally matched by a flowering of the arts and sciences. It was a magnet for poets, writers, artists, intellectuals and scientists, and among the achievements which earned it the epithet Athens of Cuba were the nation's first newspaper, new music and dance styles, the first steam train, and a handsome rotating bridge that spanned the San Juan river.

Although the once-majestic city has suffered the passage of time, the legacies of its cultural heritage are still very much in evidence. Between the Yumuri and San Juan rivers that slice through Matanzas on their way to the harbour lies the Parque Central. Facing this broad square is the old Triolet Pharmacy, now a museum but at its founding in 1882 the height of modernity, with all the facilities required for making pills and medicines on the premises. The facade of the pharmacy is a beautiful example of the vibrant nineteenth-century stained glass found throughout the provincial capital.

The pharmacy and surrounding streets formed the hub of the social and cultural scene. The Liceo de Matanzas, a music and literary lycée with elegant mirrored dance hall, provided a venue for recitals and balls. A few blocks east the elegant Sautro Theatre staged operas, ballets and concerts. The neighbouring Palacio de Junco, a colonial mansion built by a wealthy plantation owner, has been restored to its former grandeur and serves now as an example of the city's fine architectural inheritance.

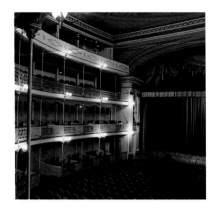

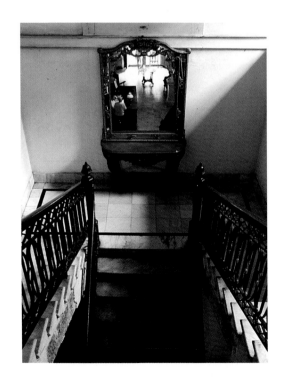

OPPOSITE, ABOVE RIGHT *The golden-hued Sautro Theatre, built in 1863, is renowned for its acoustics. It fostered a lively artistic scene, attracting composers, musicians and writers from Europe and the Americas*

RIGHT *A glimpse of dignified Matanzas – the imposing marble staircase of the former governor's residence, now the Hotel Louvre*

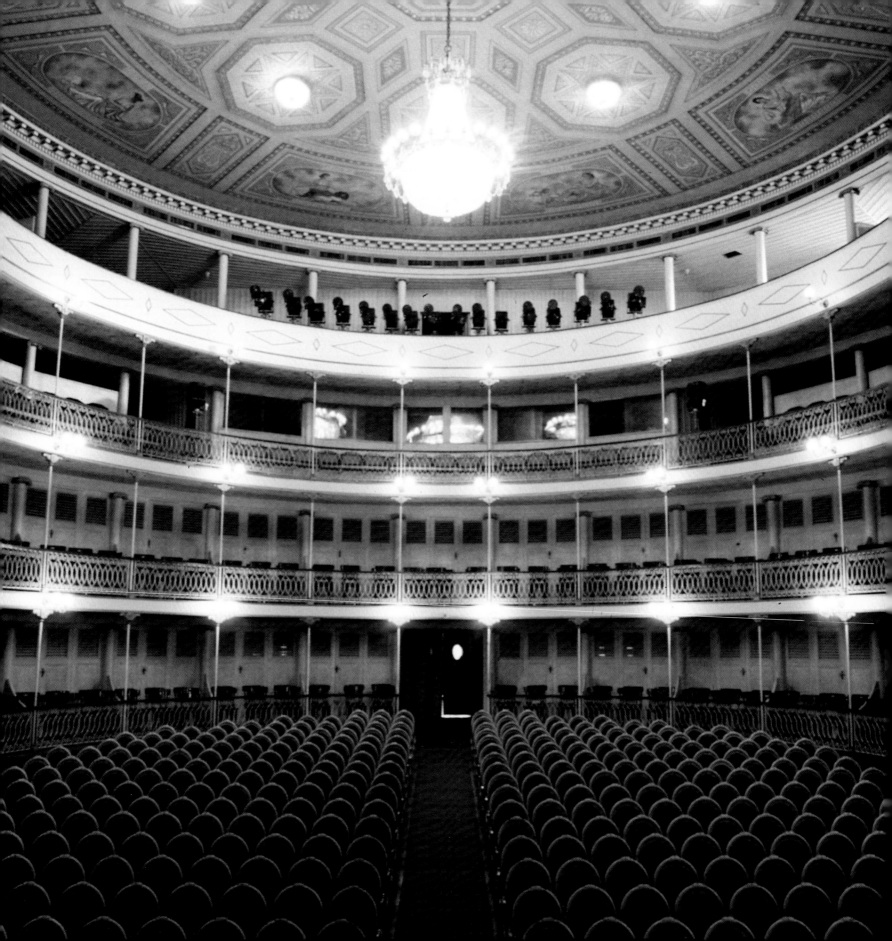

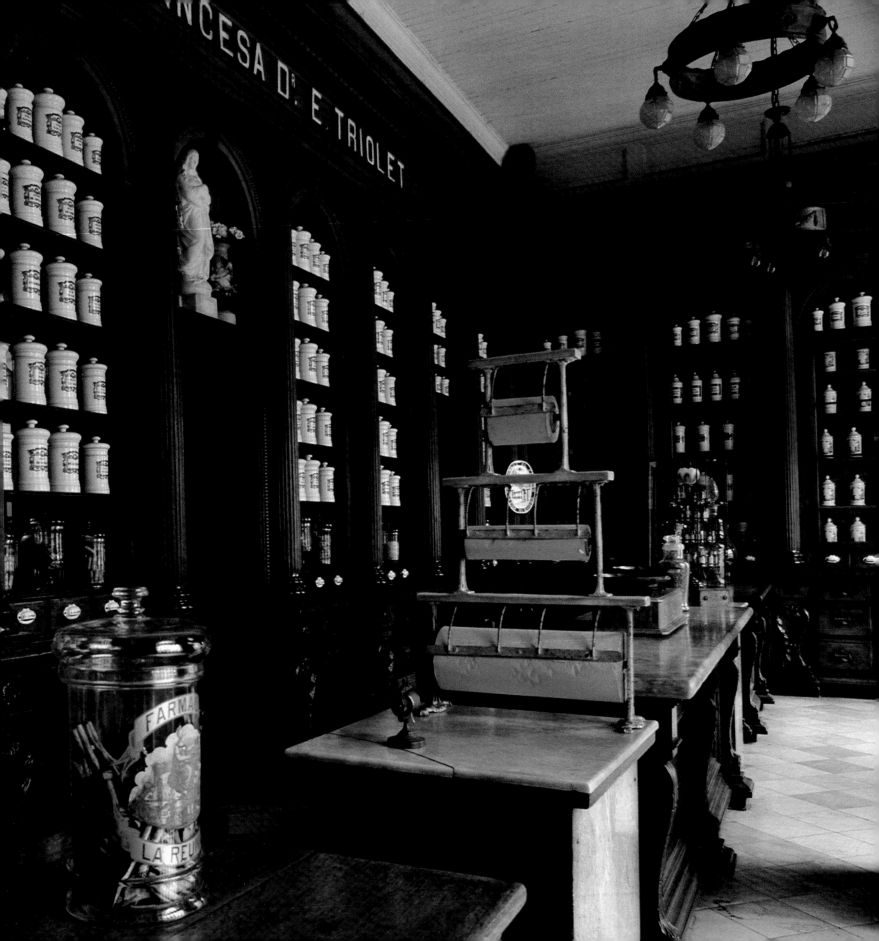

OPPOSITE *Facing customers as they entered the Triolet Pharmacy, a bank of cedar fixtures housing hundreds of natural preparations*

RIGHT, BELOW RIGHT *Medicines at the pharmacy were made according to botanical principles. Ingredients were pulverized by hand at the dispensary table, which won a bronze medal at the 1900 Paris Exhibition*

BELOW *The front window features the colours of the Spanish flag and the founder's name*

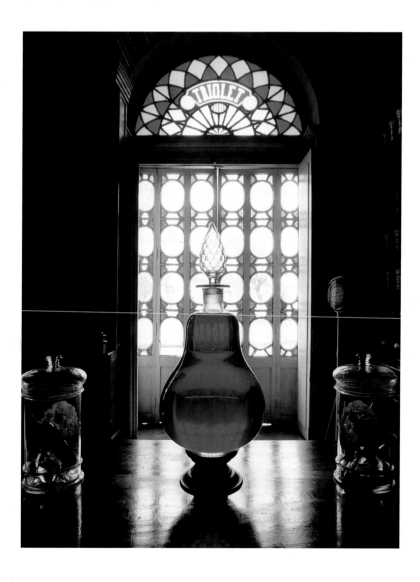

SUMMER ESCAPE

When the city of Matanzas fell into decline at the turn of the century, it was a village 10 kilometres to the west that became the surprise star of the province. The resort town of Varadero is built on the Hicacos Peninsula, a rocky sliver of land edged with soft white sand and ringed by a coral reef. Facing west to the Atlantic just over 200 kilometres south of Key West, this is the northernmost point on the island, and its proximity to the United States was crucial in the transformation of Varadero from sleepy seaside hamlet to a playground for the social set.

The peninsula had been used as a summer escape since the turn of the century by the residents of nearby Cárdenas who built gracious, airy wooden homes. A handful of these still stand along Avenida Primera, the long boulevard that runs parallel to the beach for almost its full length. Some have been restored and converted into guest houses or museums, while others bear the weathering of saltspray and sun.

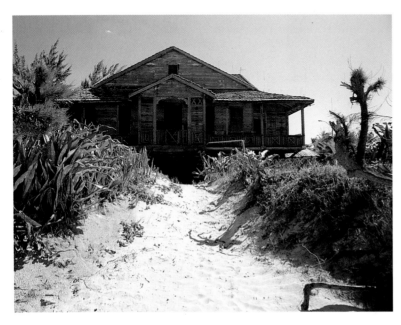

OPPOSITE, LEFT *It was the Atlantic beach of Varadero, rather than a Caribbean rival, around which Cuba's first resort was built. A few of the timber houses built right on the beach at the turn of the century still stand. Their stilted structure, wide encircling verandas and the decorative fretwork of the railings are typical features of Caribbean architecture*

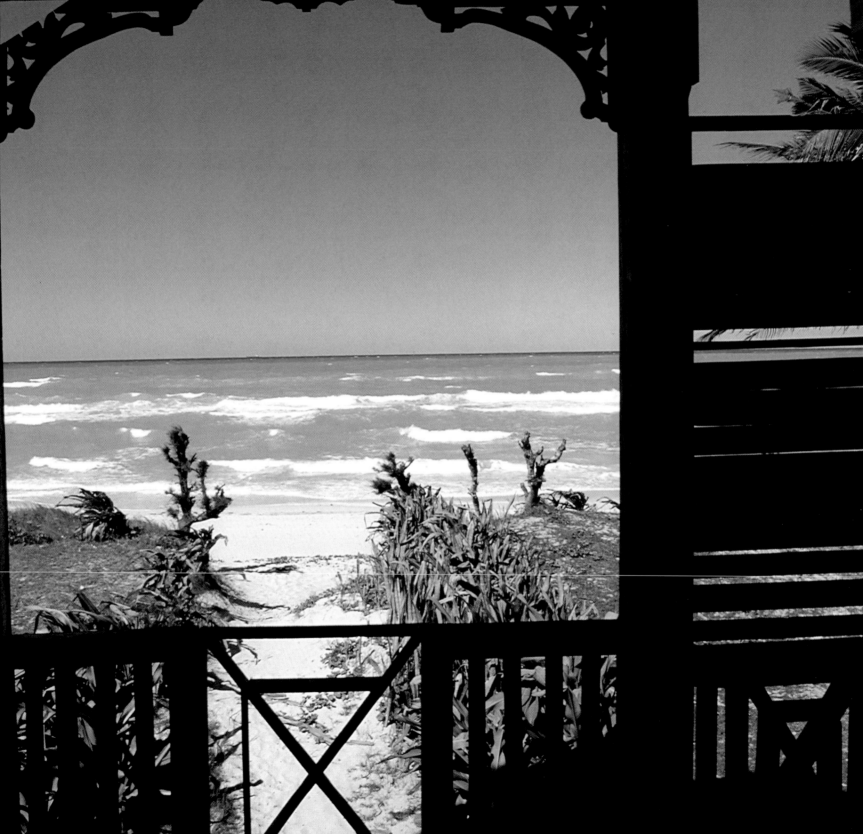

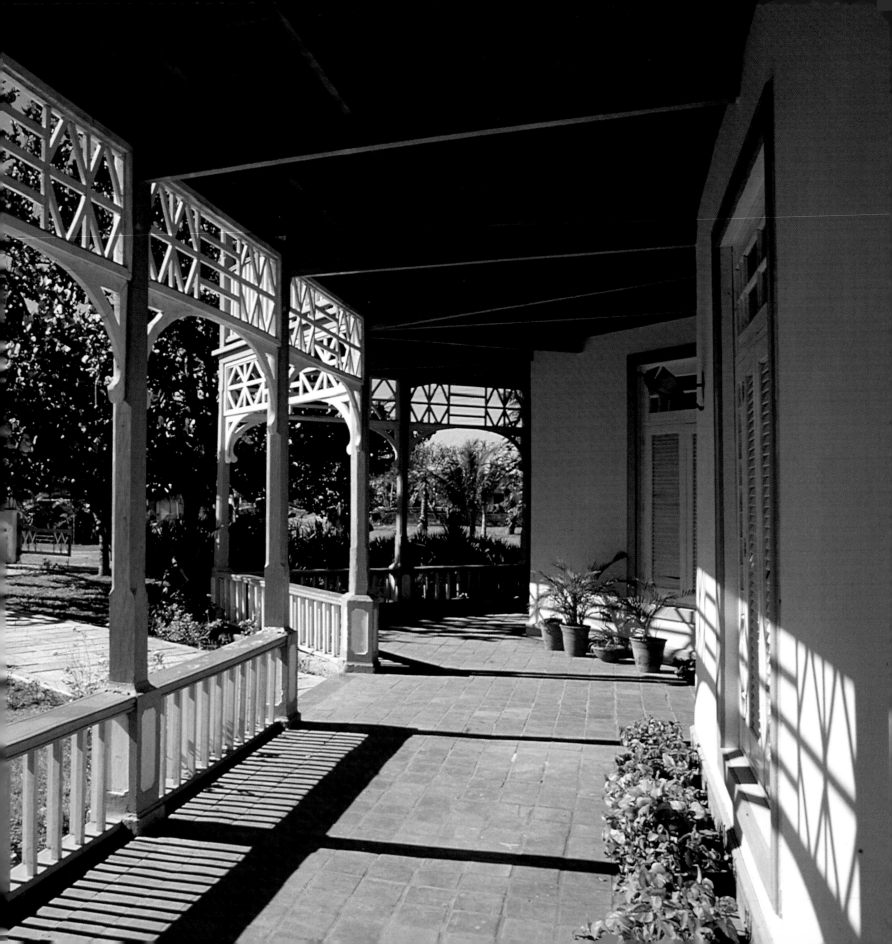

Changes began in earnest in the 1920s when the powder-white sand, glassy green water and easy distance from Florida captured the attentions of American-based industrialist Ireene Dupont. He built his summer home in Varadero, also purchasing several additional plots of land which he then sold on to friends. Over the next few decades, more Americans moved into the area during the summer, renting the fine old beach houses from a generation earlier or building their own. There were tales of rum-running during the Prohibition, of the wild parties thrown by Dupont in the Forties, and of Esther Williams, Cary Grant and Ava Gardner sunning themselves beachside in the Fifties. The beaches also attracted their share of wealthy Cubans, then-president Batista among them.

Although new hotels and flats are clustered in areas of the resort, some of the original flavour of Varadero remains – in the throngs of bicycles that ply Avenida Primera, in the aged timber houses with their shady verandas and bright blue rocking chairs, and in the unspoilt stretch of beach that Cubans still boast of as the finest on the island.

OPPOSITE *The delicate fretwork of Varadero's beach homes is a common motif in turn-of-the-century architecture throughout the Antilles. It was inspired by Britain's decorative Victorian ironwork, and popularized in timber through a technique developed in the US enabling multiple pieces to be carved at the same time*

ABOVE RIGHT *An invitation to unwind in the preferred form of outdoor furniture, the rocking chair – here in the quintessential Caribbean colours of blue and white*

RIGHT *Facing the beach across Avenida Primera to catch the sea breeze, a classic summer home from 1917 in deep turquoise edged with white*

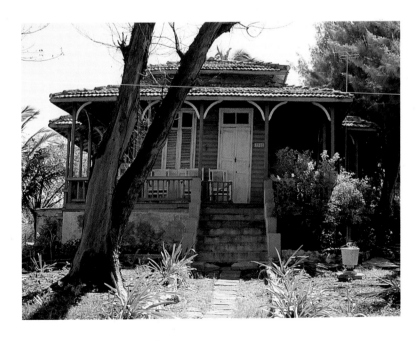

OPPOSITE *From this vantage point on the northernmost shore of Cuba, pirates once watched for trading ships bound for Havana*

RIGHT, BELOW RIGHT *Details like the faded rocking chair and gingerbread woodwork are typical features of the coastal town*

BELOW *Housed in a restored beachside home from early this century, the Museo Municipal traces Varadero's history*

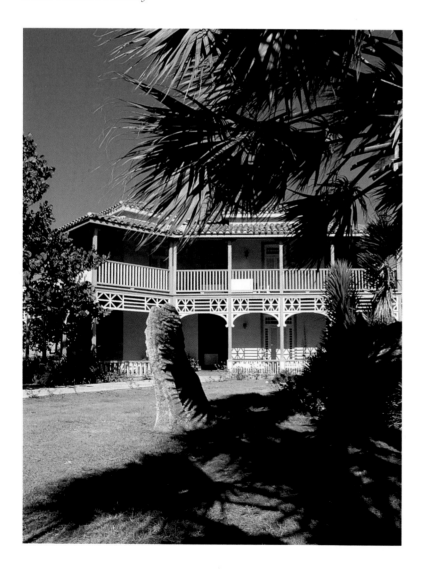

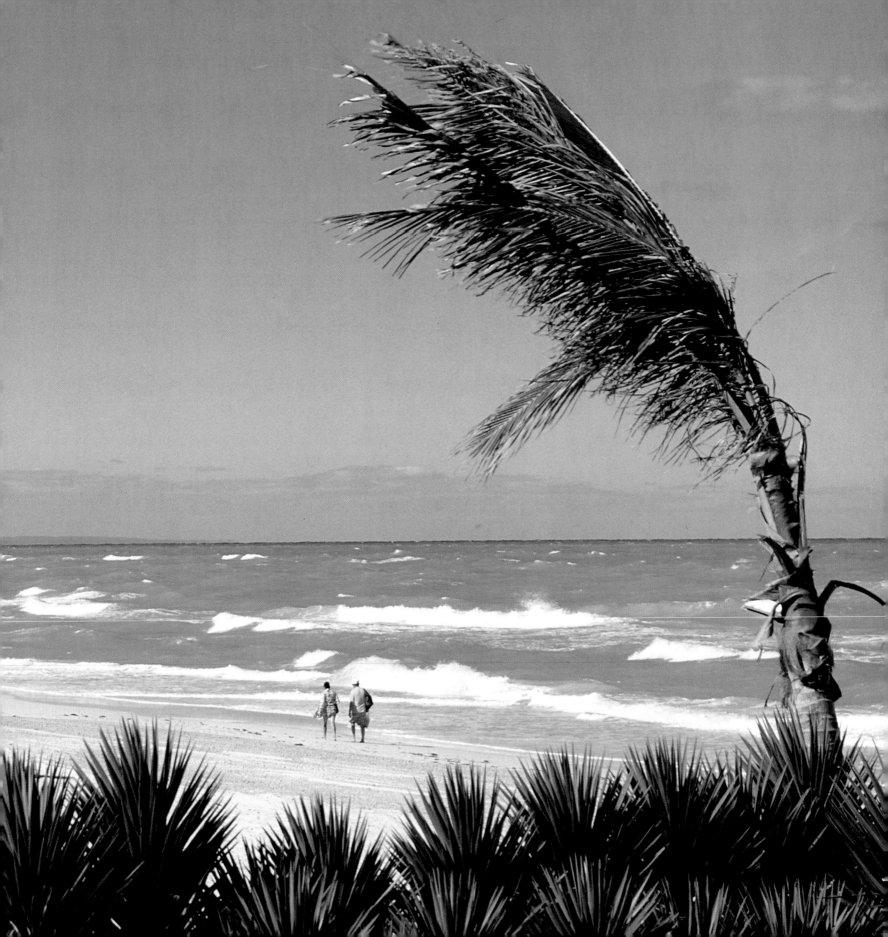

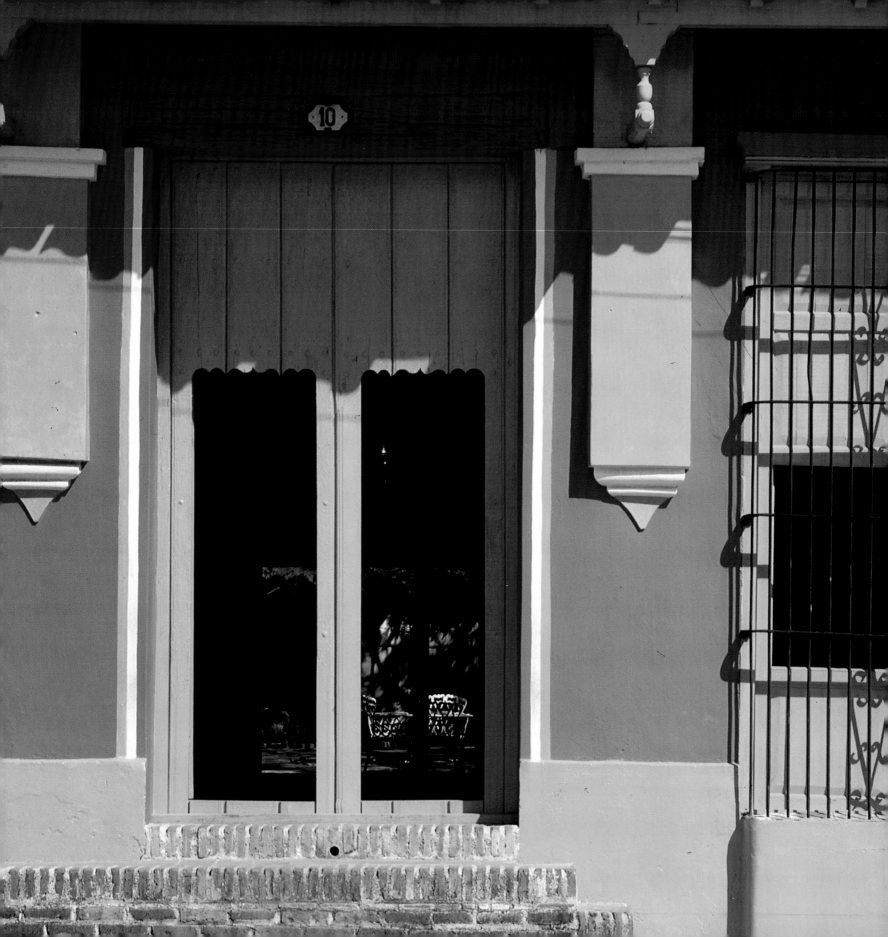

PASTORAL CHARM

The turbulent history of Camagüey has become the stuff of legends in Cuba, generating tales of intrigue, bravery and invention. Geographically at least, this provincial centre should have been doomed to failure from the start. As it turned out, however, Camagüey defied the odds to establish itself as one of Cuba's most important cities, ranking third after Havana and Santiago.

Camagüey was founded by Diego Velásquez in 1514 on the north coast of central Cuba under the Spanish name Santa María del Puerto Príncipe, but was abandoned a decade later due to incessant pirate raids, and even fiercer attacks by the mosquitoes that infested the area. The city developed instead near the Indian village of Camagüey at the confluence of two rivers, the Hatibonico and Tínima.

Even this protected setting could not save it, though, from the ravages of the Caribbean's most notorious pirate, Captain Henry Morgan, who razed the city in 1668. To guard against further losses, the Camagüeyanos rebuilt their city as an intricate

OPPOSITE *The Plaza San Juan de Dios is encircled by beautifully restored houses from the 18th century. This colonial building is now a restaurant serving the local specialty* ajiaco Camagüeyano, *a type of provincial stew*

RIGHT *Brightly painted two-tone houses with terracotta-tiled roofs are a typical feature of the city's historic centre*

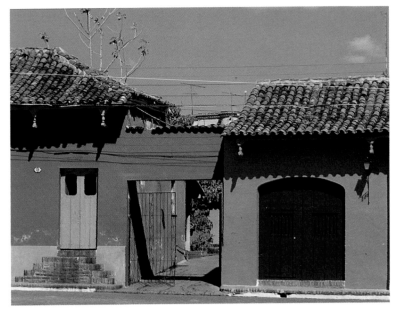

199

network of narrow, winding streets that emptied out onto dead-end squares – a strategic layout designed to foil the likes of Captain Morgan should he eye the city again.

The design worked, and today the town is beautifully preserved with more historic buildings than anywhere outside Havana. The old centre is a maze of meandering cobbled lanes lined with eighteenth-century houses echoing the simple tastes of the region's wealthy farmers. One special feature is the giant ceramic urns that grace interior courtyards. These *tinajones* have been used for centuries in Camagüey to collect rainwater, since the supply of fresh water has always been erratic.

Also notable in the old town are the number of fine colonial churches, testament to the riches acquired by Camagüey's rural bourgeois through the cattle trade that prospered on the flat plains of the province. Not only did the city do extremely well from illicit trading of meat and hides with the Dutch, British and French, it was spared the vast price swings of the sugar market which plunged many of the country's cane-growing areas into economic decline in the late 1800s.

OPPOSITE *As in the town of Trinidad, some hundred miles west, the architecture of Camagüey is distinctively 18th century. The indicators are the simple single-storey structures with few exterior embellishments save for their colourful facades, protruding window grilles and the occasional lamp in decorative wrought iron*

ABOVE RIGHT *Elegant architectural details are reminders of the care with which proud Camagüeyanos planned the city in the 1700s*

RIGHT *A restored mansion on the Plaza San Juan de Dios boasts a second storey built in a Moorish style with small, roofed balcony and multiple white-capped turrets*

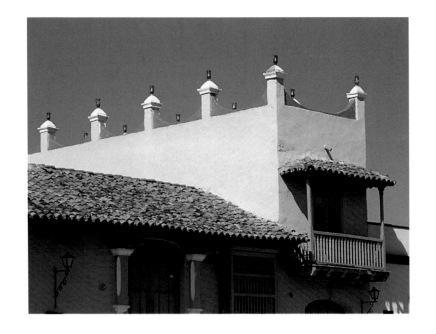

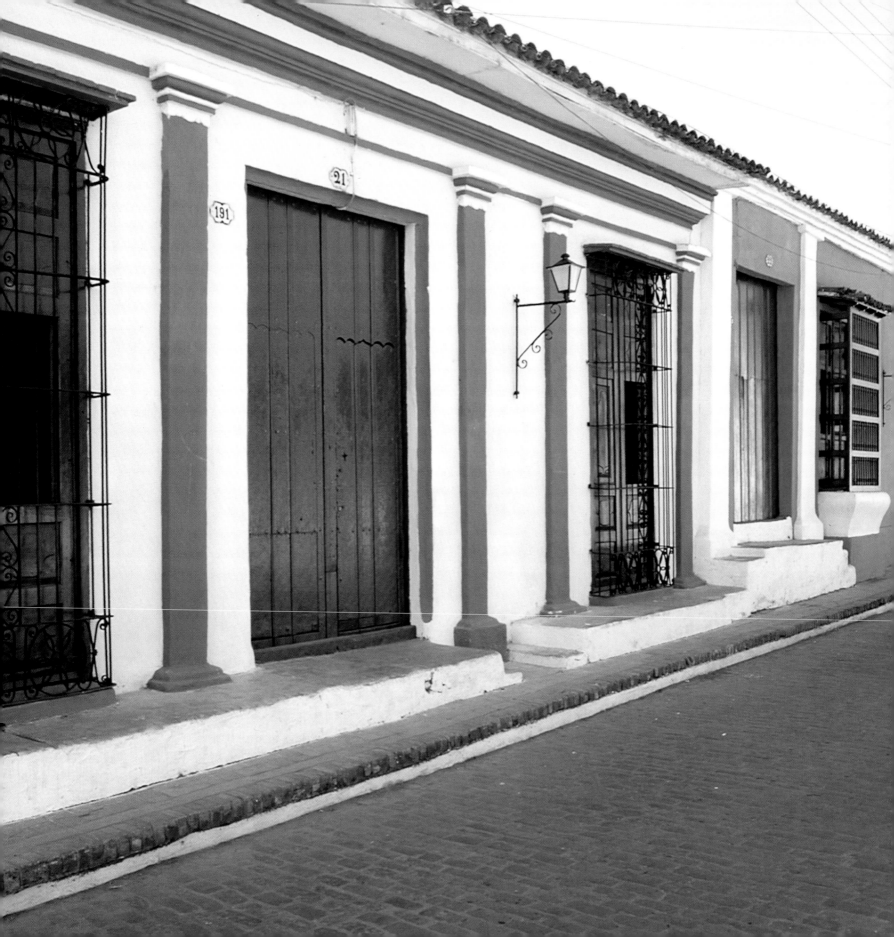

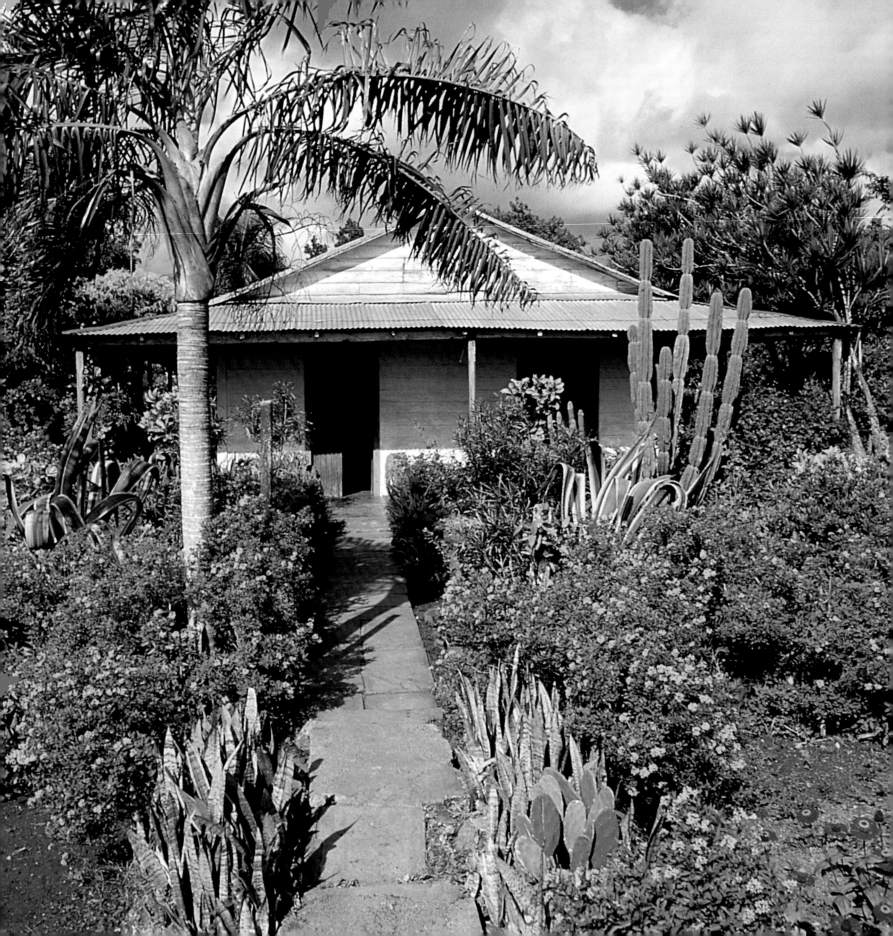

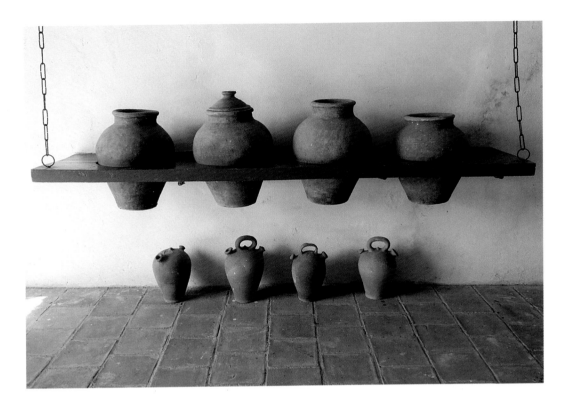

OPPOSITE, BELOW LEFT *The plains beyond Camagüey are dotted with cattle farms and peasant cottages, but few boast such an exuberant flowering garden*

BELOW RIGHT *The* vaquero, *or cowboy, with his straw hat is typical of the province*

ABOVE *Camagüey's distinctive* tinajones *originally came from Spain filled with wine, olives or oil. When empty the vessels were used to collect scarce rainwater. A local ceramics industry soon sprang up to meet demand, and a family's wealth was said to be measured by the number of pots it owned*

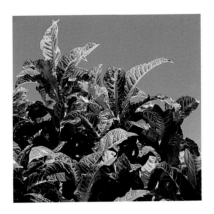

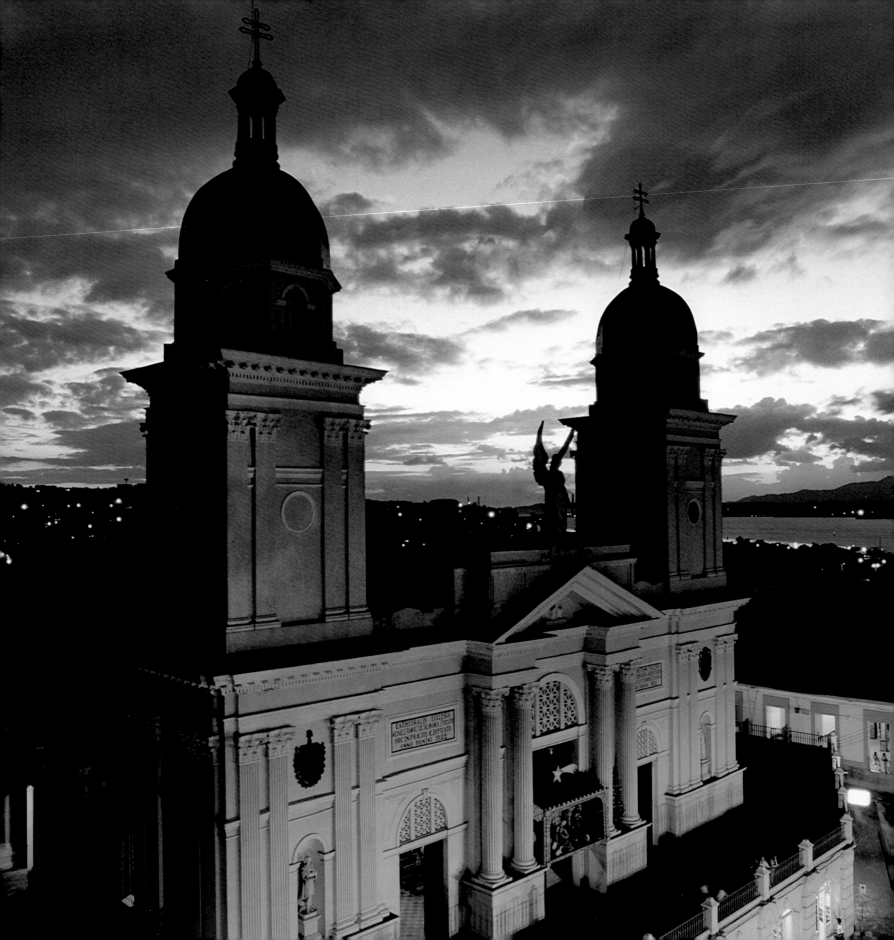

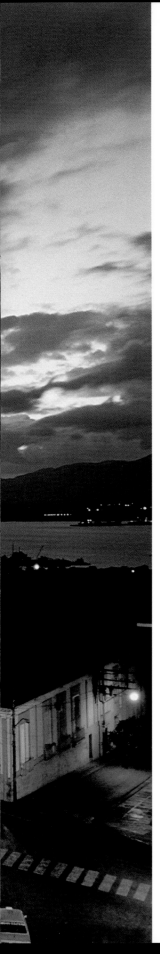

UNDER CARIBBEAN SKIES

Spilling from the foothills of the Sierra Maestra mountains to the edge of a Caribbean bay, Santiago de Cuba is much more than a scenic provincial city. It was the island's first established capital from 1515, and even after the focus of attention moved west to Havana, the city developed as a unique hybrid of Caribbean culture and experience.

While Havana became the jewel in Spain's colonial crown enjoying royal patronage and protection, Santiago expanded slowly. The turning point in the city's fortunes was a slave rebellion 70 kilometres east on the island of Haiti, which sent thousands of French settlers fleeing to Santiago in the 1790s. The economy was bolstered by the sugar and coffee plantations they established, and the cultural life of the city was transformed.

The French-Haitian influence can be found high above the harbour in the steep cobbled streets of the Tivoli district with its rows of eighteenth-century pastel timbered houses. Santiago's first theatre was also built by the French newcomers.

The music and dance of Santiago is permeated with the sound of the *tumba frances*, a musical style and drum created by

OPPOSITE *The candy-coloured Santa Iglesia Basilica Metropolitana dominates the city skyline with its distinctive twin cupolas and heraldic angel. Although the current incarnation dates from last century, there has been a church on the same site since 1524, when conquistador Diego Velásquez founded the city, building his residence on the same plaza. Velásquez' remains are said to have been buried underneath the cathedral*

RIGHT *In the Plaza de la Revolucion stands a bronze tribute to Antonio Maceo, a homegrown hero of Cuba's war of independence from Spain*

the slaves of the colonial Haitians. It has become a crucial part of the conga, and reverberates throughout the city in the summer when Santiguerans stop everything to converge on the harbour for Cuba's biggest festival – the Carnival. At most other times of the year, the focus of social life is the Parque Céspedes. The square and surrounding blocks mark the original precincts of Santiago. The cobbled streets have worn smooth from centuries of use, and the timbered buildings have taken on a roughly textured patina. Horses and carts still rattle through the neighbourhood, while children play with homemade toys or buy sugary ice creams from residential doorways.

For all its colourful charm and rustic ways, Santiago holds a very special place in the Cuban psyche as the revolutionary heart of the island. The rebellion that led to independence from Spain began here, as did Fidel Castro's revolution of 1959. It may have been that, far from the control of Havana, the people of Santiago developed an independent spirit, or it may have been interaction with the nearby islands of Jamaica, Barbados and Haiti that encouraged their strong sense of identity as part of the wider Caribbean experience rather than simply a part of Cuba.

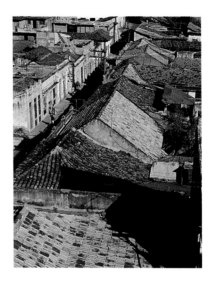

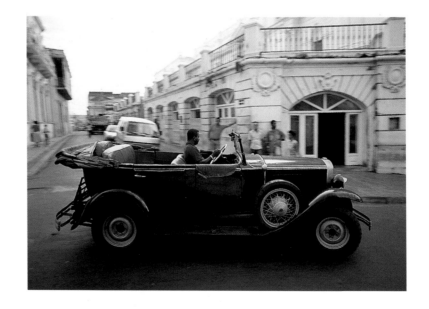

OPPOSITE *Enclosed by the Sierra Maestra mountains at one end and a secluded harbour at the other, Santiago has a hothouse climate which has influenced architectural style*

ABOVE RIGHT *Much of the city's charm is found in quiet residential streets lined with pastel-hued houses, their terracotta roof tiles still resisting the sun's rays. The sultry weather means that life here moves at a snail's pace*

RIGHT *Taxi travel, Santiago style. This restored 1930s convertible Dodge, complete with original engine, negotiates the steep streets that radiate from the city centre*

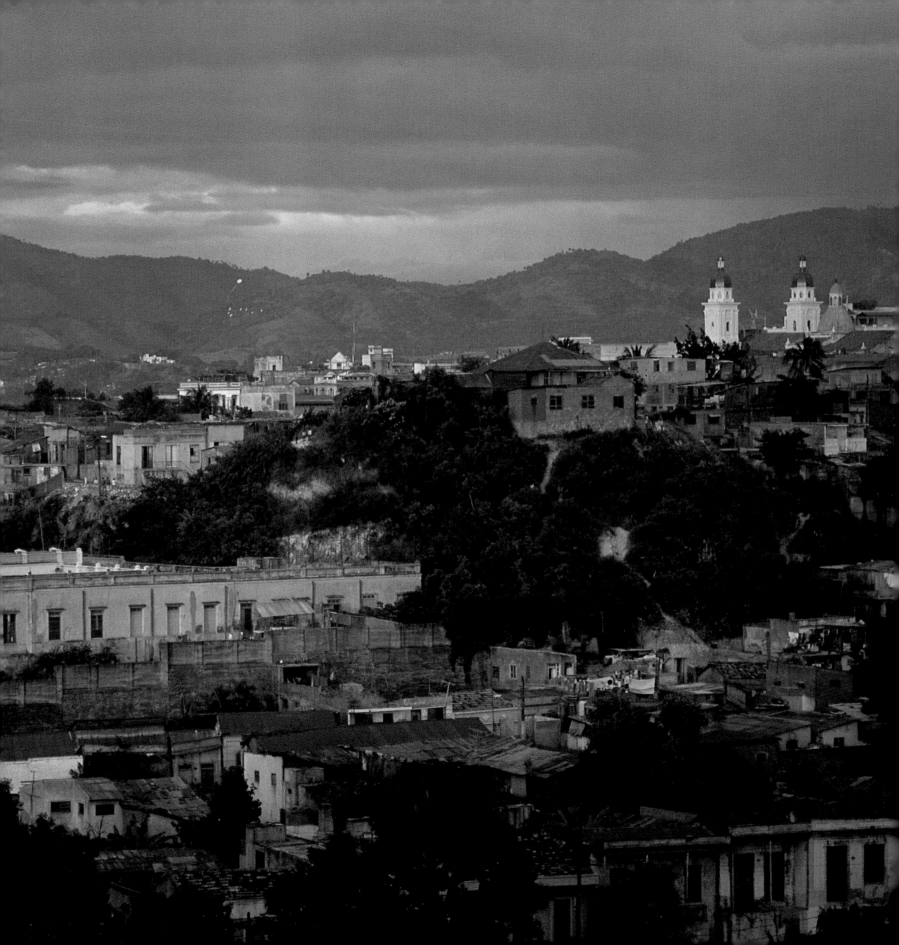

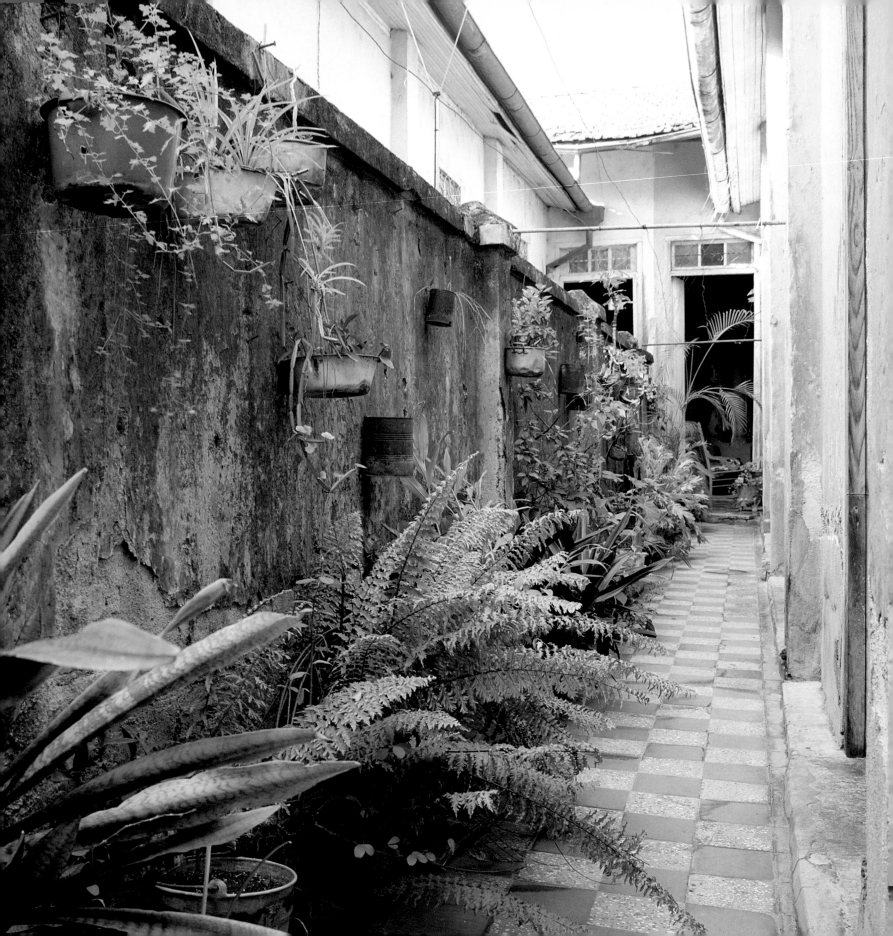

OPPOSITE *All the rooms in this turn-of-the-century house open onto a garden corridor*

RIGHT, BELOW RIGHT *Details like the rocking chair with patchwork cushion and the use of saucepans and tin cans as plant-holders are typical of the local style*

BELOW *In place of a hallway, rooms open one on to another for optimum ventilation*

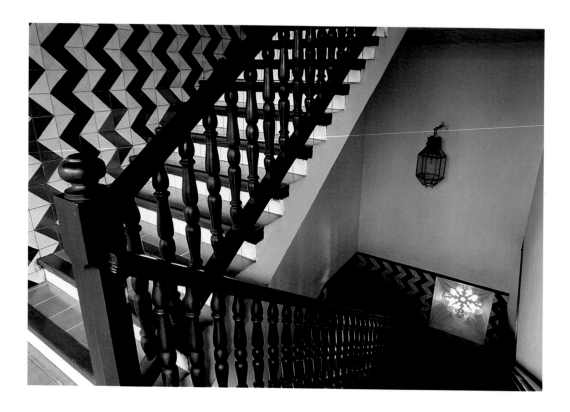

OPPOSITE *This house near the old French-Haitian quarter belies its source of inspiration. The bright pink and blue paintwork and the diamond-shaped details are typical of houses found on the island of Haiti*

ABOVE, BELOW LEFT AND RIGHT *The Ayuntamiento is Santiago's city hall, a re-creation of an 18th-century mansion. Fidel Castro famously made his victory speech from its balcony on January 1, 1959*

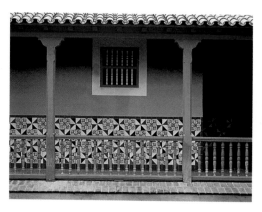

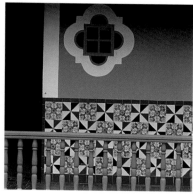

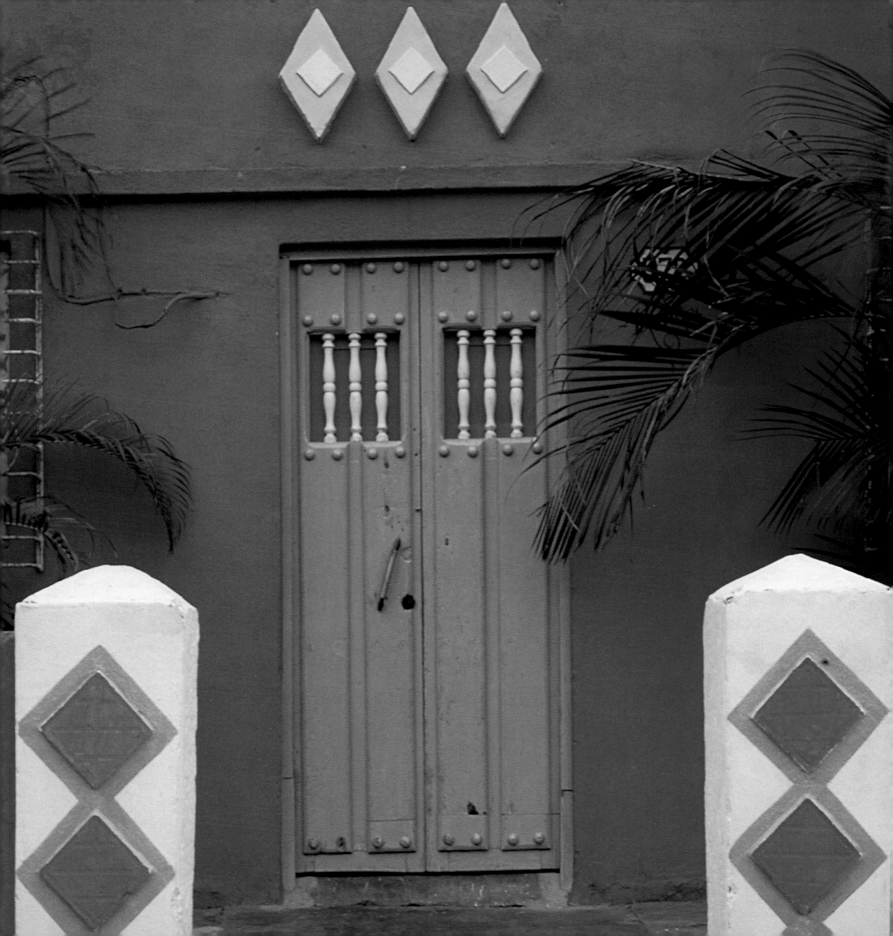

ON EDEN'S EDGE

Separated from the rest of Cuba by a mountain range covered in dense tropical forest, Baracoa is the name given to a small township at the very eastern tip of the island in the province of Guantanamo, the first settlement founded by Diego Velázquez before he moved west to Santiago and its superior harbour. It is a lush place, with more trees than buildings, and from high in the mountains behind, the rooftops are barely visible – only coconut palms, mango and wild grape trees stretching down to the curve of the bay, flanked by two Spanish fortresses.

Down in the town, the pace of life is languid. Locals walk slowly to beat the heat and humidity, often pausing to chat or to join in an impromptu game of open-air dominoes. In the central square, Plaza Indepencia, Baracoans meet to gossip or simply seek shade under the trees. At nightfall they move to the Casa de la Trova, where the regional rhythms play throughout the evening.

On the eastern side of the Plaza Indepencia is the site of Cuba's first church, the Iglesia de Nuestra Senora de la Asuncion,

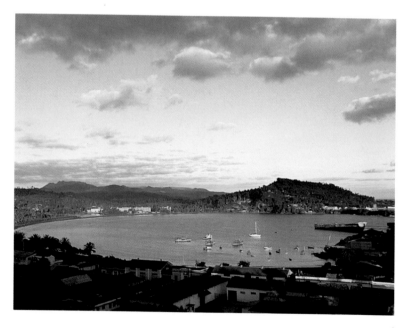

OPPOSITE *Typical of Baracoan peasant houses are stilts to elevate the building for improved ventilation, and a roof constructed from palm fronds*

LEFT *Tucked into the shores of a wide bay, the township of Baracoa is overshadowed by its stunning natural setting. In his journal, Columbus wrote passionately of the beauty of the landscape*

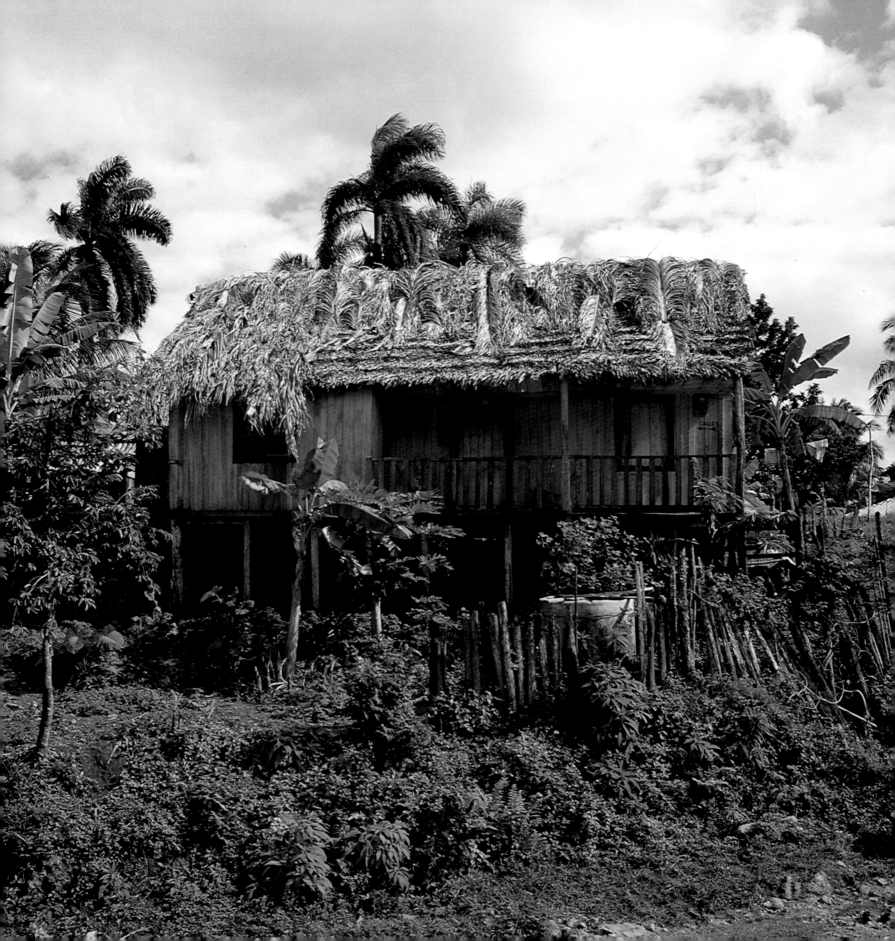

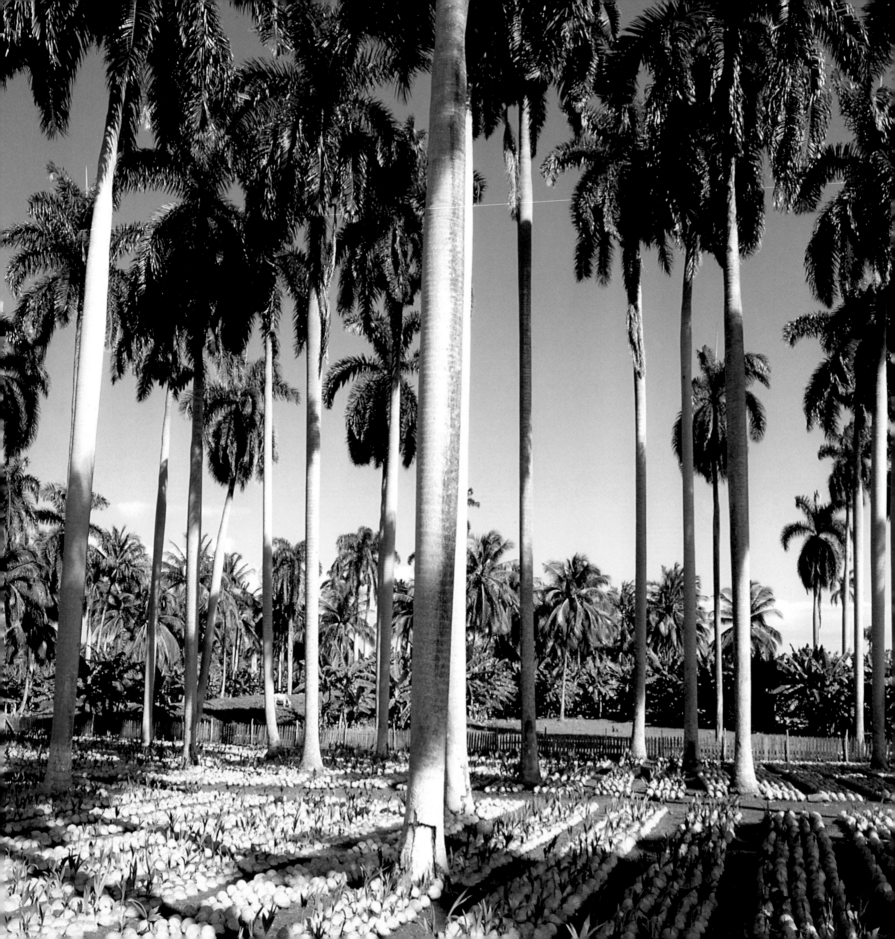

founded in 1512. The original structure was destroyed by pirates in the seventeenth century and has since been replaced, but it still contains the Cruz de la Parra, a wooden cross dating from the fifteenth century, which Columbus is thought to have carried with him from Spain. In pointed contrast to this remnant of colonial Spain, a bust of the Indian Hatuey stands outside the church. Local history has it that Hatuey led the region's natives into a four-month battle of resistance against Velázquez and his forces before the Spanish overcame them and settled Baracoa. The rebel Indian was captured and burned at the stake, an end for which he is remembered as 'the first revolutionary of the Americas'.

A few descendants of the Taino Indians still inhabit the region and traces of the native culture can be found in and around Baracoa. Cave paintings and relics have been discovered in the surrounding hills and at El Yunque, the flat-topped mountain that dominates the horizon to the west. Baracoa's isolation has helped to preserve these last remnants of Indian life, as well as its untouched landscape of deserted Caribbean beaches, palm groves and mountain forests teeming with wildlife.

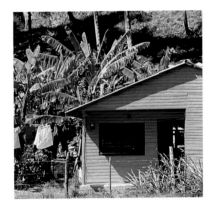

OPPOSITE *Coconuts are the region's main cash crop along with cacao, and Baracoa produces much of Cuba's export quota. With its tall, slender trunk and crown of largefeathery leaves, the royal palm that produces the coconut adds to the grand scale of the landscape. The species is indigenous to the Americas*

ABOVE RIGHT, RIGHT *Colourful weatherboard cottages line the road to the town, set against a backdrop of verdant rainforest. Until the 1970s, when the first road to Baracoa was built across the mountains of Guantanamo province, the township was only accessible by water. Its isolation from the rest of Cuba has preserved its quiet, unaffected air, and the sophisticated architecture of Havana seems a world away*

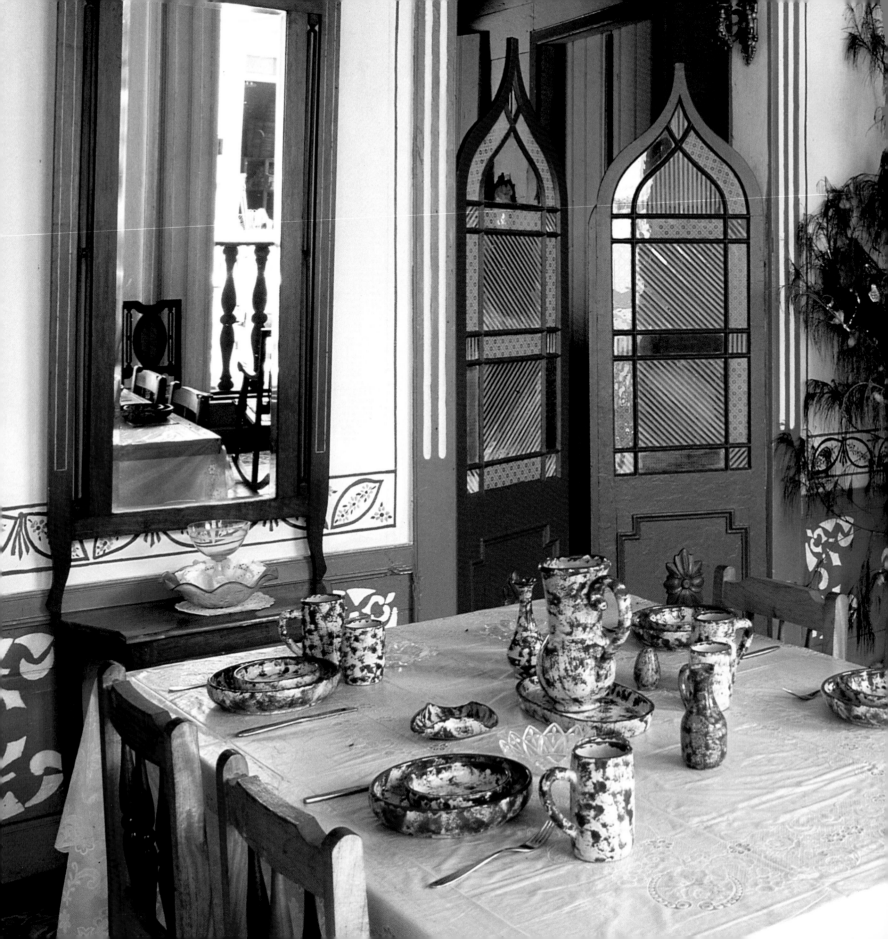

OPPOSITE *Vivid ocean blue mixed with earthy shades of brown generates an artless appeal*

RIGHT *In their colour and silhouette, these* manparras *boast a striking simplicity rarely seen in the more cosmopolitan provincial cities*

BELOW, BELOW RIGHT, *Strong ties to the native Indian heritage are evident in the naive motifs decorating this home*

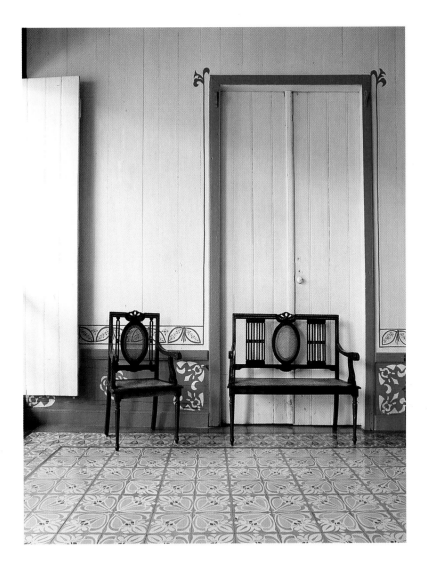

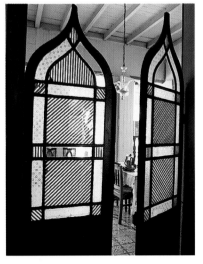

WESTERN FRONTIER

The charm of Pinar del Río province lies not so much in any great historical significance or in fine colonial architecture, but rather in its quiet rustic ways and dramatic natural beauty. Occupying the spit of land that curves west of Havana, Pinar del Río is also the home of Cuban tobacco. Heavy regular rainfall and rich red limed soil produce the best leaf in the world, and much of what goes on in the province is centred around its cultivation.

Life has changed little over the years. Fields of tobacco and vegetables are tended largely by hand, with ploughs driven by oxen yoked together; horseback is the primary means of transport for peasant farmers; and houses are still thatched with palm leaves. Stands of royal palms grow everywhere and their fronds are utilized for roofing of all kinds, including the A-shaped timber barns that are dotted throughout the province for storing tobacco, rice and yams. The leaves are also used for wrapping dried tobacco for its journey from plantations to the main cigar factories in Havana.

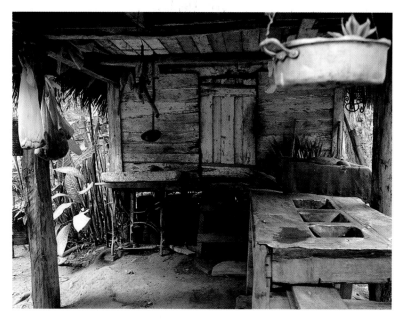

OPPOSITE *Rising from the valley floor of Viñales are spectacular limestone formations called mogotes, created over millions of years through erosion of the softer earth around them*

LEFT *Peasant houses are thatched with palm fronds as they have been for centuries. The roofs are thatched in such a way as to make them waterproof against summer storms*

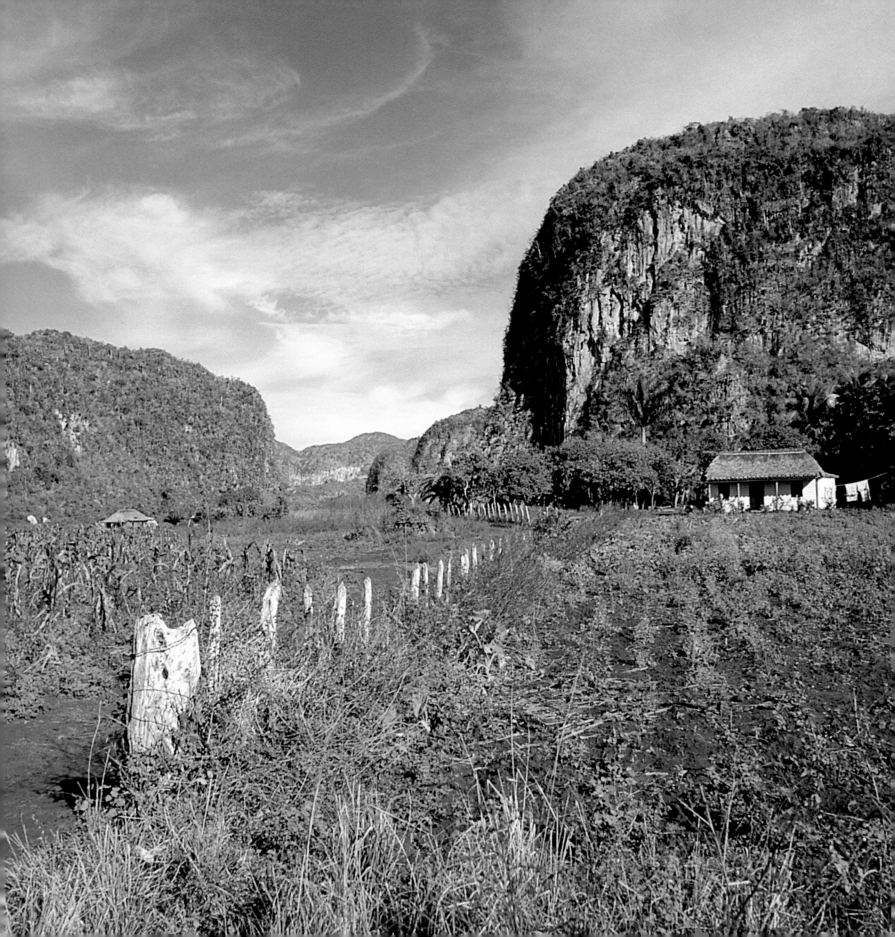

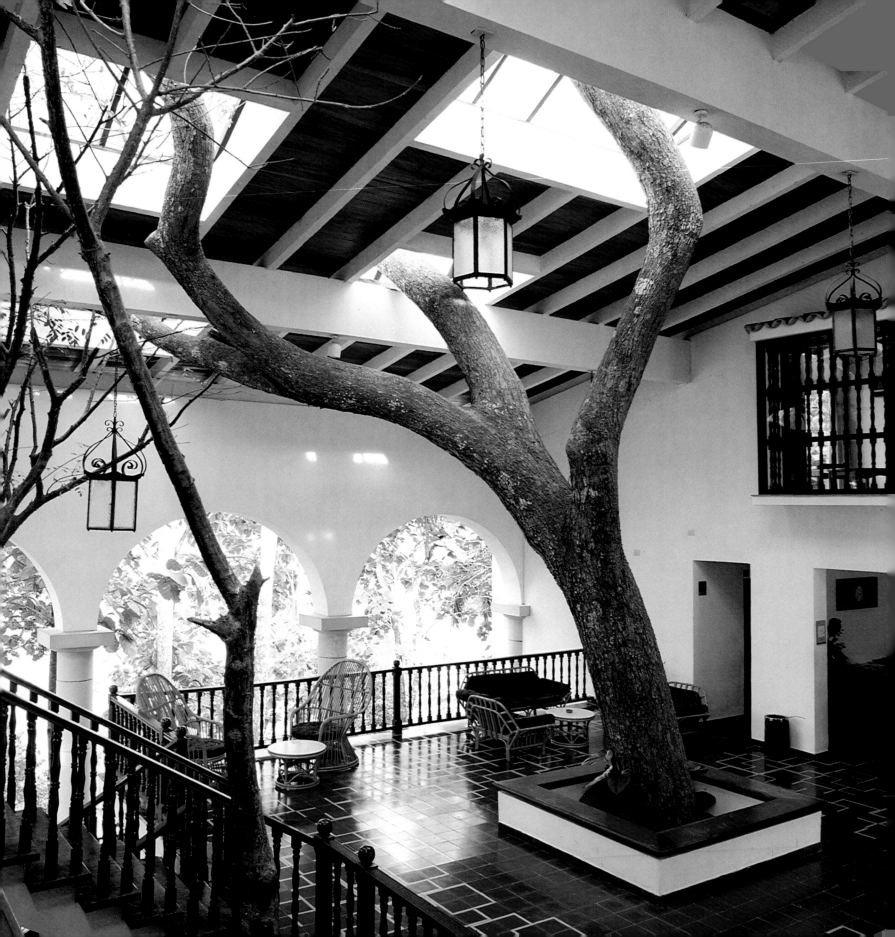

Most of the towns and villages are sleepy places showing little sign of activity. Rocking chairs sit empty on the porches of small wooden bungalows, while the occasional cowboy rides his horse at a slow walk down dusty country lanes, cigar between his teeth.

The capital of the province is the city of Pinar del Río, in actuality a big country town of simple, Neoclassical buildings where farmers or workers from the nearby copper mine come to buy supplies or stop at bars to imbibe the local specialty, Guayabita del Pinar, a sweet concoction of rum and guava juice.

The real highlight of the region is another thirty kilometres further west – Viñales, a valley of huge limestone outcrops called *mogotes* rising dramatically out of the flat valley floor. These rock formations are all that is left of a plateau that stood here more than 150 million years ago. Nearby, the township of Viñales itself consists of little more than a few blocks of single-storey bungalows with columned porches, and the streets are filled with the scent of pine trees that grow throughout the valley, and from which the province takes its name.

OPPOSITE *Far off the tourist trail, the El Moka Hotel nestles in the forest of Soroa in the eastern part of the province. The area has been designated a UNESCO biosphere to protect the diversity of its flora and complex ecosystem*

ABOVE RIGHT, RIGHT *In a city of otherwise modest buildings, the lavish Palacio Guasch is a surprising find. It was built in the city of Pinar del Río by a wealthy doctor between 1909 and 1914, and now houses the Museum of Natural Science. Gothic, Moorish and Baroque details mark the Palacio Guasch as something of an architectural oddity – its bleached walls, elaborate plaster decoration and a blanket of flowering vines imbue the Palacio Guasch with an air of romantic decay*

OPPOSITE *A whitewashed cabin roofed in the traditional way using dried palm fronds*

ABOVE *Ranch-style living on the road to Viñales – a turn-of-the-century bungalow*

BELOW LEFT *Timber boards hewn by hand clad a simple country home*

BELOW RIGHT *A sense of symmetry and faded Neoclassical charm in downtown Pinar del Río*

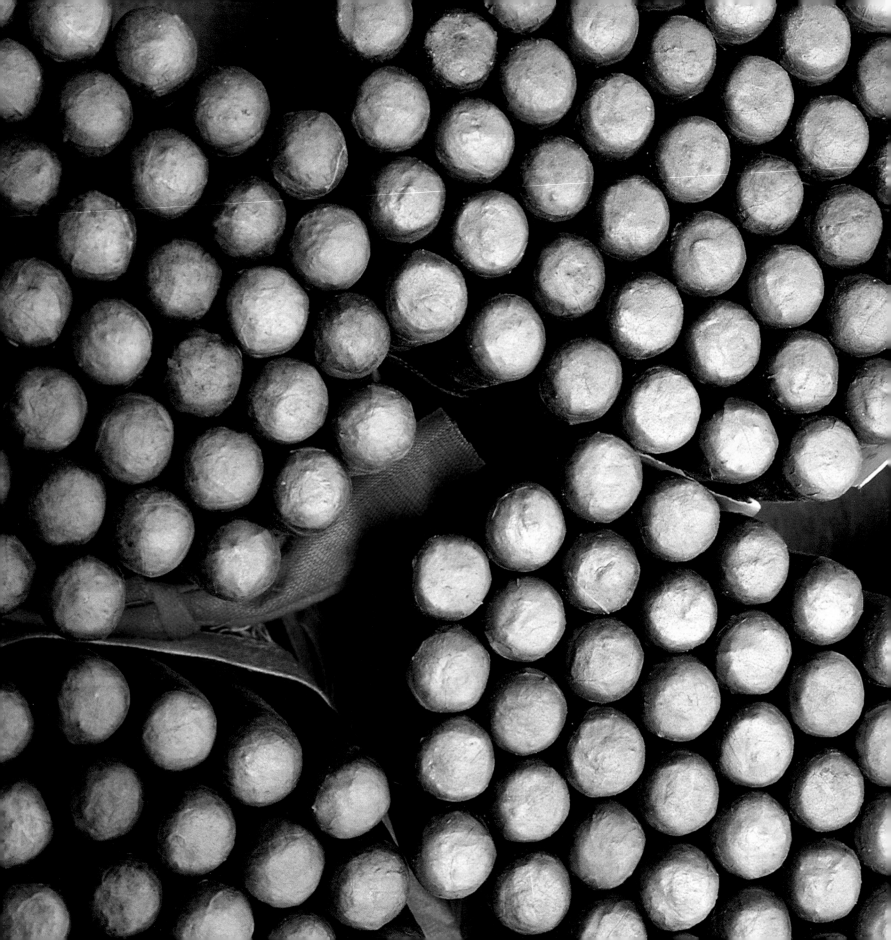

KING TOBACCO

The island's natives were the first to discover the pleasures of smoking dried tobacco leaf.
Centuries later their crude roll-ups have evolved into the elusive luxury of the Cuban cigar

IN FIELDS OF GREEN

Tobacco has always been an inextricable part of Cuban life. It became one of the key exports early on in the island's colonial history and was the most profitable crop at least fifty years before sugar transformed Cuba's economy.

As well as being a lucrative product, it was also a controversial one. Unlike sugar, tobacco is best grown on a small scale, and its cultivation earned substantial incomes for peasant farmers in the seventeenth and eighteenth centuries. Feeling their power base under threat, the colonial estate owners banded together to lobby for the introduction of a range of tobacco taxes and restrictive trade regulations, prompting farmers to stage the first Cuban revolt against Spanish rule.

Despite winning a short reprieve, the tobacco farmers pushed further afield from Havana province, to Pinar del Río in particular where the climate and soil combined to produce the finest leaf on the island. Centuries later, the fine, fragrant tobacco of the region is considered the very best in the world.

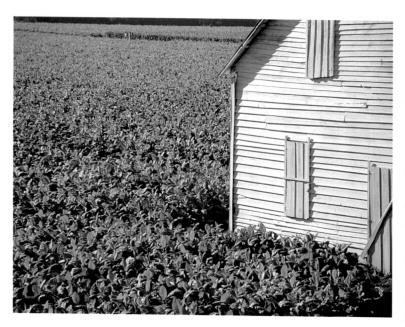

OPPOSITE *The fertile Vuelta Abajo region of Pinar del Río province, west of Havana, produces tobacco for the finest Cuban cigars. The quality of the crop relies on warm days and little rain, and on the constant attention of field hands who remove weeds and pests*

LEFT *Characteristic of the Vuelta Abajo are timber A-frame barns for storing tobacco leaf*

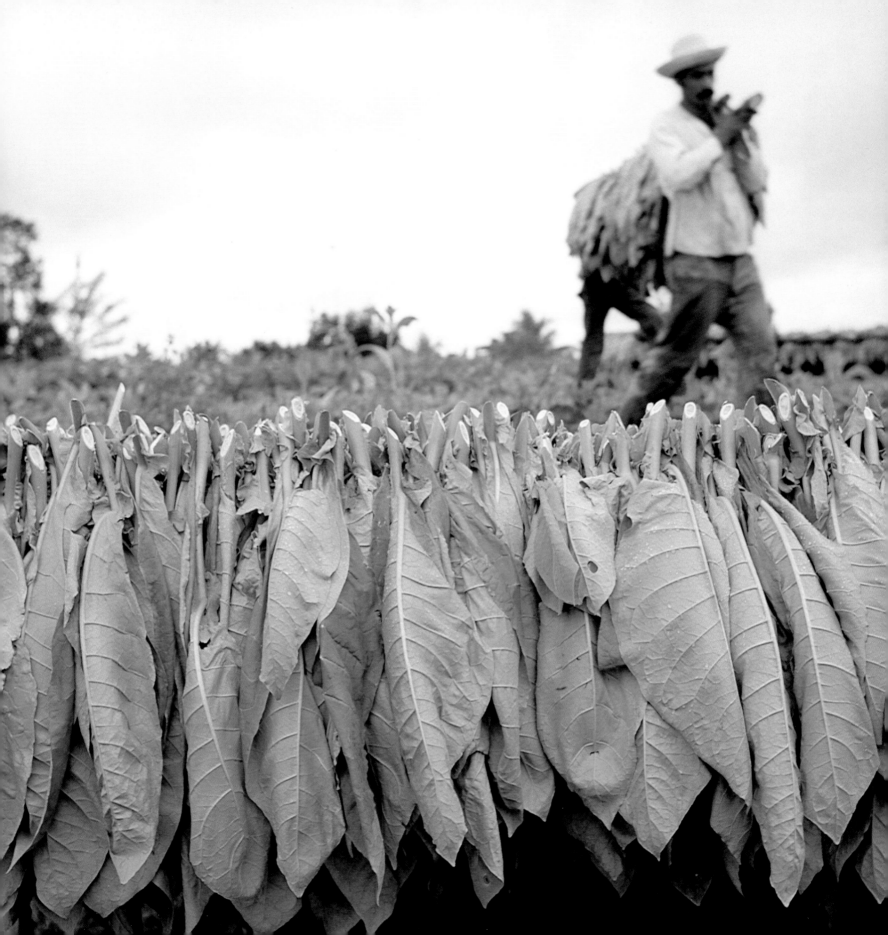

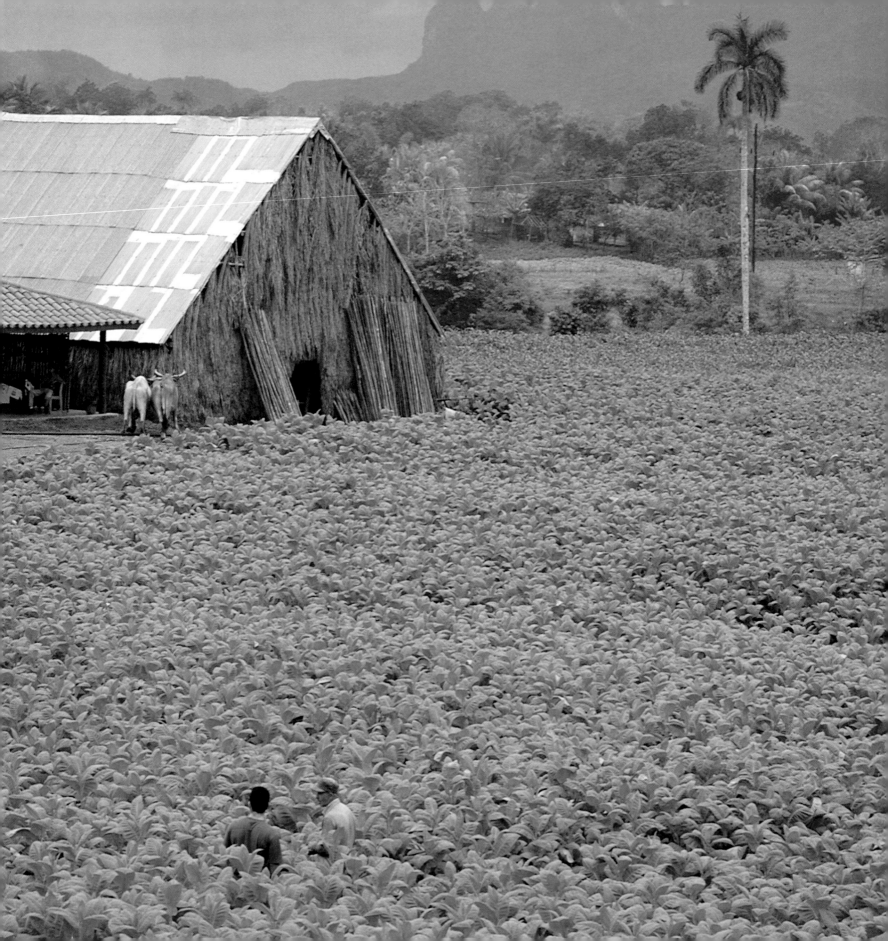

OPPOSITE *The Criollo tobacco plant, used to
make the best cigars, is planted from seedlings
in September and harvested just fifty days later*

RIGHT, BELOW RIGHT *Leaves are picked by
hand as they mature, sometimes days apart,
then stitched in pairs and hung to cure*

BELOW *The Cuban peasant, or* guajiro,
is descended from Spanish tobacco farmers

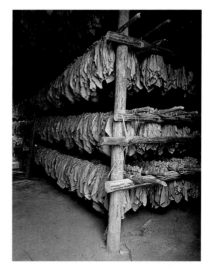

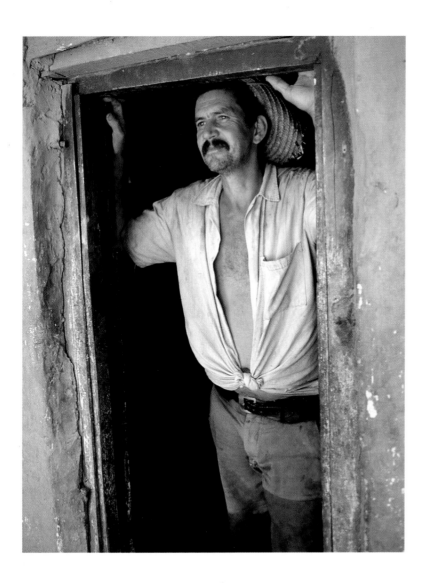

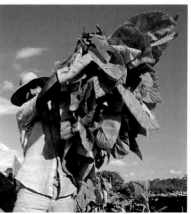

THE HAVANA CIGAR

Columbus had observed the local Indians smoking the rolled, dried leaves of the tobacco plant when he first landed on Cuban shores. When Europeans finally embraced the habit, they smoked the tobacco in pipes or inhaled it as snuff – it was not until the early 1800s that the crude roll-up smoked by the Indians was refined to create the classic Havana cigar.

The techniques for creating Cuba's most revered export have changed little from last century. The best quality leaves are shipped from Pinar Del Río province to the five cigar factories in Havana, where they are dried, washed and sorted by hand into grades. Practised noses then choose a mix of the five graded leaves that go into each cigar, before they are rolled by hand – not on the thighs of young women as legend has it, but on wooden boards by men and women of all ages, each graded according to skill. It is a combination of rolling expertise and blending know-how that goes to make what George Sand famously described as 'the perfect complement to an elegant lifestyle'.

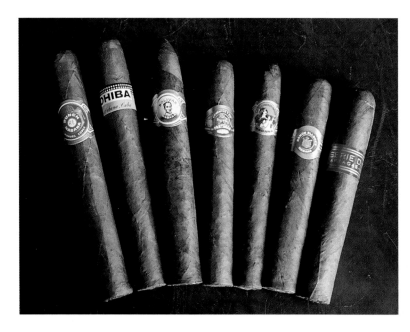

OPPOSITE *Cigar-making methods at the historic Partagas factory have changed little over the past 150 years. Each worker in the rolling gallery produces some ninety hand-rolled cigars a day*

LEFT *A selection of the finest cigar 'marques': Punch; Partagas; Cohiba; Bolivar; La Gloria Cubana; Ramon Allones; and Serie D from Partagas*

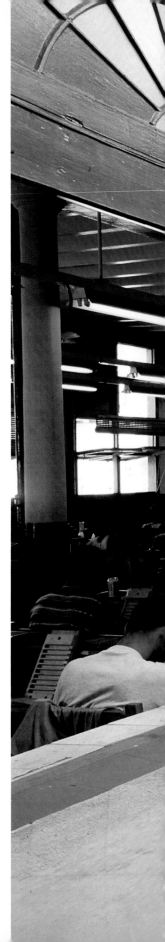

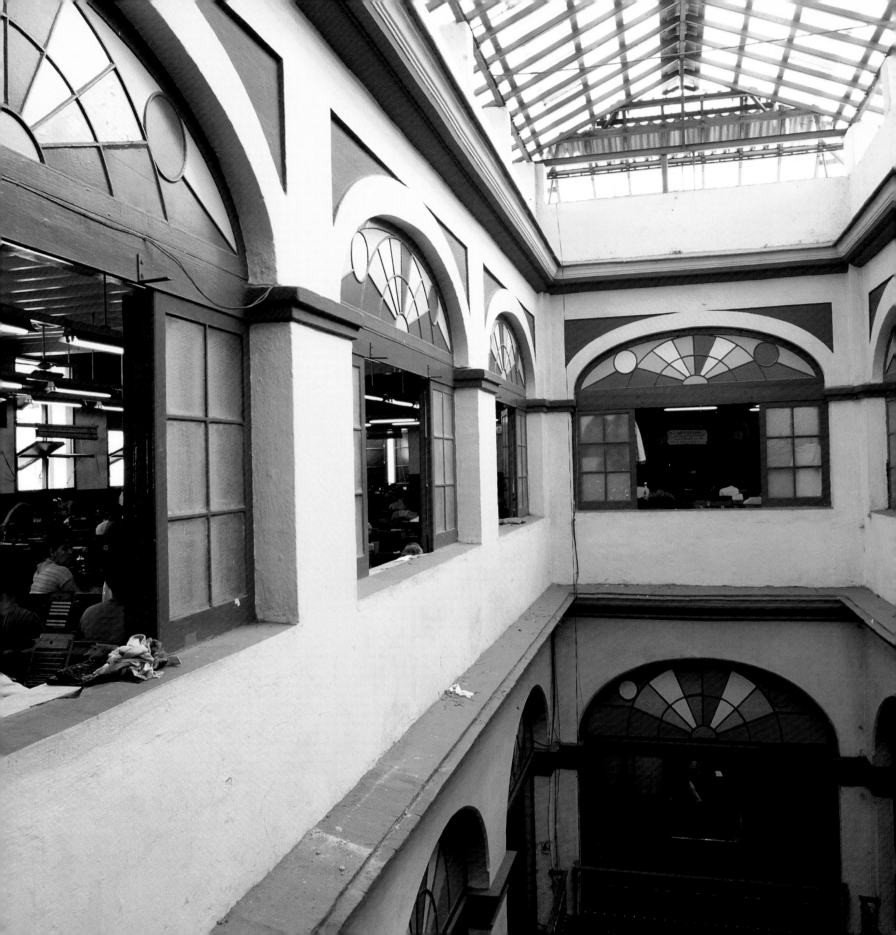

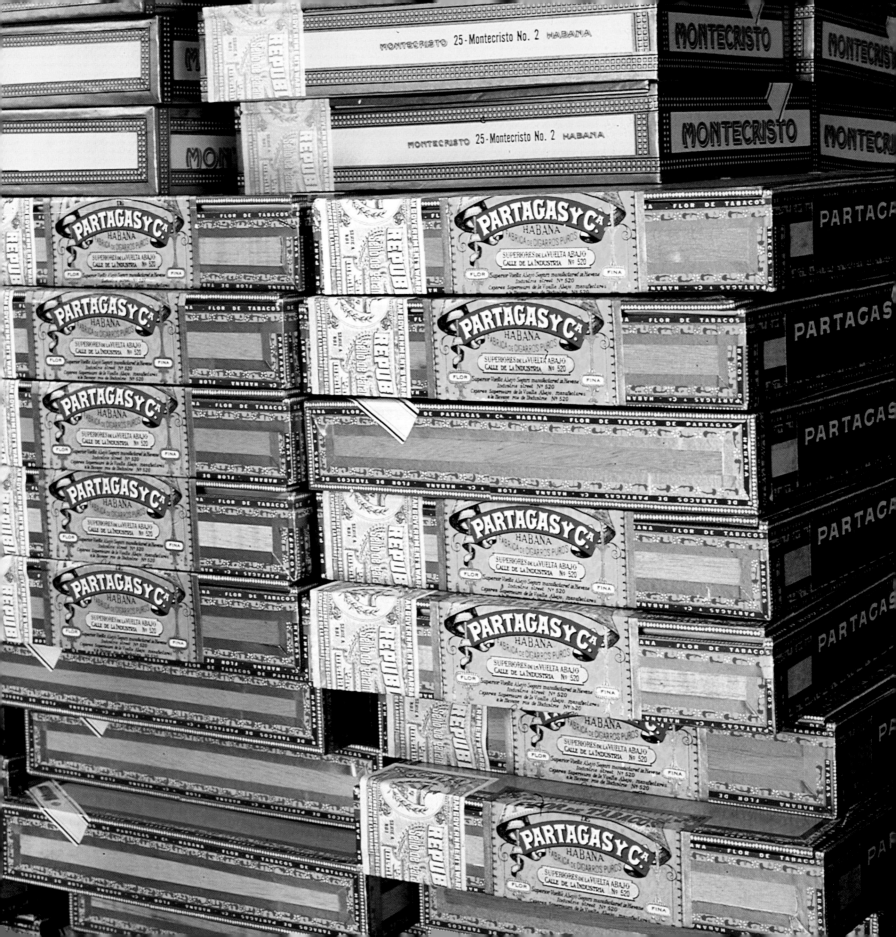

OPPOSITE *The labelling and boxing of cigars is an art as careful and practised as that of rolling. For the sake of aesthetics, the cigars are batched by colour before being packed in mahogany boxes. A thin sheet of cedar is inserted just under the lid to help retain the flavour and moisture of the cigars inside*

RIGHT *Cigars ready for packaging. Each bundle has been hand-rolled by the one cigar maker to ensure consistency*

BELOW *The finishing touch is the label on top of the box – long a part of the tobacco tradition. Cigar labels were raised to a fine art in the 19th century, and are still an integral part of the cigar experience*

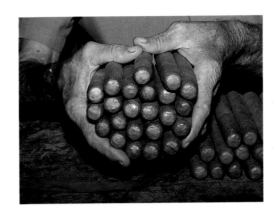

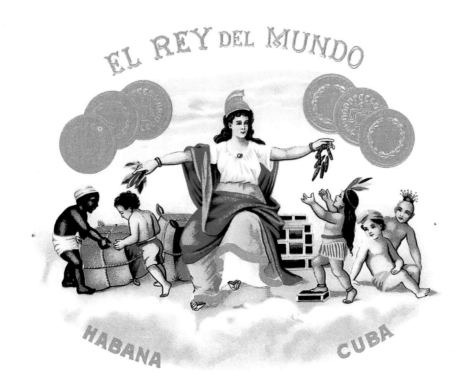

EL REY DEL MUNDO

HABANA CUBA

CUBAN DIARY

A guide to essential sights, sounds and
encounters in Havana, from classic hotels
and Cuban salsa to authentic homecooking
and Hemingway's haunts.

HOTELS

Gran Caribe
The Gran Caribe group runs luxury hotels throughout
Cuba, including the Nacional and Sevilla in Havana,
and has restored many of the island's classic hotels.
Avenida 7, between Calle 42 and 44, Miramar.
Tel: 33 05 75

Nacional
With its imposing facade, lavish Spanish-style
interior, manicured gardens and views over the
Malecon,the Nacional has been Havana's showcase
hotel since its construction in the 1930s.
Calle 21 at Calle O, Vedado.
Tel: 33 35 64

Sevilla
Beautifully restored turn-of-the-century hotel
decorated in the Spanish style, with superb
views over Havana from the rooftop restaurant.
55 Trocadero at Prado, Central Habana.
Tel: 33 85 83

Inglaterra
An old-world charm pervades one of Cuba's oldest
hotels, built in 1875. Well situated for forays into
Old Havana and for shopping trips to the nearby
Partagas cigar factory.
Prado at San Rafael, Central Habana.
Tel: 33 85 93

Riviera
A must for devotees of late-Fifties interior
decor, the hotel was built by American mobster
Meyer Lansky to house an extravagant casino.
Avenidas Paseo and Malecon, Vedado.
Tel: 30 50 51

Hostal Valencia
In the heart of Old Havana, a former colonial mansion
built around a lush courtyard, the Valencia offers
atmospheric accommodation at very reasonable rates.
Calle Oficios at Obrapia, Old Havana.
Tel: 62 38 01

Ambos Mundos
The ideal port of call for those retracing Hemingway's
footsteps. The author lived here for several months
in 1930. A small but pleasant hotel in Old Havana.
Corner of Calles Obispo and Mercaderes, Old Havana.
Tel: 61 48 87

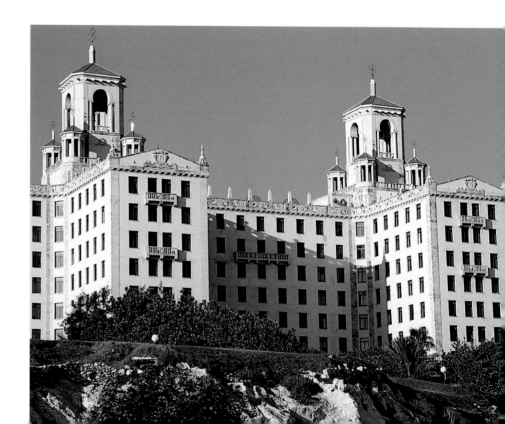

RESTAURANTS

La Bodeguita Del Medio
Creole food and Havana's best Mojitos
– a blend of white rum, sugar, lemon juice
and mint leaves. A favourite haunt of Hemingway.
265, Empedrado, between Cuba and San Ignacio.
Tel: 62 44 98

Los Doce Apostoles
A dramatic setting at the base of the El Morro
fortress for traditional Cuban dishes of rice,
beans and pork.
Habana del Este, Parque Militar, Morro, Cabaña.
Tel: 63 82 95

El Floridita
Cuba's most famous restaurant. In the 1950s
it was the heart of Havanan society, frequented
by Ernest Hemingway, Cary Grant, and a host
of other Hollywood stars. One of the best spots
to sample Daiquiris.
557, Montserrate at Obispo, Old Havana.
Tel: 63 10 60

Terraza Del Hotel Inglaterra
Simple chargrilled meals on the rooftop of the
elegant Inglaterra hotel. Offers views over the Prado.
Hotel Inglaterra, Prado, Central Habana
Tel: 33 85 93

PALADARS
The most authentic meals are served in the living
rooms of private homes, converted into restaurants
and dubbed 'paladars':

Restaurant El Festival
619, Calle D at the corner of Calle 27, Vedado.
Tel: 30 96 49

Amor
3rd floor, 759, Calle 23, between Calles B and C, Vedado.
Tel: 3 81 50

Casablanca
4402, Calle 37, on the corner of Calle 44, Playa.
Tel: 23 73 48

NIGHTLIFE

Gran Teatro, *for opera and ballet, including*
performances by the Cuban National Ballet.
Corner Prado and San Rafael, Central Havana.
Tel: 61 30 78

Tropicana, *for a lavish floorshow under the stars.*
Calle 72 at Calle 41, Marianao.
Tel: 33 01 10

Palacio De La Salsa, *for the top Cuban bands.*
Hotel Riviera, Paseo and Malecon, Vedado.
Tel: 33 40 51

SHOPPING

Cathedral Market
Plaza de la Catedral, Old Havana, daily.

La Acacia, *for antiques.*
San Jose, between
Consulado and Industria, Central Havana.
Tel: 63 93 64

Palacio De La Artesania, *for crafts.*
64, Calle Cuba, Old Havana.
Tel: 62 44 07

La Casa Del Ron, *for rum.*
Calles Obispo and Bernaza, Old Havana.
Tel: 63 12 42

La Casa Del Habano, *for cigars.*
Avenidas 5th and 16th, Miramar.
Tel: 29 40 40

TRAVEL

Havanautos
Offers car rentals from basic to luxury all
over the island. A basic network of freeways
makes for reasonable driving along major routes.
505, Calle 36, at Avenida 5, Miramar
Tel: 33 28 91

Cubana
Cuba's national airline flies from the capital
to Varadero, Santiago de Cuba, Baracoa,
and other key towns.
64, Calle 23, at Infanta La Rampa, Vedado.
Tel: 33 49 49

Ferrotour
The national rail carrier serves routes across
the island. Luxury class, especial, is a must
for the long haul from Havana to Santiago.
Central Station, Old Havana.
Tel: 33 70 30

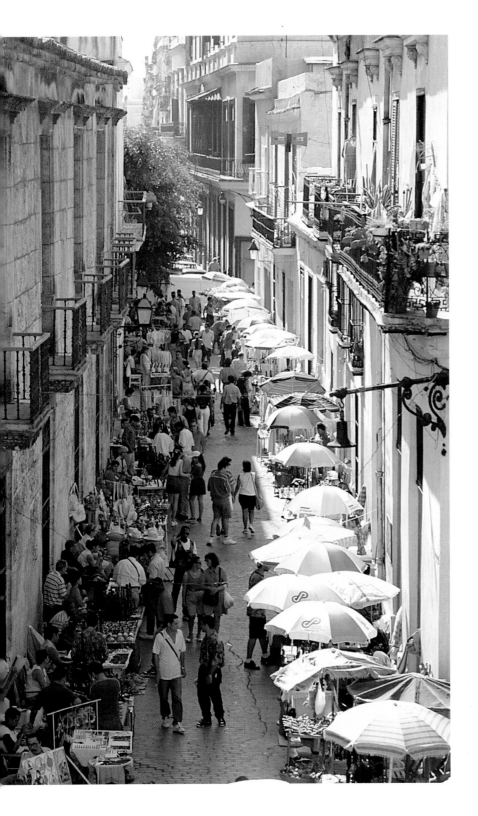

MUSEUMS

Convento de Santa Clara
Houses the National Centre for Preservation,
Restoration and Museum Studies.
Calle Cuba, between Calles Sol and Luz, Old Havana.
Tel: 61 50 43

Museo De La Cuidad De La Habana
Traces the history of the colonial city.
Plaza de la Armas, Old Havana.
Tel: 61 28 76

Museo De La Revolucion
Charts the events surrounding
Fidel Castro's revolution of 1958-59.
In the former Presidential Palace.
1, Refugio, between Misiones and Zulueta, Old Havana.
Tel: 62 40 91

Museo Ernest Hemingway
A tribute to the author at the site of his Cuban home,
complete with his boat.
Finca la Vigía, San Miguel del Padron,
San Francisco De Paula.
Tel: 91 08 09

Museo Nacional De Bellas Artes
Contains some of Cuba's finest artworks,
from the 17th century to modern times.
Trocadero, between Zulueta and Monserrate.
Tel: 62 01 40

PRECEDING PAGES, LEFT TO RIGHT: *The prestigious Hotel*
Nacional; chair and bar of the El Floridita restaurant
THESE PAGES, LEFT TO RIGHT: *One of many tiled details*
to be found in Old Havana; the daily craft market held at
the Plaza de la Catedral and surrounding streets

INDEX

Page numbers in *italic* refer to illustrations, on which information will be found in the captions.

ACKNOWLEDGMENTS

The publishers would like to thank the following people for their invaluable contribution to the book: Jorge Nicanovich, Noemi Quirch, Leda Marsal, Cristobal Viltres, Alexis 'Dynamito' Perez, Eusebio Leal, Rafael Menendez, Mary Ruiz and family, Bertha, Aurora, Bradd Nicholls, Amado Fakhre, Toby Brocklehurst, Chris Smith, Gwynn-fyl Lowe, Manuel Ayuso, and all those who kindly allowed their homes to be photographed.

Reproduction by David Bruce Imaging
Printing by Officine Grafiche de Agostini, Novara, Italy

ADDITIONAL CAPTIONS

p. 2: *Entrance to apartment block on Concordia, Old Havana*

p. 4 & 5: *Fresco in Old Havana*

p. 6: *Colonial home, Trinidad*

p. 9: *Triolet Pharmacy, Matanzas*

p. 10 & 11: *House in Vedado, Havana*

p. 12: *Beach at Cayo Coco*

p. 32: *The Malecon, Havana*

p. 96: *Art Nouveau lamp in Santiago home*

p. 170: *Central plaza, Trinidad*

p. 224: *Cigars at the Partagas factory*